CHANGING MINES IN AMERICA

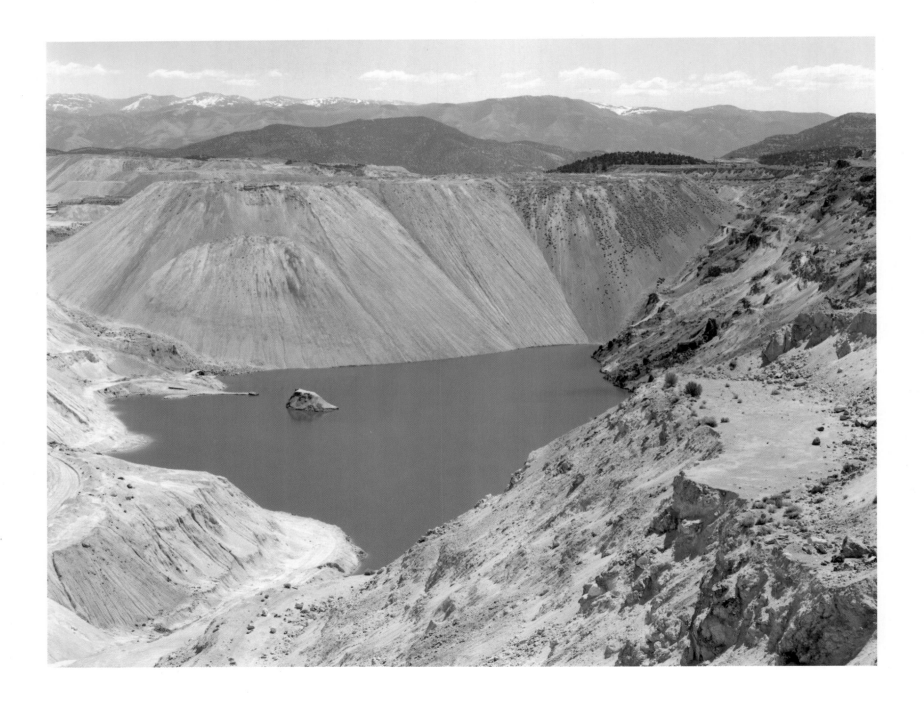

CHANGING MINES IN AMERICA

Peter Goin and C. Elizabeth Raymond

THE CENTER FOR AMERICAN PLACES

Santa Fe, New Mexico, and Harrisonburg, Virginia

Pulisher's Notes

Changing Mines in America was published in an edition of 750 hardcover and 2,000 softbound copies with the generous financial assistance of the Nevada Humanities Committee, the Graduate School at the University of Nevada, Reno, the Public Resource Foundation of Reno, Nevada, the Charles Redd Center for Western Studies at Brigham Young University, and the Barrick Goldstrike Mines, Inc., for which the publisher is most grateful. The photographer's press check was made possible, in part, through a grant from the Nevada Arts Council, a state agency, and the National Endowment for the Arts, a Federal Agency. For more information about the Center for American Places and the publication of *Changing Mines in America*, please see page 208.

Frontispiece: Begun in 1909, when the Nevada Consolidated Copper Company started to excavate what had previously been the Liberty shaft, the Liberty Pit was part of a large, open-pit copper mining operation at Ruth, Nevada. By 1986, the mine was no longer being worked and was filling inexorably with water, forming the pit lake seen here.

The Center for American Places, Inc.
P.O. Box 23225
Santa Fe, New Mexico 87502 U.S.A.
www.americanplaces.org

Distributed by the University of Chicago Press
www.press.uchicago.edu

9 8 7 6 5 4 3 2 1

ISBN 1-930066-11-2
ISBN 1-930066-12-0 (pbk)

Library of Congress Cataloging-in-Publication Data is available from the publisher, upon request.

CONTENTS

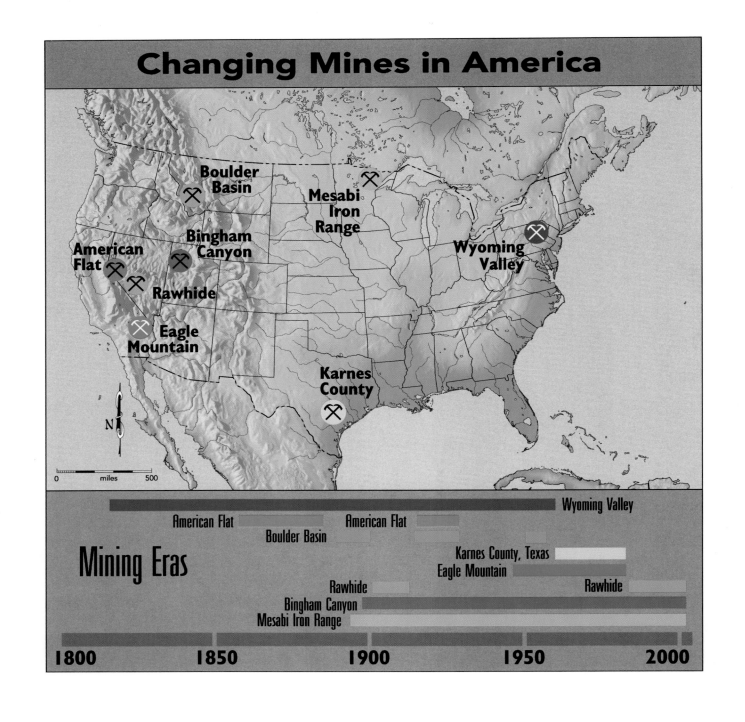

Changing Mines in America

Boulder
Basin

Mesabi
Iron
Range

Wyoming
Valley

American
Flat

Bingham
Canyon

Rawhide

Eagle
Mountain

Karnes
County

N

0 miles 500

Mining Eras

Wyoming Valley

American Flat American Flat

Boulder Basin

Karnes County, Texas

Eagle Mountain

Rawhide Rawhide

Bingham Canyon

Mesabi Iron Range

1800 1850 1900 1950 2000

An abandoned mine can be an attractive nuisance. Human-made portals into the depths of the earth beckon our imagination even as toxic chemicals, immense mounds of loose rock, decaying timbers, and animal skeletons offer evidence of unspeakable dangers. More than a decade ago Peter Goin and his assistant were exploring arid landscapes of the Great Basin when they encountered one such intriguing, dangerous mine. Clearly abandoned, the mining landscape was littered with the detritus of human industry, including rusted machines, coiled cables, refuse piles, and oil-stained soil. The entrance to the mine was a dark tunnel, and it is here that they narrowly avoided a slow death, entombed under a crystal mountain. This is where *Changing Mines in America* began.[1]

My assistant and I take a few steps closer to the entrance, then pause. Cool air emerging from the tunnel massages us, yet when we peer into the darkness we are both intrigued and unfulfilled. We want to explore the inner mine. We talk in understated tones about discovering artifacts and human spaces within the earth. The opening looks narrow and confining. Able to see only a few feet, our eyes do not adjust. The view is denied; this is a problem of contrast. In the sunlight our eyes squint because of the brightness, while inside the narrow corridor, light is absorbed into the blackness. We hesitate, then take a few steps closer. We enter the mine.

I am thankful to find a small flashlight in my camera bag. The bulb does not emit a very powerful beam, but it offers sufficient illumination, at first. As I move the light, its circle strikes the rocks and then the narrow gauge rails, reflecting lines that extend parallel to a point off in the darkness. The cool atmosphere of the opening is refreshing against the hot, dry winds of central Nevada's summer. But these tunnels and the inevitable sunken shafts are unsafe, and we retreat to a pile of waste rock just outside the mine. Without speaking, we kick a few rocks over the edge, listening to them skip, clickity-click, and finally land. A few more rocks join the cascade. We look once more at the opening to

The map by Paul F. Starrs approximates the locations and eras of active operation for the eight sites depicted in this book.

the tunnel and then at the mountaintop covered with quartz. If there's quartz, there must be gold.

I stand still in the sunlight, reflecting upon the unknown miners' life in this place. Those who lived and worked here have vanished, their history measured in spoil, tailings, and the debris of industry. There are no communities at this mine, no homes left. The structures and their wood beams have been savaged by time or salvaged by humans. Layers of debris lie scattered around the mining site, punctuated by the rock rings of campfires past. Everything is skeletal, including weather-beaten timbers partially burned. The remnant of a concrete foundation becomes a silent and unintended stage for the scurrying of mice, spiders, grasshoppers, and stinkbugs. Looking at the horizon, we realize that the broad landscape is punctuated with mining sites that have become the Great Basin's physical graffiti.

The rocks on this human-made hill are similarly sized but of different hues, bespeaking the legacy of processing and discarding low grade ore. While the rock spoil has been organized, barrels are scattered throughout the site. I suspect that each barrel contains cyanide residue. I look at my boots caked with yellow-gray soil. The air smells oddly chalky or metallic. Brackish water pools have insect larvae nestled in green algae. A baby rattlesnake curls within a rusted can. I can see its head through the lead plughole. In a passing moment, I hear the sound of an unexpected whirlwind. As I close my eyes against the dust, I imagine that day, many years ago, when some miner opened this can, ate its contents for dinner, and felt the warmth of an evening's fire. The unintended legacy of lead-sealed canned foods serves as a metaphor for the corrupting promise of gold and silver in the dreams and lives of these miners.

Again, our curiosity prevails. The tunnel beckons. Walking awkwardly over the loose rocks, we reach the entrance to the mine, bend over, and step once again into the earth. Inspecting the walls of hard rock, we discover and run our fingers along fissures, seams, and blast holes drilled but unused. The rock is cool and damp. I look at the weathered and split hardwood posts with hastily shaped wedges propping the crossbeams snug against the ceiling. Further in the passageway, pillars of rock support a cavernous room that is actually an ore transfer room for numerous spurs. These pillars, and the posts before them, support an entire mountain of quartz. Spurs lead from the main corridor but we dare not walk these paths. We do not want to get lost. A cart full of cannonball sized ore blocks a passageway. This ore cart, while old and rusted, looks ready for processing. I imagine the banging, clanking, drilling, and scraping of rock. Flashlight shadows are ghosts from years ago.

We continue walking down the narrow corridor. The sounds of our footsteps echo off the passageways. After 10 or 15 minutes, we arrive at a rope ladder suspended nearly 100 feet from the surface in a narrow vertical corridor. The climb up this frayed rope would be dangerous for me, but impossible for my assistant. A dust-laden, faint ray of light high above reminds me of the darkness, and of the limit to my flashlight batteries. Old, dusty bottles strewn around this circular cavern might be the remains of a meal, so many years ago. One blackish bottle lay unopened. A brown-gray, worn pickaxe rests against the curvature of the rock wall. Pausing, we talk about returning with our sleeping bags and spending the night, here among the elements and fragments of untold stories. The flashlight bulb begins to fade, and I realize how difficult it would be to return without light. I know that the rails lead back to the tunnel opening, but there are spur tracks that could be misleading. Without the promise of enough artificial light, we decide to camp outside.

Walking over the once traveled terrain, I follow the direction of the airflow. Soon, we emerge into the furnace of that August afternoon. The air feels liberating. That night, my assistant and I build a campfire on a nearby ridge. Our view of the silhouetted horizon, so typical of the basin and range topography, is spectacular. The black mountain range stands in only two dimensions against the deep blue twilight. We can see 200 square miles, yet the view is without depth. This is an evening with no moon, incredibly bright stars, and chilled air. The fire's warmth reaches into our souls, and we are thankful for it. We rub our hands against its light. The coyotes howl and yip from miles away, beyond the dry lake bed. Nearby petroglyphs remind us of the centuries of human presence. Finally, we seek sleep. My last thoughts return to the passages of the mine, imagining the spirit of those who labored within the dark earth.

Before sunrise, the growling sound of heavy machinery and the pungent smell of burned diesel fuel awaken us. We look through the window of the tent and see a bulldozer dragging, pushing, and lifting rocks, earth, and boulders to seal the opening of the mine tunnel. Black tufts of smoke burst from the bulldozer's exhaust. With no wind, the fumes hang over the ridge. We remember that insurance companies, ever cautious in a litigious society, require landowners to seal mine shafts and tunnels. Clearly, this attractive nuisance is dangerous, but the coincidence of our visit and the tunnel's closure is foreboding. If we had spent the night in the mine as we discussed, we might never have escaped. We wonder who would tell our story if we'd been left inside, cut off from light and sound, behind the wall of boulders? I remember the unopened bottle, and wish I had brought it with me.

—PETER GOIN

From Peter Goin's adventure in 1990, the present book emerged. Since that experience, Goin has explored the physical and perceptual realms of American mining, observing and pondering an industry that has long been censured as noxious and dangerous, at best a necessary evil. Even the language of mining, he points out, is abrasive. Miners drill and explode. They crush, grind, and leach the rock to liberate the ore. They lay waste to spectacular landscapes and violate the environmental integrity of entire biotic communities. Many Americans, it is safe to say, share a negative view of mines as malevolent sites, dismissing these industrial sites as lost and desolate landscapes.[2]

In this work we set out to explore such drastically altered places. In the photographic chapters that follow we examine eight actual mining landscapes in order to understand both their particular histories and their intricate legacies. Rather than analyzing them at isolated moments in time, we attempt to understand their creation and development, to depict them as places where change, perceptual as well as technological, is ongoing. In the process, we came to understand mining as a process extending far beyond a single lifetime and incorporating more than mere rock.

Our approach to these landscapes was collaborative, drawing equally on visual and textual evidence. With Eric Margolis, we operated on the principle that "Visual knowledge cannot be reduced to verbal description—and vice versa . . . The grammar and syntax of photographic images are not interchangeable with that of prose."[3] Some potentially interesting sites were thus rejected because they were insufficiently visual, or had already been extensively depicted. Others proved to have little narrative interest. Ultimately the eight landscapes of mining that appear in this

work were chosen because they were visually compelling to an artist and culturally intriguing to a historian. The photographs and text are meant to be read together.

Collectively they vividly illustrate the idea that mining is a temporary use of the land. While mining has an ancient and continuous history as a human activity, few individual mines are as long-lived as Spain's centuries-old Rio Tinto. Most have far more limited life-spans, as is the case for the eight sites featured here. Three are in areas still actively being mined. Others are post-mining landscapes, each with a history that responds in different ways to their mining pasts. Several are in the midst of the physical reclamation that current state regulations decree for all active mines. Others are undergoing cultural recontextualization of their meanings. None of them is static.

Popular impressions of mining, however, often *are* static. In part because they are based on photographs such as the ones that follow, or on narratives of historical environmental abuses, conceptions of mining tend to belie the dynamic complexity of the contemporary landscapes. One danger of the photographic image is that it implies that mining is monolithic and unchanging. For this reason we have included historical photographs wherever possible. We thus attempt to provide a context for these eight particular mining areas by documenting at least some of the change that they have undergone over time. Individual histories of the various sites in accompanying essays summarize a more complete history of their use and interpretation. In two instances there are time-lapse images of the same location.

Changing Mines in America makes no claim to comprehensive coverage of American mining. Our choices are thematic. They combine in four related pairs, explained later, to portray developments or issues that we found particularly intriguing, although certainly others could have been examined. We selected areas that illustrate some of the paradoxes of American attitudes toward mining, as well as the surprising variety of mining landscapes.

In particular we sought out places that complicated a simple, linear narrative of environmental exploitation. Although each of these sites has been irrevocably changed by mining, and some are quite seriously polluted, their histories and their connotations are varied and specific. Polluted landscapes can continue to have meanings other than despoliation for their residents, and not all mines are simply waste places. Indeed, current state regulations require mining companies to reclaim sites to an approved post-mining status, and the sites in Karnes County, Texas, and northern Minnesota, featured in this book, have already been extensively restored.[4]

Each of these eight mine sites has a particular history that encompasses multiple meanings. It is our hope that the visual variety and the cultural complexities of these eight places can qualify simplistic notions of mining. *Changing Mines in America* is intended to further appreciation of the multiple ways that mining both affects and reflects American culture.

Mining, after all, has a rich figurative legacy in the U.S. Americans may know little about actual mines, but they are surrounded by images of mining. Elaborate celebrations of the sesquicentennial of the 1849 California Gold Rush reminded citizens that the iconography of mining permeates American popular culture. The western part of

the continent, in particular, is replete with it, in the form of Prospector Cafés and Nugget Casinos (see pages 187 and 190). The nineteenth-century miner with his pickaxe is ubiquitous on state seals and in period photographs. The lone prospector with his mule is an iconic figure in western movies and popular novels. The twenty-mule teams of Death Valley were long a television staple.

The miner is the cowboy's mythological counterpart in western regions too arid for agrarian pursuits. As Thomas Power points out, "For more than a century, metal mining . . . has been an integral part of the vision people have of the American west."[5] It has also been an integral part of westerners' self-presentation, as these photographs suggest. The terrors of a darkened mine become the setting for an amusement park ride in Oregon (see page 183). The underground miner's carbide lamp and helmet dictates the shape of a building where land is sold in Idaho (see page 186). Mining's status as a quintessential western endeavor is demonstrated by state parks such as Bodie in California and Berlin in Nevada. In these and other similar sites, abandoned mining towns are frozen in time and painstakingly preserved in a state of arrested decay as a setting for visitors to indulge in what Richard Francaviglia labels "technostalgia," the romanticizing of the industrial past.

Such romanticization is not limited to physical remains in historical parks. Miners' superstitions about how rats will desert a mine that is about to collapse enter into regional folklore, and mining ballads are passed down through generations of singers. Virtually every U.S. mining district has at least one locally famous disaster story that is told and retold. At once particular in their details and depressingly similar in their denouements, these stories record for poster-ity the particular mine fire or cave-in or poisonous gas that happened to claim the most miners' lives in each place. Violent strikes receive similar commemoration. These talismans of a mining heritage help establish the miners as heroic figures, and distinguish mining communities as places where, in the words of the Merle Travis song, "the danger is double and the pleasures are few." Although the modern mine is likely to be an open-pit operation, in which the majority of workers drive or load trucks, the mythical miner still works underground with a pickaxe.[6]

The power of the myth is such that even modern gambling resorts invoke it. When a Nevada casino recently sought a theme that would both tie it to its locale and tantalize its audience with the lure of sudden great wealth, it chose silver mining. The owners of Reno's Silver Legacy Casino invented a completely fictitious mining baron, "Sam Fairchild," and gave him a biography. According to casino publicity, Fairchild had journeyed west as a young prospector. Fortuitously he made the biggest silver strike ever, on the precise site of the casino property, during the 1890s (a period when Nevada's actual mining industry was moribund).

To commemorate this supposed discovery, the Silver Legacy erected a 120-foot tall moving apparatus that it dubbed "The Baron's Rig." In reality nothing more than a huge, elaborate noisemaker in the center of the casino, it was provided with a fake pedigree attesting to its authenticity (see page 187). An explanatory sign identified the fantastic "machine" as part of the apparatus of historical mining: "Sam enlisted a team of top engineers to design a revolutionary machine to simplify the mining process. The rig you see before you is an exact replica of that machine. Twelve stories high, it stands directly over the site of Sam's original claim."

Innocent casino patrons may have little idea of the extent to which they have been duped. Not only was there no Sam Fairchild and no silver discovered at the site of the Silver Legacy, but there was also never any "revolutionary machine" that brought ore up from underground, processed it into ingots, and then minted coins from the ingots in a matter of hours. The entire installation is ersatz history, relying for its effect on the general ignorance of the public about the actual mechanics of mining.

Initially the rig alone proved insufficient to impress casino visitors. Despite an elaborate artificial sky that cycles through sunrise, sunset, and a thunder and lightning storm, and the occasional clinking of "coins" issuing from the bottom of the machine, early customers reportedly kept asking when something was going to happen. In response the Silver Legacy added actors in mining gear who climb up the apparatus and rappel off its higher levels. By their presence, the casino sought to add human interest to the mechanized wheels and bellows that constituted the basic elements of the display. At the Silver Legacy, the romance of mining has disintegrated into pure chimera.[7]

The physical landscapes of actual mining are decidedly more mundane than the fabulous version on display in this Nevada casino. The machinery is merely industrial, lacking stunt actors to enliven it, and the surroundings are dusty. Genuine artifacts of mining are often disappointingly prosaic in appearance. Only their size hints at the tremendous scale of the undertakings that employed them. Historical exhibits featuring mining machinery are often at a loss to explain how particular isolated pieces fit into the complex system of exploration, ore mining, processing, and refining that together constitute the mineral industries. The machines are mute about the meanings that may have been attributed to the landscapes by workers or by displaced tribal peoples. The result is that mining, for all its iconographic intrigue, remains somewhat obscure as an actual American enterprise.

After an introduction, Chapters 1–8 of *Changing Mines in America* explore some ways that mining has played out on the ground. Each is a discrete essay, but collectively they are arranged in four thematically and visually related pairs. The first pair (chapters 1 and 2) examines two historical eastern mining districts: the Mesabi Iron Range of northeastern Minnesota and the anthracite coal field of Wyoming Valley in northeastern Pennsylvania. Both are in densely inhabited communities that have longstanding relationships to mining. In these places, unlike more isolated mines in the western U.S., the closure of mines does not automatically mean depopulation. Instead, residents must shape and adapt to mining's aftermath.

Their responses vary. In Minnesota, authorities are pursuing various methods to recycle the mining landscape. Some sites are revegetated and "restored" to simulate natural landscapes. Others are self-consciously maintained as tourist landscapes, meant to instruct visitors about the history and importance of the iron industry in shaping the Arrowhead region. In Pennsylvania, on the other hand, recent efforts at environmental reclamation are destroying the familiar contours of waste rock dumps that have long signified "home" to residents. The environmental imperative that dictates restoration and promises redemption paradoxically threatens the local sense of place.

The second pair (chapters 3 and 4) delineates the perils and pleasures of radioactivity by examining two uranium

mining areas with divergent histories. The first, in Karnes County, Texas, was mined for just over twenty years in the mid-twentieth century, but lives now with radioactivity that will endure for centuries. Active mine restoration projects have been quite successful, but the deceptively bucolic landscape that they produced obscures the potentially troublesome environmental legacy of the Texas uranium mines, about which some residents are uneasy.

The second uranium site, in southwestern Montana, actively advertises its radioactive heritage. Here a group of six former iron, gold, and uranium mines now market themselves as "health mines." They appeal to sufferers from arthritis and bursitis who come specifically to breathe the radon gas that promises relief from their ailments. Former mine workings are outfitted with comfortable chairs and reading lights to accommodate a steady stream of visitors taking "treatments," who believe they benefit from proximity to the rock. Here in Montana the same radioactivity that seems vaguely sinister in Texas has become an attraction.

The next two sites (chapters 5 and 6), Bingham Canyon, Utah, and Rawhide, Nevada, are currently active. In these two classic open-pit mines, immense quantities of soil and rock are removed in order to recover relatively small amounts of copper and gold, respectively. The former is so big that it is visible from satellite orbit and has entered its second century of continuous operation. The latter is just over a decade old in its present form, but was the site of an early twentieth-century mining boom that was largely the creation of assiduous public relations specialists. Ironically, the mine at Rawhide was famous as a prototypical mining camp long before it actually became a substantive mine. Now gold mining operations are systematically dismantling the mountains that once constituted the landscape of the

historical boom town, in order to recover microscopic amounts of precious metal per ton of ore.

The final pair (chapters 7 and 8) is also western, but these concern the future of post-mining landscapes rather than active mines. Together, the two case studies—a former iron mine at Eagle Mountain, California, and a silver mill site at American Flat, Nevada, on the historic Comstock Lode—rhetorically pose the question, "What is the proper post-mining use for a mine?" Mining at Eagle Mountain ceased in 1983, and the location is now slated to become the disposal site for at least fifty years' worth of household garbage that will be transported from southern California. Despite an urgent need for landfill sites and the apparent congruity of using waste to fill wasted open pits, this planned use is enormously controversial. Twice challenged in court, it was upheld in 1999 even though the mine is surrounded on three sides by Joshua Tree National Park.

The site at American Flat is a huge, abandoned concrete mill from the 1920s, located on public land. Long used informally as a place for paintball games, drinking parties, and graffiti, it is now being restricted by the Bureau of Land Management in the interests of public safety. Reinterpreting this outlaw recreation site as a setting for historical instruction about twentieth-century mining poses a considerable challenge for a public agency that only nominally controls it. Here an apparently derelict post-mining landscape has been informally expropriated by a community of enthusiastic, but socially marginal, users.

Collectively these eight sites illustrate a number of diverse landscapes and issues associated with mining. Our methods, however, were similar in each place. Peter Goin made the contemporary photographs of each site, sometimes during successive field trips that stretched over months

or years. The interpretive themes that emerged in each place were derived collaboratively, based on the narrative supplied by the photographs and on-site interviews. Elizabeth Raymond then researched the historical background, located historical photographs where available, and prepared essay-length chapters and captions. The photographs are thus integral elements of our study and not simply illustrations of the text. Our goal has been to combine our distinctive ways of seeing in order to make the intricacies of eight particular mining landscapes both interesting and comprehensible for our readers.[8]

In analyzing these landscapes we have relied on the theoretical perspectives provided by recent scholarship in cultural landscape studies. We assume that any landscape is a form of communication which can be decoded to reveal various strands of cultural values that are woven into the fabric of the whole. Our subject is thus not simply the physical changes that have combined over time to produce these various mining landscapes or their economic or environmental legacies. Instead we focus on the ways that those changes have been understood by diverse audiences—those who undertook them, those who experienced them, those who observed them, and those who have inherited them.[9]

In studying these meanings we assume that human perception and values directly affect landscape and are, in turn, influenced by it. The appearance of specific mining landscapes can be explained physically; but their *meanings* are cultural products, influenced not only by individual preferences and purposes, but also by general assumptions about what constitutes beautiful scenery or a devastated wasteland. For many contemporary Americans, it is virtually impossible to see beauty in a mine. Middle-class tourists in the nineteenth century, however, visited mines and other industrial sites much as they toured scenic wonders such as Niagara Falls or Yosemite.[10]

Both the physical landscapes and prevailing attitudes toward them have a history. Places and perceptual frameworks change over time. The latter can also vary among individuals, depending on factors such as age, gender, class, ethnicity, and purpose for being in the landscape, among others. Journalists reporting on miners' living conditions during the 1902 anthracite strike in Pennsylvania, for example, saw squalor where residents reported comfort. Those who live in the Texas uranium district view its dangers differently than do non-resident scientists, who confidently dismiss the possibility of any lingering danger from low-level radiation. What one can see and understand depends, quite literally, on where one is standing.

In this work, we argue that mining landscapes should not be dismissed simply as waste places, a hideous legacy of the extractive industry. In their tremendous complexity, and their surprising variety, mining landscapes can be places of beauty and curiosity, as well as apocalypse. They are places that warrant more sustained examination and analysis. As Americans consume each year the more than 47,000 pounds of minerals extracted from the earth for their benefit, it is worth assessing the consequences for the people and places that produce them. While *Changing Mines in America* presents no single narrative of mining, there are multiple and, we hope, enriching meanings to be extracted from this ground.

—C. ELIZABETH RAYMOND

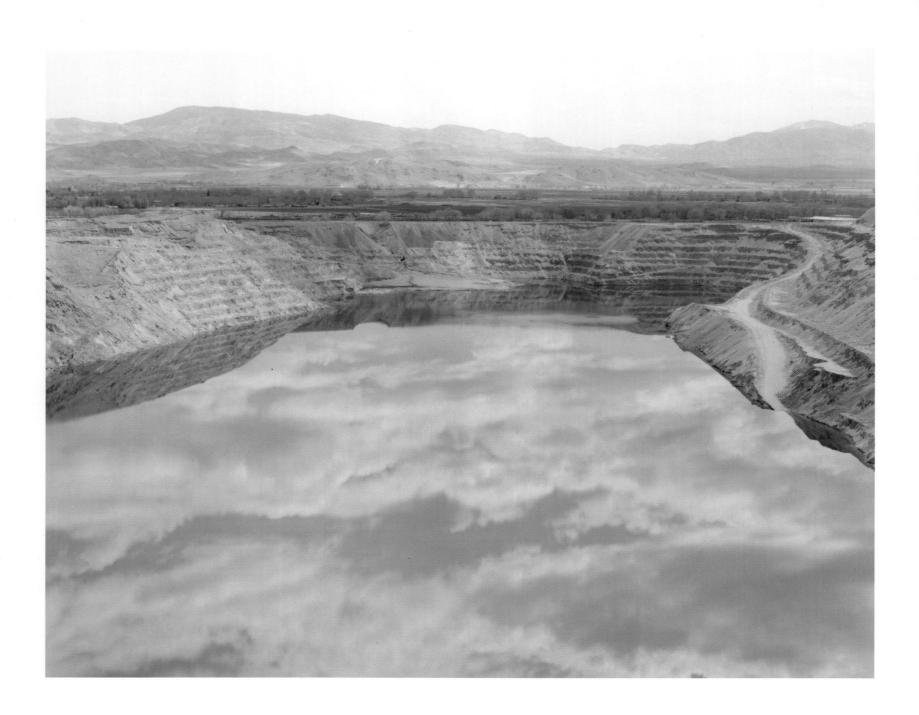

Waste Places?
Mining and the American Landscape

The American appetite for minerals, as for most natural resources, is apparently insatiable. Annual U.S. consumption of newly mined materials, not including precious metals, is more than 47,000 pounds per person.[1] At first the figure seems staggering impossible, but quick reflection reveals the myriad things that depend on the output of mining—the toasters and toothpaste, refrigerators and weather satellites. A single telephone requires up to forty-two different minerals, including some expected ones—such as copper and iron—but also obscure components such as talc and wollastonite. It takes thirty-five different minerals to make a television, 30 for the computer that many Americans now find equally essential to their lives. Without the steel manufactured from iron and coal, modern life would be unthinkable: no automobiles, no high-rise buildings, no Brooklyn or Golden Gate bridges, no razor blades. Without aluminum, no airplanes. Without sand and gravel, no roads. Without salt, no life itself.

The list is potentially endless. As a mining industry bumper sticker summarizes: "If it isn't grown, it has to be mined." Without minerals, radiation therapy for cancer and numerous other life-saving techniques of modern medicine would be impossible. Modern roads depend on asphalt and concrete, and modern automobiles on the gasoline to propel them. The pipes that deliver water and take away waste from most American homes are made from copper, iron, concrete, lead, or perhaps plastic, all substances derived from minerals. The fuel that generates electricity or heats and cools homes is ultimately extracted from the earth. Despite fiber-optic cable, electricity still depends on copper for distribution across the landscape. In short, the impact of mining on twenty-first century American life is absolutely inescapable. It would be impossible to live our current lives without the huge range of substances extracted from the earth's crust. Even modern U.S. agriculture is essentially the conversion of oil into crops.[2]

It is not only modern, postindustrial life that depends on mining. Human beings have long transformed substances

This abandoned, open-pit copper mine, at Weed Heights, Nevada, epitomizes the dilemmas of the post-mining landscape. The Anaconda Company actively worked this mine from 1951 to 1978, producing roughly seventy-five million pounds of copper annually, along with numerous byproducts, including gold, silver, platinum, cadmium, manganese, gallium, and indium. At its height the company employed 500 people who were housed nearby in a town named after the company's chairman. When operations ceased and pumps were turned off, it began to fill with water that beautifully reflects the sky but posed unknown environmental problems. In 2001, the 3,500-acre site was identified by the Environmental Protection Agency as a candidate for Superfund listing, signifying that it is among the most polluted places in the nation.

from the earth's crust into resources, and historians characterize past cultures according to the various kinds of material they manipulated. In this scheme the Paleolithic stone age—when weapons and tools were hewn from flaky rocks like obsidian—is followed successively by the Neolithic (beginning approximately 10,000 BCE), Copper (7000 BCE), Bronze (5000 BCE), and Iron (3400 BCE) ages. Mining has long been part of human history, and the earliest miners learned to work rock faces by building fires to heat them, then dousing the heated stone with water to shatter it into workable pieces.[3]

The range of mined products is surprisingly large. Salt was among the earliest and most important. Chinese bronzes and Roman concrete both depended on mining. Ancient porcelain, stoneware, and glass all derived from substances that were mined. Weaponry improved with the development of bronze from copper and tin, in western Asia. As minerals became increasingly central to political and military power, trade networks grew and governments actively sought them out. Eventually this quest brought Columbus to the New World.

Here, too, mining had a long history. Although the gold and silver found in South America and Mexico were unknown in the rest of North America, that continent, too, had important mines. Indigenous peoples mined salt from underground tunnels; they quarried flint, turquoise, and pipestone. Around the Upper Great Lakes, people of the Old Copper Culture dug copper and smelted it for use in 3000 BCE, possibly even 1,500 years earlier. Hematite had been worked, presumably for ceremonial pigment, before the arrival of Columbus, as had cinnabar (mercury) and uranium ore. The Hopi mined coal in Arizona sandstone as early as 1300, using it as fuel to fire their pottery. Ancient miners sought gypsum in Kentucky's Mammoth Cave long before the first Euro-Americans entered it. Precious metals, however, were scarce, and the principal wealth of the European colonies in eastern North America came from fur and fish rather than gold and silver.

Still, the European colonies were not without mineral wealth or activity. Iron was noted on Roanoke Island, off North Carolina, in 1585, and the Jamestown settlement in Virginia sent iron ore to London to be smelted in 1608. A group of skilled iron workers sent to the region in 1620 established an iron works, but it was destroyed during the 1622 native uprising against the English. Massachusetts built its own Saugus Iron Works in 1646 (a restoration is currently operated as a historical site), and iron manufacturing spread throughout the English colonies during the eighteenth century. By 1750, colonial iron production was sufficient to trigger English regulations forbidding its export. Eventually these restrictions on incipient American industry became an issue contributing to the Revolutionary War.

Copper was mined in Connecticut beginning in 1709. The site was abandoned around 1770, and later served as a prison during the American Revolution. Copper was also found in New Jersey in 1719. No major deposits were known, however, until the existence of a high-grade deposit in northern Michigan, on the Keweenaw Peninsula, was announced in 1841 by state geologist Douglass Houghton. At least 10,000 mines there had earlier been worked by people from the Old Copper Culture, who produced axes, knives, arrowheads, hooks, and other implements from the ore, but Houghton's careful study relocated the deposits for exploitation by nineteenth-century Americans. Along with coal, lead, iron, and petroleum, Michigan copper formed

the basis for nineteenth-century industrialization in the United States.

Coal was in use by tribal peoples in Illinois and Mississippi in the seventeenth century, and was located by English colonists in Virginia in 1750, in Ohio in 1770, and in Pennsylvania in 1790. By the seventeenth century, coal had become increasingly important in England as a substitute for charcoal, but it gained new industrial importance with the discovery by Abraham Darby, in 1709, of a technique for smelting iron using coal-derived coke instead of charcoal. Because extensive American forests made for a copious supply of charcoal, coal was only utilized for industrial processes in the nineteenth century once economical methods of bulk transport in the form of canals and railroads had been devised. By then coal was known to be common throughout the U.S., and only considerations of economical mining and transport dictated the utility of specific deposits.[4]

Lead was discovered by the colonists and smelted in Virginia in 1621. By 1765, it was mined on a small scale throughout New England and in Pennsylvania and New York. Lead was known to the native peoples in the upper Mississippi Valley before the French arrived there in the seventeenth century, but they didn't mine it until they acquired guns that needed bullets, and French traders who provided a market. Most of this mining was done by women, who removed the ore from shallow, hillside drift mines (horizontal tunnels) in baskets. The French employed mostly Indian women to mine lead at Potosi, in Wisconsin, and at Dubuque, in Iowa, during the eighteenth century. The Sauk and Fox people, who controlled extensive lead deposits in and near Galena, Illinois, and in southwestern Wisconsin, concealed their location as long as possible, fearing that if the Americans knew they would drive them from their land to get at the lead. Eventually, however, in a pattern repeated whenever valuable mineral deposits were located in Indian territories, the U.S. government seized title to the land and forcibly displaced the native Sauk, Fox, and Winnebago owners. This incident contributed to the 1832 Black Hawk War.[5]

Another classic example of such exploitation involved the 1828 discovery of gold in Georgia. This was not the first gold found in the U.S. That distinction belongs to North Carolina, where gold was officially recognized in 1799, although the area had clearly been mined before then. In North Carolina the early placer mines (where gold that washed out from the hillsides was separated from the surface gravel by a variety of means such as panning) were replaced beginning in 1833 by underground mines that followed the lode or ore deposit. The underground labor force was comprised mostly of slaves, who received a portion of the gold that they mined in exchange for their work.

In Georgia, however, discovery of gold on lands reserved to the Cherokee set off a gold rush. In a pattern repeated again in the 1870s, in the Black Hills of South Dakota, land that had been legally set aside as a perpetual reservation for an Indian tribe was overrun by Euro-Americans who ignored the law in their frenzy over a precious metal. In Georgia the battle eventually led to a legal showdown between state and federal authorities, with the former determined to relocate the Cherokee and make their reservation part of the state, and the latter determined to defend the treaty rights of the Indian owners of the land. In an early states' rights confrontation, an 1830 Supreme Court decision in favor of Cherokee rights to their land was ultimately ignored by the state of Georgia, with the open support of President

Andrew Jackson. Eventually the gold discovery in Georgia was the cause of an infamous Trail of Tears (1835 to 1838). Perhaps as many as one quarter of the 16,000 Cherokee who were forcibly relocated to what is now Oklahoma lost their lives along the way.

Meanwhile, eager wealth seekers swarmed into Georgia, where many remained until another gold discovery, in 1848, enticed them west to California. Although some Georgia gold mines continued to be worked into the twentieth century, the attention of most Americans was redirected to "the diggings" along the western foothills of the Sierra Nevada. Beginning in 1849, when the discovery on the American River became widely known, tens of thousands of people from throughout the world rushed to this largely unknown territory, which had been acquired by the U.S. during the Mexican-American War. Expecting to strike it rich and bring back huge gold nuggets, not only Americans but Australians and Mexicans, Chinese and Swiss—people from throughout the world—flocked to the mines that ultimately stretched more than 120 miles along the mountains. The community and traditions they established influenced much subsequent American mining.

Fortuitously, much of the initial gold in California was on the surface where it could be worked by placer mining, making it accessible to individual miners. Because of its relatively high specific gravity, once gold had washed out of ore-bearing rock it sank to the bottom of streambeds where it could be simply retrieved. Neophyte 49ers sought it by hand, in individual pans where they swirled together gravel and water until only the gold remained behind; or in larger cradles or sluice boxes, called "long toms," where quantities of gravel were shoveled in and then washed out by gravity-fed streams or sluices. Following Saxon and Cornish min-

ing traditions, individual miners, or small groups formed into associations, could stake a claim by right of discovery to a particular stretch of ground. As long as they registered this claim within their community, and continued to work it, they could expect their rights to be respected by other miners. No special licenses or fees were required.

As early as 1850, however, quartz-bearing rock that contained gold was discovered at Grass Valley, California. Here and elsewhere along the so-called Mother Lode, new, more complicated techniques of underground mining were required. In order to extract this ore, deep shafts and drifts had to be dug into hard rock. Ultimately, Grass Valley's Empire Mine (now operated as a state historic site) extended down more than 11,000 feet. Power was needed to provide ventilation in the mines and to haul out the ore. New technology was required as well to process this ore, in order to separate the gold from the surrounding "country rock," which was worthless.

An amalgam process based on Mexican practice was adopted, with huge stamp mills, operated first by steam and later by electricity, to crush the rock. This was then combined with mercury derived from the quicksilver fortuitously produced as early as 1848 at nearby New Almaden, southwest of San Francisco Bay. When the resulting amalgam was heated to distill out the mercury, gold was left behind. Substantial investment capital was required, however, before the production of any gold. Hard-rock, underground mining transformed the California gold fields. No longer the amateur pursuit of an individual, gold mining was now the organized undertaking of eastern financiers, in which miners were merely employees.

Similar changes applied to hydraulic mining, introduced in California in approximately 1856. Here the force of water

was substituted for miners shoveling gravel. Streams were dammed to provide pressure, then channeled into giant hoses with nozzles five or six inches in diameter. These, in turn, were directed at hills 100 to 300 feet high, in order to wash them away entirely into sluices. Not only gold-bearing gravel, but also soil and worthless rock poured down from the foothills to clog the rivers of California's Central Valley, leading to frequent, devastating floods from 1862 on, and to serious impairment of downstream agriculture. In 1884, a U.S. circuit court outlawed the practice, but while it prevailed "hydraulicking," too, required a substantial capital investment to build the reservoirs and sluices, supply the equipment, and pipe the water to the hillsides to be worked. It was a kind of mining few individuals were equipped to pursue.[6]

As the nature of California mining changed, some men found other employment and others went home. A significant number remained, however, inspired by visions of riches. Spurred by the lack of any actual wealth, these "prospectors" traveled throughout the interior West in search of likely rock outcroppings that might indicate the presence of gold. Through their efforts, numerous additional mines were located, including among others the fabulous Comstock Lode of silver in Nevada in 1859, and gold in Colorado, at Blackhawk and Central City, in the same year.

Gold was discovered at Virginia City, Montana, in 1863, and in South Dakota's Black Hills, on the Sioux reservation, in 1874. The latter find was widely reported in the newspapers, and the ensuing stampede of prospectors eventually provoked retaliation from the Sioux, which led in turn to the Custer campaign along the Little Big Horn in 1876 and to a treaty legalizing mining at Deadwood and other camps in 1877. The silver-lead deposits of Coeur d'Alene, Idaho, were discovered in 1883; gold had been mined there since 1879. The biggest Colorado gold discovery was made at Cripple Creek, spurring a rush in 1892. Subsequent excitements brought gold seekers to Alaska in 1898 and Goldfield, Nevada, in 1904. A substantial silver deposit was discovered at Tonopah, Nevada, in 1901.

With them these men and women took the legal and technological practices they had adopted in California and refined over subsequent years. The Mining Law that Congress adopted in 1872 still governs mining on public lands today, despite fierce opposition from environmental groups. Under its terms, hard rock minerals such as gold, silver, copper, and iron can be claimed wherever they are found, upon annual payment of a $100 fee and performance of a specified amount of "assessment work" (currently $500) to maintain it. Once a claimant establishes the existence of a valuable deposit, he or she can purchase the land outright for prices ranging from $2.50 to $5.00 per acre. Patented lands do not have to be mined, and can be sold by their owners, although there is currently a moratorium on patenting of new mining claims, in effect since 1995.[7] Despite early federal attempts in the Wisconsin lead district and elsewhere to impose leasing fees on mineral land, the U.S. government currently collects no royalties or taxes for valuable minerals extracted from public lands.[8]

Precious metals were often the first to be discovered and worked in a region, because they were sufficiently valuable that they would pay the expenses of producing them in remote areas and transporting them to market. By the mid-nineteenth century, with the advent of new technology and more refractory ores, as mining engineer T. A. Rickard well knew, "It [took] money to make mines, especially large mines

needing mills and smelters."[9] Only the richest deposits could hope to pay the necessary expenses of establishing transport routes and processing facilities in addition to paying the miners to locate and take out the ore. Other deposits were too small or too remote, or the ores proved resistant to treatment and were abandoned.

Many of these western mines followed a pattern epitomized by Virginia City. Gold was known to exist there, and a few people were working placer mines in small canyons, but the gold was mixed with a disagreeable, wet, blue material that subsequently turned out to be an extremely rich silver ore (argenite). Once this news spread a rush to "Washoe" began in 1859. Wealth seekers poured in from the California gold fields as well as from the eastern U.S. Unlike California gold, Nevada silver required elaborate processing from the beginning. Early miners adapted the Mexican "patio process" into the "Washoe pan process." In addition to mills to crush and process the ore (which contained both silver and gold), huge engines were required to pump out the water that otherwise threatened to flood the underground mines. The clay-like nature of the ore meant that elaborate techniques were required to shore up the mine walls as the tunnels were blasted. A German mining engineer, Philip Deidesheimer, trained at the Freiburg School of Mines, introduced a method known as square-set-timbering, which allowed the underground tunnels and drifts to follow the sloping vein of silver wherever it led.[10]

From the beginning, the situation was complicated legally. Claims were staked on the surface, but mining occurred underground. California practice provided the basis for Comstock land division. It allowed the person who possessed the apex of a vein—the place where it came closest to the surface—to follow it and mine the ore, even if it extended beyond the boundaries of the surface claim. The ore vein of the Comstock was both broad and meandering, and its underground course was not well delineated. The result is that numerous mines spent all of their proceeds litigating with each other about whether the Comstock Lode was a single deposit of silver ore or a series of distinct ledges, each with its own apex. Lawyers, bankers, and stockbrokers made money, but numerous mining companies were bankrupted in the process.

Aboveground, meanwhile, a familiar boom ensued. The population of the principal settlements, at Virginia City and Gold Hill, went from virtually nothing to perhaps 20,000 people in less than fifteen years. Primitive shacks were replaced by solid brick commercial buildings and elaborate residences, as schools and churches were established and a railroad was constructed over challenging mountainous terrain. A small, complicated city followed the silver underground, with accompanying above-ground support and processing facilities to provide the miners with fresh air in the hot mines, to hoist out the rock they blasted and dug, and to process the ore into silver and gold ingots. Numerous newspapers competed with each other for patronage, and Samuel Clemens wrote for one of them for a time. The place had all the trappings of a settled city, until the mines gave out in the 1880s; then the miners and businessmen moved on, and the fantastic city subsided into torpor.

The pattern was a familiar one repeated numerous times throughout the American West. Unlike agriculture, mining was not a renewable industry. Eventually and inevitably it exhausted the very resource that gave it life. The human communities tied to it were often evanescent. Their con-

tinuation depended on external forces such as global markets for minerals, and on the vagaries of ore deposits that couldn't be accurately forecast without first investing tremendous sums of money. Ores that looked familiar sometimes proved impossible to treat so that minerals could be extracted in paying quantities. Sometimes they disappeared altogether once the ore body was "opened up."

Resident work forces, subjected to the indignities of nineteenth-century capital, responded vigorously, sometimes violently, to attempts to exploit their labor. Both accidents and strikes were common. Mining towns could dry up and blow away—or be packed up moved on to the next location—as quickly as they appeared and for any number of reasons.[11]

Despite the recurrent pattern of boom and bust in individual mining locales, the search for precious metals helped develop portions of the U.S. that might otherwise have remained remote in the course of traditional agricultural settlement. Many places that first attracted attention for gold or silver proved to be much more valuable for other minerals, including the vast copper deposits, in Montana, at Butte; in Utah, at Bingham Canyon; in Nevada, at Ely; and in Arizona, at Jerome, Bisbee, and Globe. Similarly, because mining often made previously remote areas accessible, some historical mining towns—including Virginia City, Nevada; Aspen and Central City, Colorado; and Park City, Utah—have been reincarnated in the twenty-first century as tourist destinations.[12]

The precious metals extracted from western mines helped to pay for the phenomenal industrial expansion of the nineteenth-century United States. As Elliott West puts it: "Gold reconstructed the West and America, physically and mythically."[13] During the nineteenth century, the U.S. rapidly mechanized, drawing on technologies that might have been invented elsewhere, but were eagerly adopted and perfected in America. Grace of gold, and the country's abundant supplies of coal, iron, lead, and copper, Americans produced steel for railroads and steam engines, and fuel to power myriad factories. The country's nearly total mineral self-sufficiency contributed to its emerging industrial primacy.

After the 1856 discovery of the Bessemer process for making steel more cheaply, the demand for iron increased. Fortunately high-grade iron deposits had been discovered along Lake Superior, in northern Michigan, in 1844. These later proved to extend westward into Wisconsin and Minnesota, where the largest and richest—the Mesabi—was located in 1890.[14]

With the Pennsylvania oil boom that began at Oil Creek in 1859, all the elements of American industrial expansion were complete. Petroleum had long been known to exist in western Pennsylvania and elsewhere, floating on the surface of creeks. Because it contaminated the water, it was generally regarded as a nuisance, occasionally skimmed off for use as a lubricant or salve. Only after an improved distillation process was invented in the early 1850s, by Pittsburgh businessman Samuel Kier, did petroleum find a market as a fuel for lamps. Thus, when Edwin L. Drake drilled the first successful artesian well to pump oil, in western Pennsylvania, there was considerable excitement. John D. Rockefeller entered the industry as a refiner, eventually controlled American production, and developed additional markets for petroleum. Oil was rendered into petroleum jelly, paraffin wax, naphtha (a solvent), kerosene, gasoline, and heating oil. Petroleum products became ubiquitous and demand grew.[15]

During the twentieth century, as Americans enthusiastically embraced the affordable automobiles produced by Henry Ford, gasoline gained new importance as a fuel. This rising demand was met by new oil discoveries, including the Mid-Continent Field in Oklahoma, Kansas, and northern Texas in 1892 and the dramatic Spindletop "gusher" in 1901, which revealed the presence of the extensive East Texas field. Other major reserves were located in Wyoming and in southern California's Signal Hills, as well as the North Slope of Alaska's Prudhoe Bay in 1948. Technological innovation influenced the petroleum market again after World War II, with the invention and proliferation of plastics, and the perfection of a pipeline system to transport the natural gas that previously had been a waste product of pumping oil. Once natural gas could be contained and transported, it became desirable as an alternative fuel source that was cleaner and cheaper than oil for lighting and heating.[16]

Legally these fuel minerals developed a status distinct from the precious metals. Coal, oil, and natural gas came to be governed by the Minerals Lands Leasing Act of 1920. In contrast to the pattern established by the 1872 Mining Law, this act imposed both lease fees and royalties, payable to the federal government, which also retained ownership of the public lands from which the resources were extracted. In 1977, Congress passed the Surface Mining Control and Reclamation Act, which applied exclusively to coal mining. By the terms of this act, coal mines are required to reestablish the approximate original contours of any site that is strip-mined, to revegetate it, and to achieve a productive post-mining use for it. No other mineral is similarly regulated at the federal level, although states all impose their own reclamation regulations on mines operating within their boundaries, which mines located on federal lands are obliged to comply with.

Until the twentieth century, coal, iron, lead, copper, gold, silver, oil, and zinc were the principal products of American mining. Without them, as Duane Smith points out, the U.S. could not have become a world power, and they continue to be mined in large volumes in the twenty-first century.[17] Over time, however, new technologies evolved to create new uses for other minerals in the earth's crust, and the scope of American mining broadened accordingly. One example is borax. Used in the nineteenth century principally in glass blowing and gold refining, it was famously associated with Death Valley, California, where it was discovered in 1881, and whence it was hauled with twenty-mule teams. By the twentieth century, however, there were more than 100 industrial processes that utilized borax.

Tungsten, too, became a critical metal only during the twentieth century. Produced in the intermountain West and in North Carolina, it is now utilized as a filament in light bulbs, in electrical machinery, in heat and radiation shielding, dyes, enamels, paints, and for coloring glass. As uses for tungsten multiplied, so, too, did tungsten mines. Titanium, mined in Florida among other states, is used for airplanes and power plants, as well as a white pigment. Like petroleum in the nineteenth century, these and other twentieth-century minerals, including vanadium, magnesium, perlite, bentonite, and bauxite, became commercially valuable and were mined only after new uses were discovered for them.

Among the preeminent examples of a twentieth-century

mineral, valuable because of new technology, is uranium. Produced in Colorado from 1911, uranium enjoyed a significant market only after the invention of nuclear weapons and the consequent arms race that characterized the years of the Cold War. In 1948, the Atomic Energy Commission (AEC) guaranteed a minimum price for all domestic uranium ore, which it needed to manufacture plutonium for bombs and nuclear power plants. In addition, the AEC offered special bonuses for the discovery and production of uranium, as well as subsidies for transportation, a mine-development allowance, and premiums for high-grade ore. Thus encouraged, twentieth-century prospectors went hunting with Geiger counters, which they used to locate huge deposits on the Colorado Plateau and in Wyoming, as well as in Texas and South Dakota. The federal government controlled all uranium sales and its policies thus stimulated, and subsequently suppressed, uranium mining.[18]

American attitudes toward mining shifted uneasily beginning in the late nineteenth century, as both its human and its natural costs became clearer. Twentieth-century America gradually came to place a higher value on both human and natural life, and to object to the consequences of treating land as simply a commodity. In particular, as environmental consciousness grew after Earth Day in 1970, the unmitigated benefits of such minerals were increasingly questioned. Mining was a particularly salient example, because it was so destructive. Early pollution cases—such as the ones that pitted California farmers against hydraulic miners—multiplied as residents questioned the environmental damage done by huge smelters such as those at Salt Lake City, Utah, Bunker Hill, Idaho, and Anaconda, Montana. In these places and numerous others, including the Great

Copper Basin of Tennessee, North Carolina, and Georgia, the years of smoke and chemicals that had been spewed into the air blighted crops, denuded forested hillsides, and left a troubled legacy of health problems. Abandoned coal mines across America are responsible for acid mine drainage that threatens both surface and groundwater, further contributing to a distrust of mining.[19]

Misgivings about mining were not simply a matter of increased American sensitivity to its effects. With new techniques and new technology, the scale of those effects also increased dramatically during the twentieth century. The introduction of huge steam-powered shovels on Minnesota's Mesabi Iron Range, and later in Bingham Canyon, Utah, began a spiral in which ever more colossal machines were devised to dig still more gargantuan open-pit mines. Along with the invention in 1905 of the flotation process for concentrating sulphide ores, these developments made possible the mining of low-grade deposits—such as the ones at Bingham Canyon—that previously would have been uneconomical.[20]

Giant open-pit mines were less expensive to operate than underground mines. This made it economical for mining companies to open new, low-grade ore bodies and to reprocess old tailings piles and areas that had previously been subjected to underground mining. Open-pit mines were also far safer for miners, who were not exposed to the dangers of poisonous gas, falling rock walls, or miscalculated blasting. In modern open-pit operations, few workers are classified as miners. Most drive trucks or operate heavy earth-moving equipment.

But the huge open-pit mines also completely obliterated the existing contours of any landscape they touched. Pro-

cessing tremendous volumes of rock in order to extract microscopic amounts of ore, they created literal mountains of spoil (or waste rock) that had to be disposed of in order to remove the ore. These huge spoil piles, and the tailings ponds of rock mixed with chemicals that result from the actual extraction process, are a ubiquitous sign of modern mining.[21]

Twentieth-century industry's taste for new minerals also presented new dangers. Both asbestos (chrysolite) and uranium introduced previously unknown health hazards into the lives of not only miners, but also nearby residents, with consequences that are still not completely known. By the twenty-first century, then, mining was both more physically conspicuous in the landscape and recognized as more socially and environmentally insidious in its effects. Many Americans agreed with the characterization offered by one modern critic that "Mining in all its various forms—hydraulic, strip, open pit, deep pit, etc.—provide[s] a succinct paradigm for a constellation of activities commonly summed up in the phrase, 'the rape of the land.'"[22]

Such negative attitudes toward mining, as John Stilgoe points out, are venerable.[23] Mining was historically associated with violence against the earth, because the surface soil must be ripped away to get at the minerals concealed beneath. Underground shafts, violently blasted into the earth in order to reach the ore, were characteristically dark, dank, and dangerous. Not infrequently, laborers were conscripted to work in them. Conditions were atrocious. Many workers died, both from accidents and environmental poisons.

In agricultural societies mines were often seen as an aberrant use of the land and miners were scorned. Even before modern mining's abysmal record of environmental pollu-

tion and social exploitation, nothing about the operation of mining seemed benign. The contemporary legacy of polluted and abandoned mining landscapes detailed by Duane Smith only strengthens such negative connections in the public mind.[24]

Furthermore, mining's changes are not limited to the landscape. Mining also radically alters the material that it brings forth, employing arcane sciences in the process. Richard Francaviglia reminds us that mining has always been "inherently magical," because it so completely transforms the substance of the earth. Not all rock is ore, for example, but only a mineral geologist can reliably ascertain the difference. The processing that ore must undergo before it becomes a useable mineral is not only expensive, but also extremely complicated. Metallurgy, and the creation of new metal alloys, require highly specialized knowledge. Smelting and refining recall the complicated recipes by which medieval alchemists once sought to purify lead into gold, and they carry similar diabolical associations in the popular imagination.[25]

Indeed, the realities of mining are often remote and mysterious to the very people who use its products so profligately. As Robert Thayer comments, Americans have a complicated relationship with all technology: "Despite the predominance of technological creature comforts in our everyday surroundings, we often seem uncomfortable in their presence." This is particularly true of mines. According to Thayer, Americans harbor a "romantic predisposition toward farming and rural life."[26] We are a people rendered particularly uncomfortable in the presence of highly conspicuous technologies such as mines, because of their huge scale, and the pervasive changes they make

in the landscape. Although we zealously use the minerals that mines provide, we would rather not ponder the sacrificial landscapes that produce those minerals.

As a result, Americans know relatively little about the places from which their minerals come. Even in the best of circumstances such enlightenment is difficult to obtain. Only sand and gravel pits are ubiquitous. Because the basic construction materials they produce are too bulky and low cost to be profitably shipped for any distance, these mines must be located near the places where their products are to be utilized, in roads and other kinds of construction. They are so familiar that they barely register to most Americans as mines. The same is true for the limestone quarried for use in cement, although even these relatively benign, non-metallic mines are increasingly meeting with public objection because of the dust and noise they create and the dangerous terrain they leave behind them when exhausted.

Metal mines, however, are more imposing and more remote. Both base and precious metal mines are concentrated in the western U.S., frequently in isolated areas where substantial public land and a sparse population make access easier and competing land uses fewer. Coal and oil are more widely distributed, but as working landscapes such mines mostly lack the resources to offer explanation to casual visitors. Historical sites commemorate only defunct, non-working mines. Numerous publications are devoted to particular mining communities or to notable labor conflicts, but explanations of the mechanics of the mining industry, or the intricacies of its landscape, are available primarily in the technical literature. This leaves the novice with no obvious way to apprehend mining's ubiquitous effects on the American landscape.[27]

This book represents our attempt to do so in eight specific locations, some of them contemporary, others historical mining sites. We were concerned not only with the physical changes that have occurred over time, but also with the complex cultural heritage embedded in each locale. Our inquiry focuses on how the generalized activity of "mining" was actualized in individual mines, and with what visual and social consequences.[28]

Mining is an industry that effects landscape change on a geological scale, yet does so within the compass of a single human lifetime. Depending on the market for particular metals or advances in metallurgy or materials science, mines can open, close, and then reopen again. Only rarely is mining a terminal use of the land where it occurs. Depiction and analysis of those successive transformations, and of their multiple implications, is our goal in *Changing Mines in America*. As Richard Francaviglia admonishes, dismissing mining landscapes simply as "wasted" places is a form of visual elitism that prevents an understanding of what such landscapes mean, both to the people who inhabit them and to the society that benefits from them. In our eight sites, we consider mining as one distinct phase of a landscape history, one that has a beginning and an end, either actual or potential. From this exploration no simple narrative of mining emerges; but sometimes, we suggest, there are some surprising chapters along the way.[29]

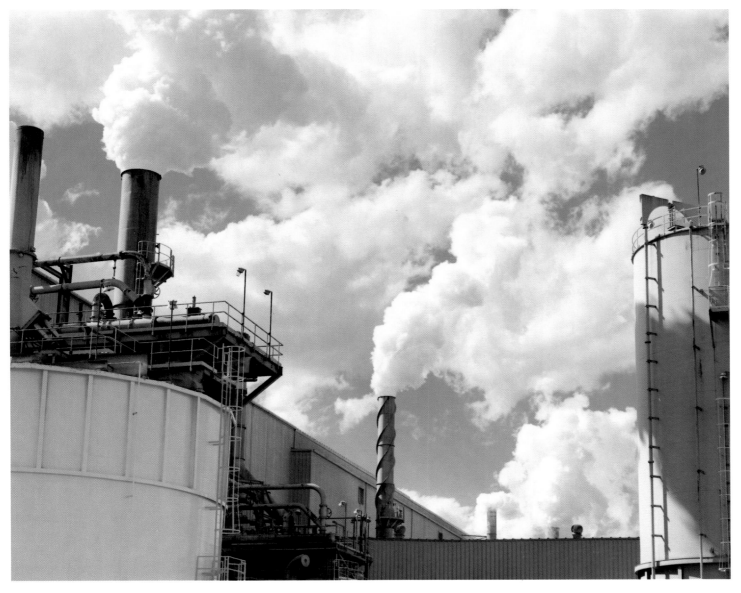

Autoclaves at the Meikle Barrick Goldstrike Mine north of Carlin, Nevada, are pictured here in 1999. This processing plant is part of a complex cyanide heap leaching operation that is able to extract gold profitably from very low grade ores (see chapter 6). Autoclaving oxidizes sulfides in the gold ore, which makes it easier for cyanide solutions to dissolve the gold later in the process. Although autoclaving adds about $14 per ton to the cost of processing, it improves gold recovery from the oxidized ore more than threefold.

In 1987, when this photograph was made, the few trees in this park in Tonopah, Nevada, had been pollarded. The waste rock dumps, clearly visible on the top left, remained at the angle of repose, ungraded and unvegetated.

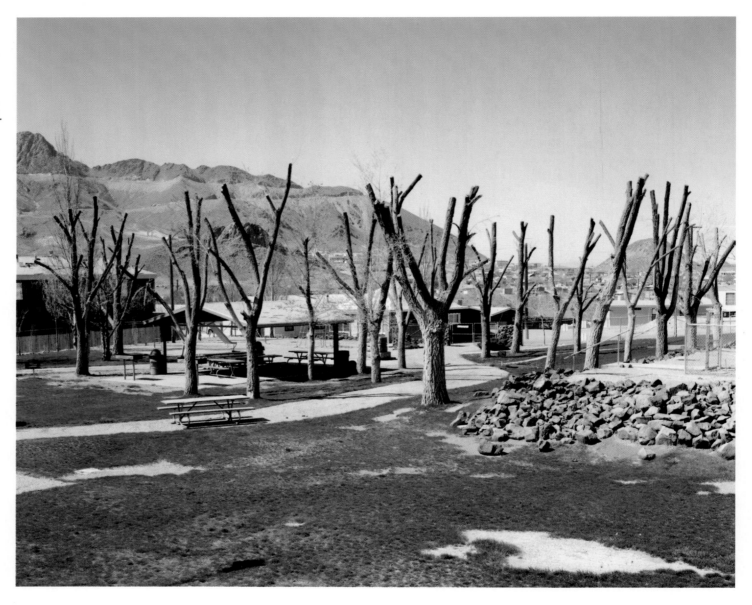

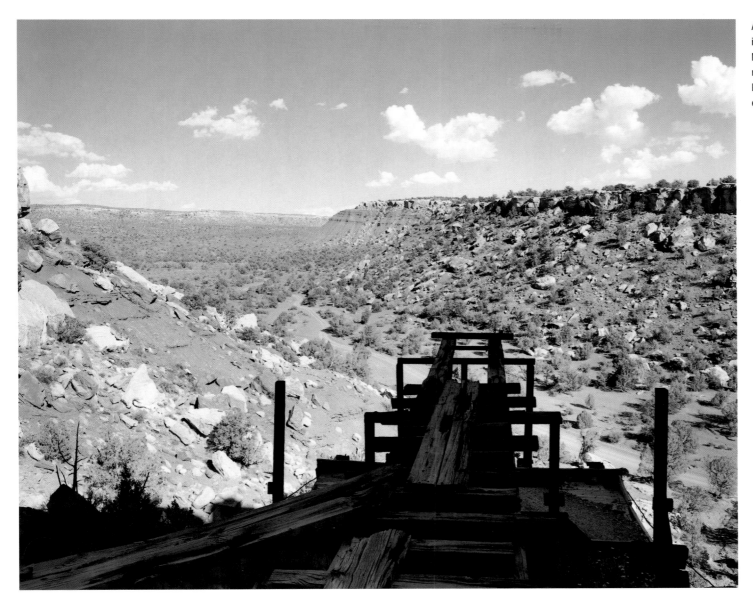

At this abandoned mine site, in Grand Staircase Escalante National Monument, Utah, the remains of extractive industry loom into an otherwise apparently pristine landscape.

Among the most recognizable vestiges of historical mining are ore carts such as this one, on display at the Borax Mining Museum in California. Now sometimes planted with flowers or heaped with decorative rocks in the front yards of homes, these heavy metal carts are mining icons. Like drilling contests, they tangibly evoke the demanding and dangerous physical labor of the mining past.

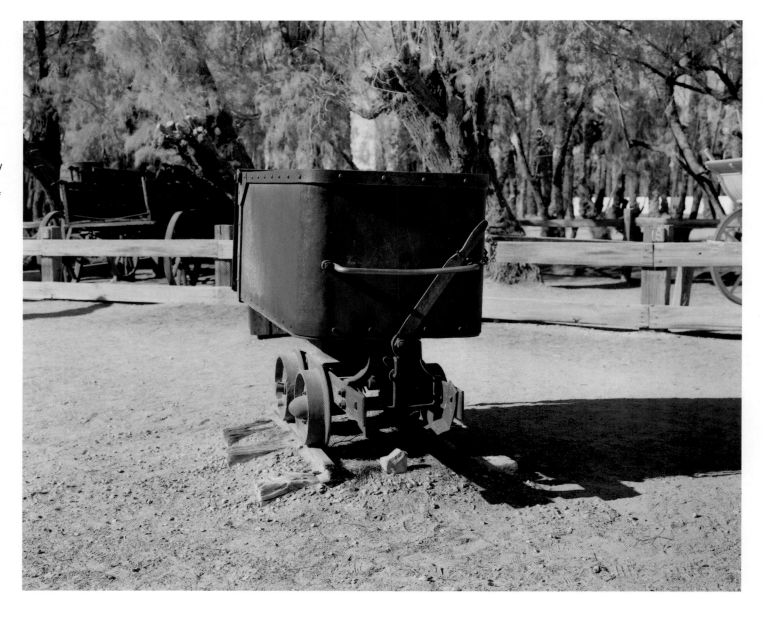

CHANGING MINES IN AMERICA

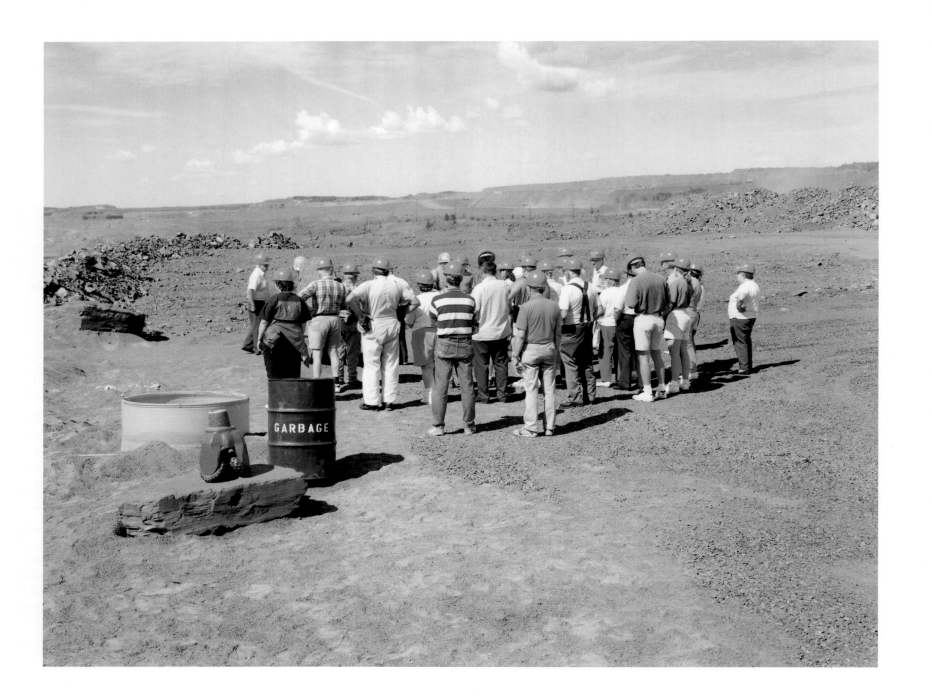

When Lewis Mumford castigated the mining industry in 1934, in *Technics and Civilization,* the Mesabi Iron Range of northeastern Minnesota was one of his examples of all that was wrong:

> Usually pocketed in the mountains, the mine, the furnace, and the forge have remained a little off the track of civilization: isolation and monotony add to the defects of the activities themselves . . . taking mining regions as a whole, they are the very images of backwardness, isolation, raw animosities and lethal struggles . . . from the modern iron mines of Minnesota to the ancient silver mines of Greece, barbarism colors the entire picture.[1]

Mumford's diatribe encapsulates a familiar cultural condescension toward mining—and the landscapes it creates—as blasted and God-forsaken, sinister and vaguely demoralizing in character. A modern commentator would surely add extensive environmental pollution to Mumford's catalogue of mining's original sins.

Yet even as Mumford was condemning them so energetically, the towns of the Mesabi Iron Range were advertising their charms as "a summer vacation center of unusual attractions," including those selfsame mines. This apparent paradox remains at the heart of the Mesabi landscape, where the vestiges of more than a century of iron mining are simultaneously hidden through reclamation and reuse, and celebrated through mining tourism.[2]

The area now known as the Mesabi Range initially attracted Euro-American occupants when its timber began to be exploited commercially during the 1880s. While iron ore was known to exist elsewhere in northern Minnesota, the Mesabi Range was not discovered until 1890, when the long-term prospecting efforts of Lewis Merritt and his eight sons finally paid off.[3] A crew working for the Merritt

A tour group at the MinnTac Mine receives lessons in "instructed seeing" from guide Forrest Koland, who reports that plant workers refer to the tourists as "pumpkin heads" because of their distinctive orange helmets. The tourists occupy an uneasy position as leisured visitors in a working landscape, where they must be taught to understand industrial operations that workers take for granted.

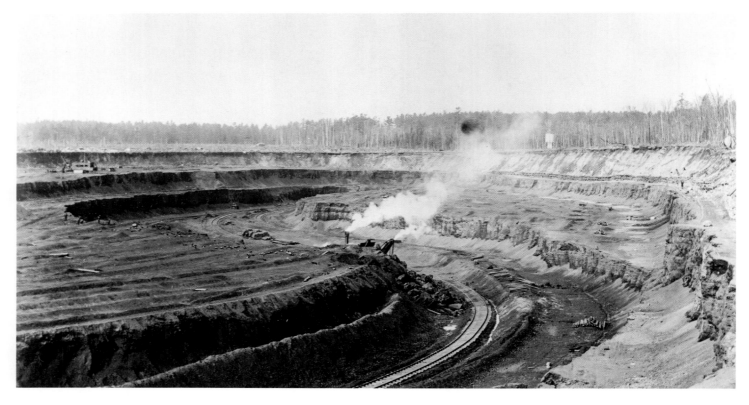

The Mahoning Mine was photographed in September, 1899, in the earliest stages of iron mining on the Mesabi. Note the steam shovel and railroad tracks in the pits and the extensive forest still visible at its edges. After subsequent mergers, this became part of the Hull-Rust-Mahoning mine now celebrated as the largest open-pit iron mine in the world (see pages 16 and 24). *Photograph courtesy of the Minnesota Historical Society, in St. Paul.*

brothers uncovered the ore after the wheels of their heavily loaded wagon cut into the soil at what is today Mountain Iron, Minnesota, to expose a rich, red hematite that was sixty-seven percent iron and so soft that it could be shoveled without blasting. The Merritts had spent years in search of the deposit they believed to lie in the vicinity. By virtue of this spectacular discovery they briefly became millionaires, controlling forty percent of the Mesabi (although they eventually overextended themselves and lost all of their holdings on the range).[4]

The deposit they had discovered fully justified their years of searching. It was the largest area of the purest iron ore then known, one of the largest deposits anywhere in the world. Ore stretched for a distance of approximately 115 miles, ranging from two to ten miles in width, and up to 600 feet in depth. After an initial struggle by metallurgists to find ways of using the soft Mesabi ore in their blast furnaces, it proved to be the foundation of the thriving U.S. steel industry. As an 1892 railroad company prospectus crowed, "We need not worry about the market for Missabe ores, for this is the age of steel."[5]

The Merritts' discovery set off a sensational iron boom as miners and railroad companies rushed to gain access to the huge deposits. Initially some underground mining was pur-

locator and property owner who participated in the process, observed in retrospect that "few areas in the United States have been so completely altered by man."[20] Yet the modern observer might entirely miss that fact, unless he or she knew that the region was initially almost flat, and that the ubiquitous hills, now increasingly covered with trees, are products of mining.

In the process of such reclamation, visual reminders of

of containerized seedlings to speed growth of trees planted on waste dumps. Areas revegetated through IRRRB efforts are proudly identified with signs to distinguish them from areas of natural regrowth (see page 28).

The implicit premise of such environmental restoration is that the Mesabi landscape, despite the massive upheaval to which it has been subjected, can and should be made to appear more "natural." Edmund Longyear, a pioneer mine

These views of the Mountain Iron Mine are only three years apart, in 1959 and 1962, respectively. Because of the high water table in the area, mines required constant pumping. Once the pumping stopped, they filled naturally with water. Some of these pit lakes now serve as municipal water supplies or are stocked with fish for recreational and commercial use. The natural ore is inert, and poses no pollution dangers by its presence. Taconite processing, by contrast, involves more complicated and controversial waste disposition strategies. Photographs by Paul Shafer (left) and E. D. Becker (right), both courtesy of the Minnesota Historical Society.

Iron mining and processing thus continue to be important elements of the regional economy, even as it has massively transformed the physical environment. Yet, as the state government of Minnesota cheerfully notes in its guide to minerals: "Mining is a *temporary* use of the land."[16] In many parts of the Mesabi, mining is over for the foreseeable future. Only its vestiges remain, in the form of ore dumps and pit lakes. A salient question for the Mesabi, then, is what kind of use *can* follow a pit mine? Just exactly how *does* one recycle a mining landscape?

Responses to such questions are embedded in the physical landscape, and also in the various promotional and framing devices that surround it for public consumption. Tour guides and visitors' brochures now formulate the Mesabi landscape alternately as a technological wonderland or a recovering natural area. An industrial theme park, Ironworld Discovery Center, maps the Mesabi as a kind of historical food court, where immigrant cultures are manifested as distinctive costumes and cuisines. Photographic images suggest an intriguing range of meanings attributed to the mining landscapes of northeastern Minnesota.

These meanings, in turn, are informed by differing assumptions about the cultural role of mining and about place. As Doreen Massey has pointed out: "The identities of places are always unfixed, contested and multiple."[17] Where Lewis Mumford found backwardness, Mesabi residents took pride in a transformed landscape and the hard work that it incorporated. They celebrated their union victories over recalcitrant companies and their stubborn survival in a place with frequent layoffs and "so much iron ore dust you can't tell when a thing is rusting."[18] Workers exulted in the magnificent public schools built with mining tax dollars.

Mining companies, on the other hand, advertised their mines as tourist sites, monuments to capital and engineering. In explaining their industry, they boasted of production figures, safety records, equipment size, and environmental commendations. Both views—and all their permutations—have visible consequences in the landscape. They are manifest in the various forms of landscape recycling currently evident on the Mesabi Range, including both environmental restoration and industrial tourism.

As has always been true on the Mesabi, the fortunes of local residents rise and fall with those of the U.S. steel industry. When operations slow because global demand for iron flags, the local economy and workers bear the brunt. Citizens of the Iron Range have been preparing for many years for the ultimate cessation of iron mining. In 1941, the state created the Iron Range Resources and Rehabilitation Board (IRRRB), "for purposes of developing the resources of any county in the State in which distress and unemployment existed by reason of the removal of natural resources and the increase in unemployment resulting therefrom."[19] Funded by taxes on the mining industry, this public entity has been active in promoting economic development in the region. Reorganized in 1977, its Mineland Reclamation Division is charged with both reclamation and recycling of the unused mine dumps and pits that remain from natural ore mining.

The IRRRB constructs boat ramps, develops wildlife habitat, reshapes ore dumps for use as industrial sites, fences off abandoned mines, and plants trees. It helps to beautify the highway entrances into the various communities of the Mesabi. After disappointing results with bare-root planting, the division developed an innovative system

ists who financed it and the miners who did the physical work—literally refashioned the contours of the earth. John Caddy describes the scale of that transformation in "The Color of Mesabi Bones":

The mine-dumps dwarf houses on the outskirts
of towns, foothills of gravel and rock dropped
first by glaciers, draglined and trucked
from the open pits. Above them brood
the worn gigantic breasts of the Giant's Range,
oldest earth, the blasting shaking even this.[11]

Their handiwork was admired by novelist James Gray, in 1945:

An open-pit iron mine is like a man-made canyon, smaller than a great natural phenomenon, of course, but having the same kind of lurid color scheme, the same design and shape. It looks almost as though the hot interior of the earth had just begun to cool into various shades of yellow, brown, ocher, orange, and purple-black. The sight is the more impressive when one realizes that man has created the whole scene.[12]

The region's iron ore deposits seemed inexhaustible when first discovered. A steadily growing appetite for steel, however, combined with the tremendous defense needs of World War II, soon diminished the supply of the red hematite known as *natural* ore (because it required minimal processing). Natural ore mining on the Mesabi ceased during the 1990s. While this marked the end of a mining era, it did not signal cessation of all iron mining in the district. The range still contains significant deposits of a low-grade, hard rock form of iron ore called taconite.[13]

Foreseeing the exhaustion of the natural ore, and spurred by 1941 Minnesota legislation that encouraged development of low-grade ores, companies such as U.S. Steel began in the 1940s to subsidize research to find a way to utilize taconite. The low percentage of iron in this gray rock, ranging from fifteen to thirty-five percent, had caused it to be scorned by earlier generations. It was more difficult to mine than the red natural ore, requiring blasting, not just shoveling; and it couldn't be utilized in existing blast furnaces. In the words of one retired miner: "It was in our way, and we hated it."[14] After considerable experimentation, it was demonstrated that the ore could be used if it were first crushed and concentrated, then processed with bentonite (a type of clay) and baked into pellet form. It had the added advantage of not freezing in the winter, so that it could be mined year round.

Mesabi companies began to invest in taconite mining and processing after a 1964 tax concession from the state. This came in the form of a constitutional amendment guaranteeing that, for a twenty-five-year period, taconite would be taxed at a rate no greater than that for any other industry in the state. Thus reassured, mining companies invested in the expensive processing plants required to prepare low-grade taconite for market and the life of the Mesabi operations was indefinitely extended. The Minnesota Taconite Mine Company, operator of the Minntac Mine pictured in the image that opens this chapter, employed more than 1,500 people in 1998. Minnesota is today the largest producer of iron ore and taconite pellets in the U.S., but also suffers the environmental consequences of taconite tailings that have been dumped into the waters of Lake Superior.[15]

By now, the Mesabi Range has been mined intensively for more than 100 years. Geologists estimate that at least 100 more years' worth of taconite ore still remain in reserve.

sued, but most mining on the Mesabi was by the open-pit method. After removing the overburden of soil and gravel (which might be ten to 200 feet deep), the soft, earthy ore was dug out, at first by individual miners and later by massive steam-powered shovels. It was loaded into railroad cars for shipment to harbors on Lake Superior whence it could be transported to the steel mills of the industrial heartland. Techniques developed to mine iron on the Mesabi were later used effectively in open pit copper mines in Bingham Canyon, Utah, and Bisbee, Arizona.[6]

The town of Hibbing, Minnesota, became the principal commercial center of the Mesabi district, but numerous other mining communities came and went as railroads were built and mines were dug. Some of the more evanescent towns, called "locations," were company owned and controlled. Others, such as Virginia, Eveleth, and Mountain Iron, were independent settlements, where individuals owned surface rights to the land. Most were populated largely by European immigrant workers who arrived to do the hard physical labor of digging and shipping the iron ore. Some had earlier experience in the copper mines of northern Michigan. It was a population and an industrial economy vastly different from the rest of agricultural Minnesota. School teacher Polly Bullard recalled that there were no old people in Eveleth when she came to teach there in 1908, and almost every child in her third-grade class was foreign-born.[7]

Mining on the Mesabi was seasonal work. From January through April, when the Great Lakes and the ground were frozen, ore could not be shipped to the industrial centers where it was processed into steel, so mining slowed or ceased. Miners supplemented their income with hunting, fishing, and the produce they raised on small plots of land.[8]

Despite occasional financial crises, including the Panic of 1893 that forced the Merritt Brothers into bankruptcy, industrial exploitation of the range progressed rapidly. Andrew Carnegie, James J. Hill, and John D. Rockefeller all bought Mesabi properties, and large parts of the range were eventually incorporated by J. P. Morgan into the U.S. Steel Corporation, formed in 1901. Other landowners, including the Pillsbury, Bennett, and Longyear families, retained title to land that they had initially purchased for its timber, and leased it to Mesabi mining companies. Whatever the mechanism, large fortunes were being made or augmented by producing and shipping iron ore from this rich new deposit. The physical consequences for the landscape were equally striking. As a regional history observed:

Once such wealth was discovered, the face of the land changed irrevocably. In only a few years the magnificent virgin forests of red and white pine and spruce were gone, leaving miles of stump-littered, barren hills. Gaping red canyons were gouged out of the land, the lean ore dumps forming man-made mountains.... Nowhere else in the nation have such changes of such magnitude occurred as quickly.[9]

The remains of these pits, and the accompanying hills composed of discarded overburden (removed in order to reach the ore underneath) or noneconomic ore (not rich enough to process, but possibly useful in the future), characterize the landscape of the modern Mesabi. Their use and modification reveal the landscape, as W. J. T. Mitchell has urged, "as a cultural practice, not merely symbolizing but embodying cultural power."[10]

On the Mesabi, the iron industry—including the capital-

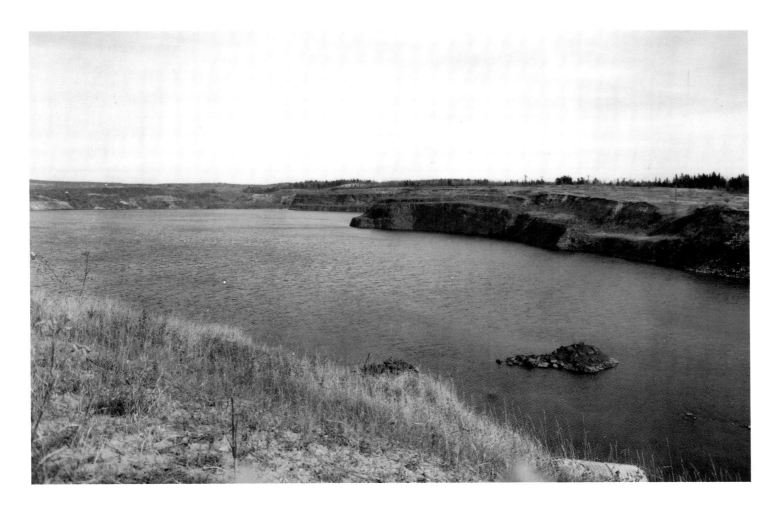

the working landscape are disguised and the visual legacy of Mumford's "barbarism" is slowly effaced. There is a certain irony, for example, in the fact that one of the most exclusive residential districts in modern Hibbing is located on an old ore dump from the Hull-Rust-Mahoning Mine.[21]

Minnesota takes justifiable pride in having been—in 1980—one of the first states in the U.S. to require comprehensive reclamation for iron ore and taconite mines. The Iron Mining Association of Minnesota extolls the IRRRB's reclamation work, pointing to the uses of abandoned pits as fishing lakes, municipal water supplies, wildlife refuges, and tourist attractions. Their brochure boldly claims that "mining is an asset to Minnesota's tourism industry," and they applaud their stewardship of the Mesabi environment.[22] The Iron Mining Association promotes a vision of the modern Mesabi as virtually indistinguishable—at least eventually—

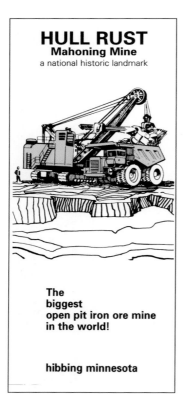

factured' landscape of dramatic topographic features unique on this continent," complete with "man-made mountains and buttes." It recommended that these features, rather than being destroyed, should be "exploited as tourist attractions."[23]

In this realm, too, the IRRRB has been active. It has financed various mining displays and in 1977 established Ironworld Discovery Center, an iron industry theme park and research center in Chisholm. Ironworld features a restored trolley imported from Australia, a Hall of Geology, ethnic food kiosks, mining equipment displays, remote-controlled ore boats that children can steer, a homestead demonstration area, genealogical and historical displays, and interactive exhibits focusing on the history of mining. Its location is marked along the highway by the eighty-one-foot Iron Man statue erected in 1987. The latter is identified with admirable precision as the third-largest free-standing memorial sculpture in the U.S. (after the Statue of Liberty and the St. Louis Arch).

Hibbing, meanwhile, promotes visitorship at the Hull-Rust-Mahoning mine complex, notable as the world's largest open-pit iron mine. A visitor's pamphlet distributed there recommends the view from the observation complex, which shows "the vast pit more than 3 miles long, up to 2 miles wide, and 600 feet deep."[24] The rhetoric of the pamphlet, and the tourism it promotes, depends on qualities of gigantic size, scale, and ambition delineated by historian David Nye as part of the American technological sublime.[24] These qualities are most often represented visually for tourists by mining equipment of enormous size. In particular mining truck tires seem to be a universal metaphor for the scope and complexity of modern mining. Displays throughout the Mesabi dutifully record statistics on the dimensions, weight, and cost of the trucks and other pieces of historical

from its original character as part of Minnesota's North Woods. In this massive restoration project, technology is employed to mask its own effects in the landscape, rather than to perpetuate its achievements.

Industrial tourism, by contrast, celebrates the presence and the transformational impact of humans. It enshrines the massive steam shovels and trucks that were the tools of creating the present artificial landscape, and builds viewing platforms for the huge abandoned pits, insisting on their inherent human interest. A 1964 recreational survey of the Mesabi range, commissioned by the Minnesota Department of Business Development, made much of this resource, "a 'manu-

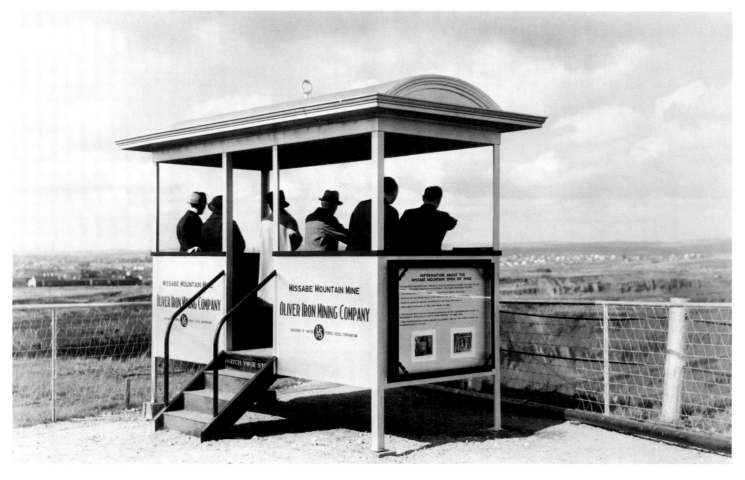

Visitors to the Oliver Mining Company's operations on the Mesabi in 1937 enjoyed viewing facilities remarkably similar to those provided today (see page 24). *Photograph by E. D. Becker, courtesy of the Minnesota Historical Society.*

equipment that are exhibited. The viewer is thus encouraged to marvel at the immensity of the enterprise rather than its mixed social and environmental consequences.

In Mountain Iron, where the Merritt family initially discovered the Mesabi iron deposit, the Minnesota Taconite Company now conducts daily tours of its low-grade taconite mine and processing facilities. MinnTac bills itself as the largest taconite plant in the world, supplying Midwestern steel mills with the hardened pellets that have replaced natural ore. But rendering iron mining appealing in twenty-first century U.S. requires considerable effort and imagination. Where the landscapes are unnatural, but technological, modern tourists need substantial instruction in order to comprehend their import, to be persuaded that there is anything appropriate to see.

Mining tourism is not new to the Mesabi Iron Range. It

At a loss to convey the huge scale of modern open-pit mining, companies often display pieces of the gargantuan machinery they use. This 1950s-era publicity photo provides models to give a sense of the huge size of the bucket used to remove overburden. A display in Mountain Iron, Minnesota, provided a modern counterpart in 1996 (see page 25). *Photograph courtesy of the Minnesota Historical Society.*

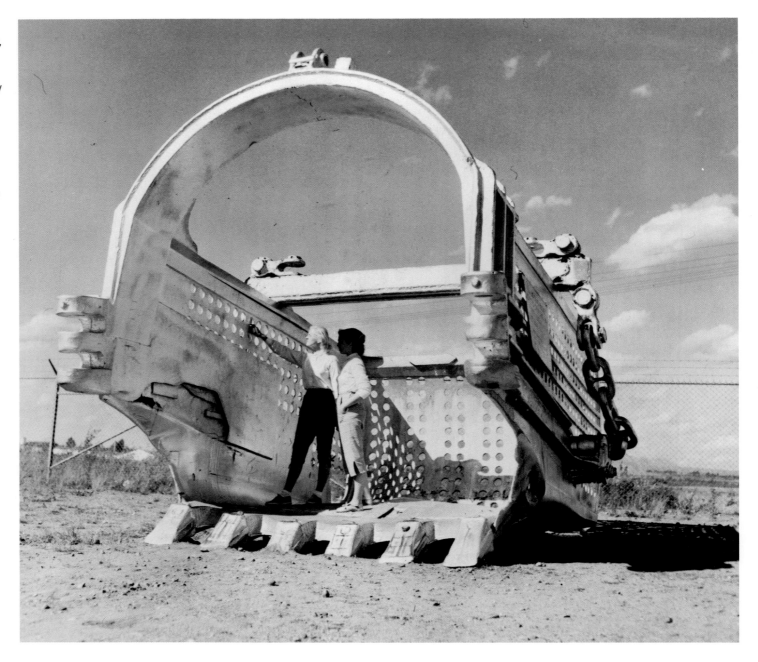

was being promoted locally as early as the 1920s. Facilities necessary for visitor comprehension, in the form of viewing platforms and interpretive text, were in place by the 1930s (see page 11), and the Minnesota Division of Publicity was staging photos to promote mining tourism in the 1950s (see facing page). Success was elusive. It remains difficult to find visual appeal in abandoned iron pits and waste dumps, and modern awareness of mining's environmental consequences promotes ambivalence. Tour guides and framing devices can only help to mark views that remain cryptic for the uninstructed visitor.[25]

Mining operates on numerous levels simultaneously on the contemporary Mesabi. It is actively pursued in operating taconite mines. Its historical past is commemorated in parks and roadside displays. Through reclamation activi-

ties, it is erased visually from the landscape. Simultaneously it is promoted as a tourist activity. Manifest in this single terrain, then, are a number of competing landscape identities for mining. Though they jostle insistently against each other, no one of them prevails over the others.

Technology works both to create this landscape *and* to obliterate it in the interests of a more "natural," forested version. Residents and visitors encounter the same space within different perceptual contexts, so that its history may be vivid and immediate to one group but abstract and institutional to another. One group relaxes in another's working space, as the memory of ethnic tensions and labor unrest is expunged from the recycled landscape. As a case study the Mesabi Iron Range confirms the observation of Stephen Daniels that "any apparently simple picture of a country scene may yield many fields of vision."[26] On the Mesabi, the apparently empty ore pits are anything but.

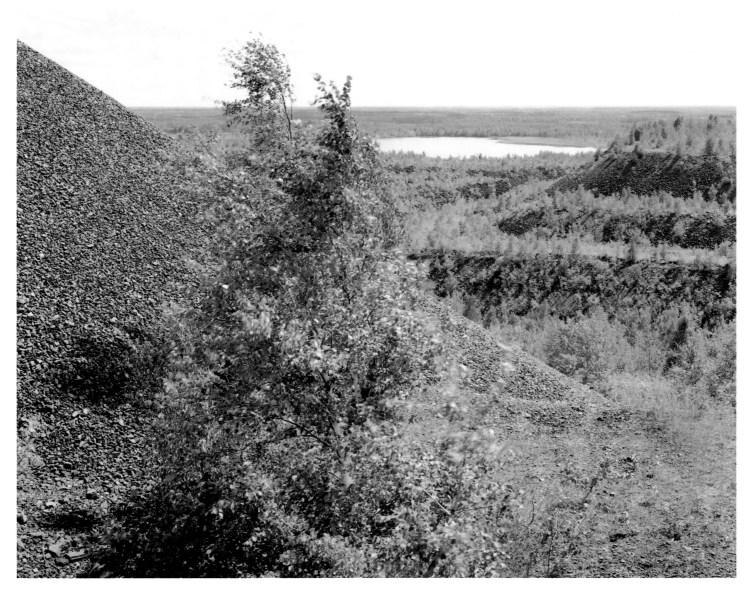

This 1996 view between Hibbing and Chisholm includes reclaimed and abandoned rock dumps. Over time both kinds begin to blend back into the hillocky contours of the surrounding terrain. Volunteer vegetation is sparser but more diverse than that on reclaimed sites. Reforestation makes it difficult for the uninstructed observer to see the dumps as unnatural landscape features.

Seen here c. 1940, the Hull-Rust Mine was on its way to becoming the behemoth that operates today as the Hull-Rust-Mahoning. Note the town of Hibbing, visible in the distance at the edge of the growing pit, and the ubiquitous railroad tracks. Although the techniques of open-pit mining have not changed substantially, modern mining on the Mesabi and elsewhere now relies on trucks and conveyors rather than railroads to transport the huge volumes of ore and waste rock. *Photograph courtesy of the Minnesota Historical Society.*

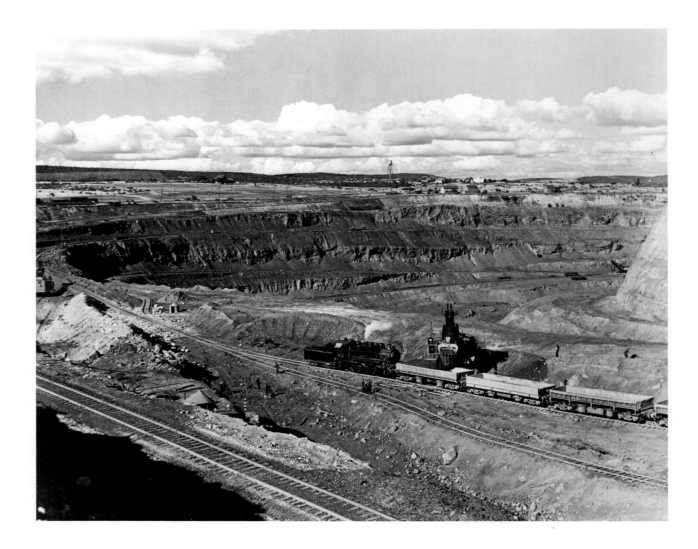

This photograph depicts the site of North Hibbing, Minnesota, located at the edge of the pit seen on page 16. Hibbing was a mining boom town founded in 1893 as a collection of tents, tar-paper shacks, and log cabins. By 1910, it was a bustling community of 16,000 people, but the Oliver Mining Company held most of the mineral rights beneath the town. As the demand for Mesabi iron increased, the company expanded its operations to surround Hibbing on three sides. Property owners complained about blasting and noise. The company began to buy up surface rights in 1918, and built a new business district two miles to the south. Numerous buildings were moved, most by 1922. The old townsite was then called North Hibbing. Ultimately only about one third of it was mined. The remainder—complete with the remains of curbs and foundations—has become a city park, which nestles incongruously alongside the mines that created it.

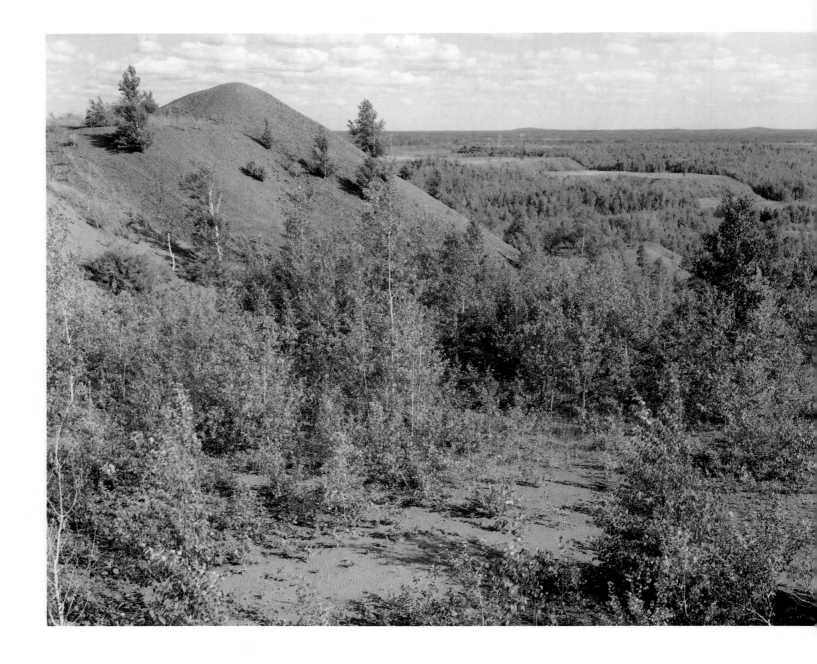

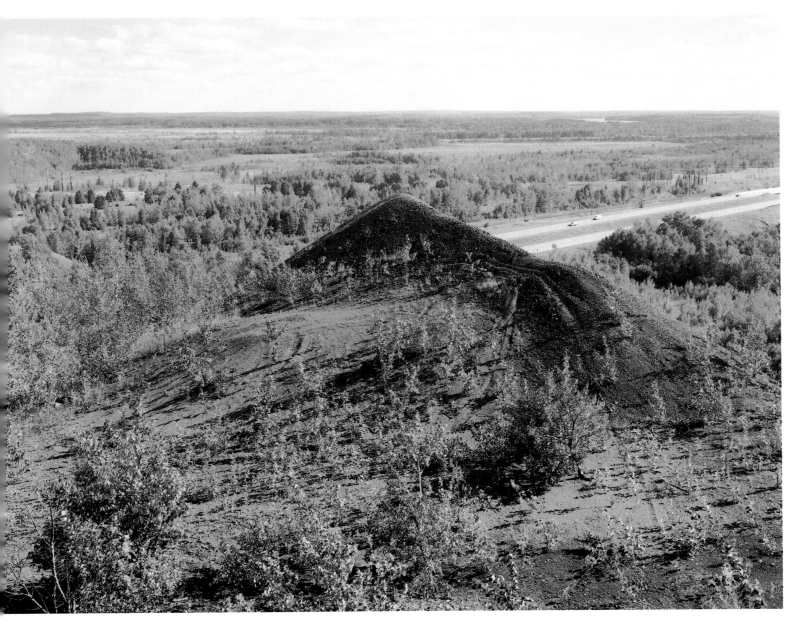

Viewed from above, the waste rock and overburden of a typical mined landscape near Little Fork stand out as prominent features of a generally flat landscape. Depending on their contents and the demands of the market, stockpiles such as those visible at the left in this panorama may be reworked to extract additional ore, recontoured for use as building sites, or revegetated to look more natural. Although they may appear to be permanent landscape features, not all of them are.

In this stark view, made in 1978 near Little Fork, Minnesota, volunteer revegetation has barely commenced. The conical shape and artificial contours of the piled rock reflect its human origins.

(opposite) In a 1996 view in the same area, natural revegetation continues slowly. Still dominant is the color of the natural ore, which writers and artists have recorded for decades as characterizing the Mesabi.

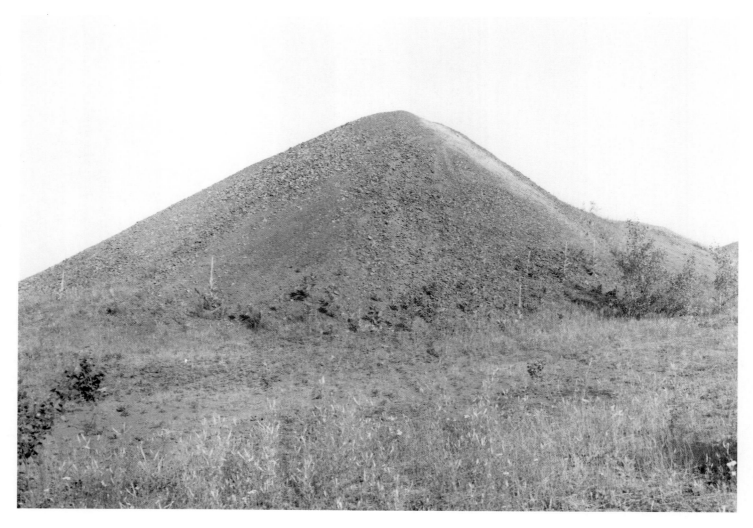

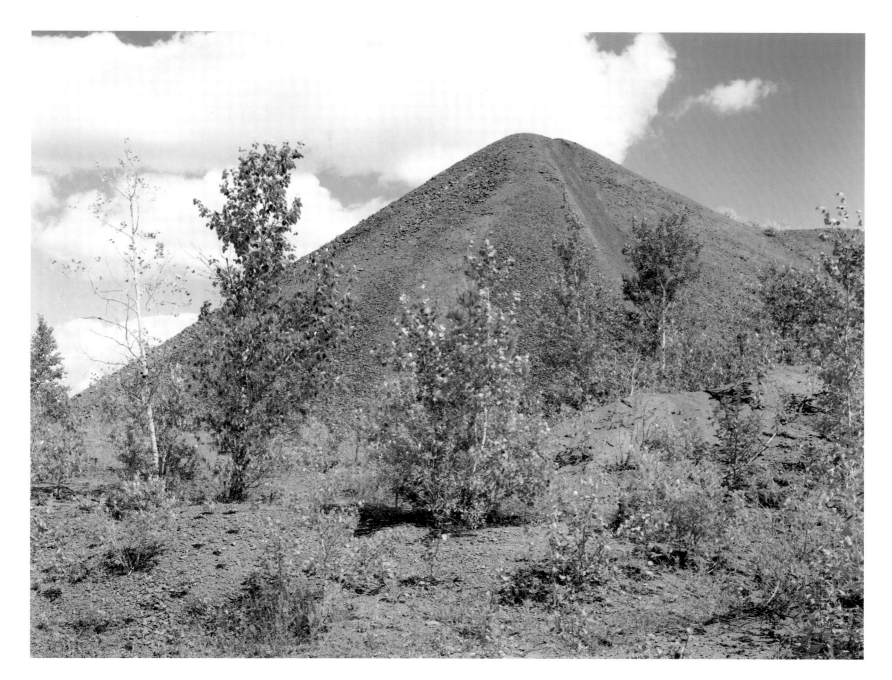

These two views depict the same site, between Hibbing and Chisholm, at an eighteen-year interval. The black-and-white photograph is from 1978, the color image from 1996. The roads in the foreground of the latter view are evidence of the incorporation of these landscapes into local patterns of recreation and commerce. Some provide access to power lines; some are used by hunters, snowmobilers, berry pickers, and others who access the recycled mining landscapes in order to pursue their favorite leisure activities.

23

Contemporary mining tourism on the Mesabi is facilitated by means of this viewing platform at the Hull-Rust-Mahoning Mine in Hibbing. From it is visible the largest open-pit iron ore mine in the world, which the Hibbing Visitors' Guide celebrates as "a monument to the ingenuity—and just plain hard work—of man." The mine is still being operated by the Hibbing Taconite Company, which celebrated its centennial in 1995. During the late 1990s the pit was again being pumped in order to get access to ore formerly rejected as low-grade.

The massive scale of mining equipment is a common theme of mining tourism. Rendering the technological sublime, comprehensible through the trope of the huge tire, the accompanying signs proudly recite statistics about the size and weight of the equipment. Paired with the ubiquitous giant tire to the left, this Amsco bucket is large enough for several grown adults to stand upright inside. The 1996 photo is from Mountain Iron, the original discovery site of Mesabi iron.

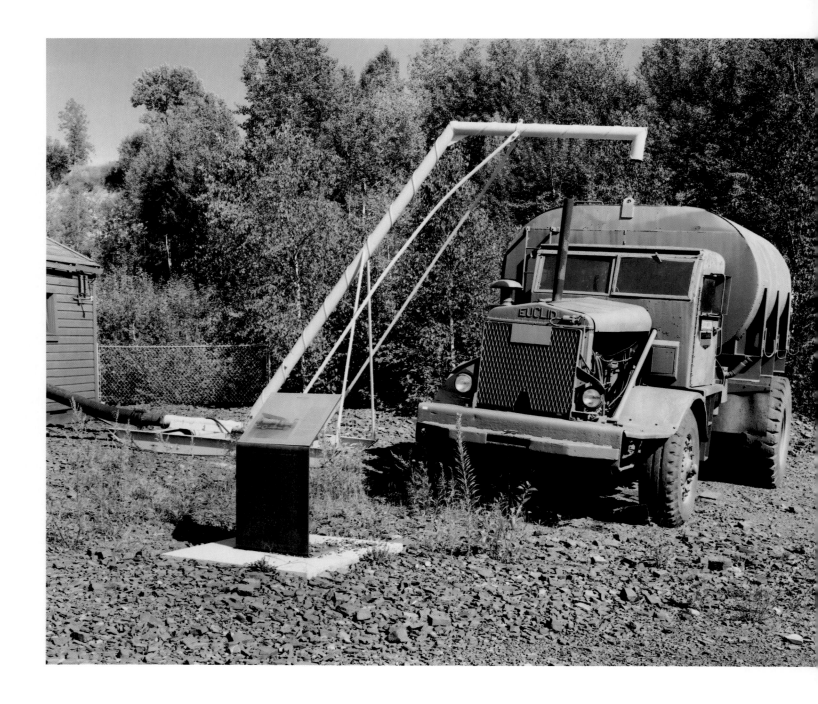

This display is part of the Glen-Godfrey Mine display at Ironworld Discovery Center, in Chisholm, Minnesota. The scene combines commemorative, educational, and recreational functions in a landscape specifically interpreted for tourists. A restored trolley transports visitors to this site on the grounds of Ironworld. A sign at the left explains the necessity for constant pumping of water at Mesabi mines, and the role of the pump house and water truck in keeping a pit clear of water. Water removed from the mines was used to keep down dust on haul roads. Since the cessation of mining, the Godfrey-Glen pit has filled with water. It is now pointed out to visitors as a scenic site along the trolley route. Despite the apparatus of tourism, the picnic table at the right implies a recreational potential otherwise not immediately apparent at the site.

The tax-supported Iron Range Resources and Rehabilitation Board (IRRRB) reclaimed the Judson Pit, which is barely visible in the background of this 1996 photograph. It is now maintained by city of Buhl, Minnesota. The sign carefully distinguishes this reclaimed area from other naturally, and more sparsely, revegetated iron mining landscapes.

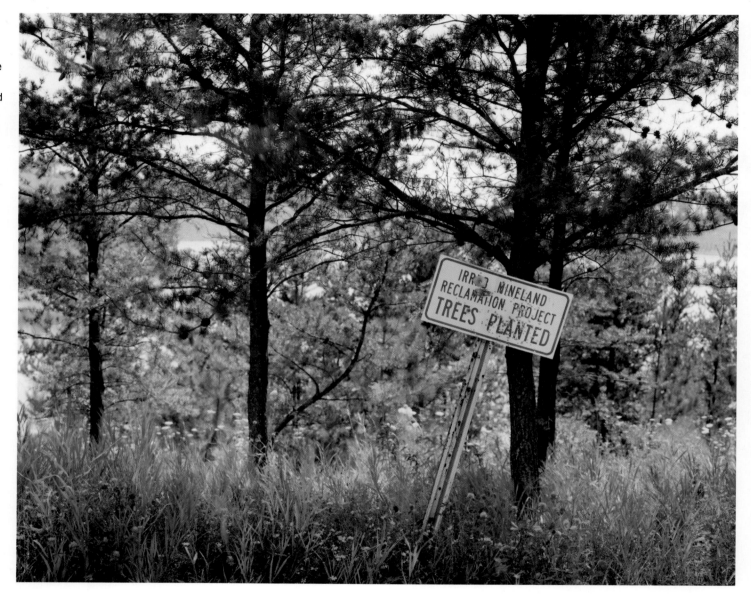

Mining tourism has its dangers. At some sites, visitors are protected by means of required hard hats. The Old Town Mine view in Virginia, Minnesota, employs a different strategy. There a caged-in lookout protects sightseers from a potentially threatening landscape. The visitors are overlooking a massive, thickly revegetated pit that is no longer actively mined.

At the Pellet Peter miniature golf course in the Ironworld Discovery Center, a recreational landscape mimics the technological one beyond the gates of the theme park. This hole features a scaled down waste dump that displays the characteristic red color of the natural ore stockpiles. The theme park commemorates the heritage of mining as its actual practice slowly disappears from the Mesabi landscape. Within its gates, however, the only hazards are those of the game.

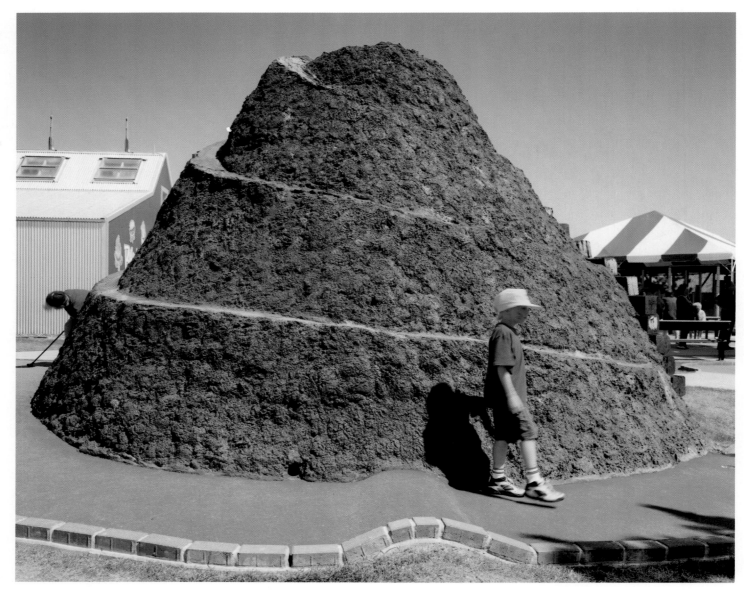

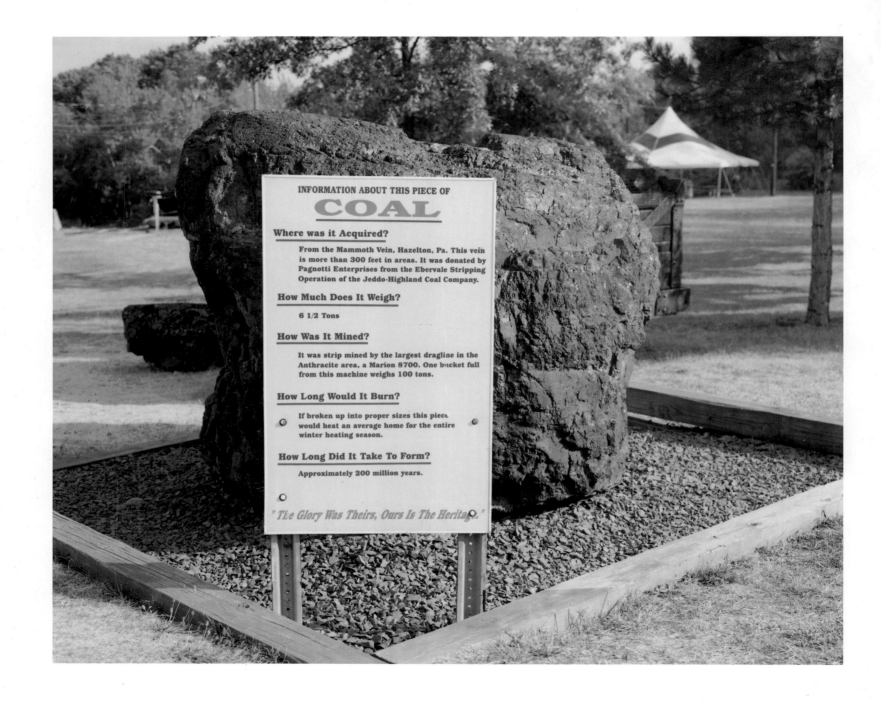

INFORMATION ABOUT THIS PIECE OF

COAL

Where was it Acquired?

From the Mammoth Vein, Hazelton, Pa. This vein is more than 300 feet in areas. It was donated by Pagnotti Enterprises from the Ebervale Stripping Operation of the Jeddo-Highland Coal Company.

How Much Does It Weigh?

6 1/2 Tons

How Was It Mined?

It was strip mined by the largest dragline in the Anthracite area, a Marion 8700. One bucket full from this machine weighs 100 tons.

How Long Would It Burn?

If broken up into proper sizes this piece would heat an average home for the entire winter heating season.

How Long Did It Take To Form?

Approximately 200 million years.

"The Glory Was Theirs, Ours Is The Heritage."

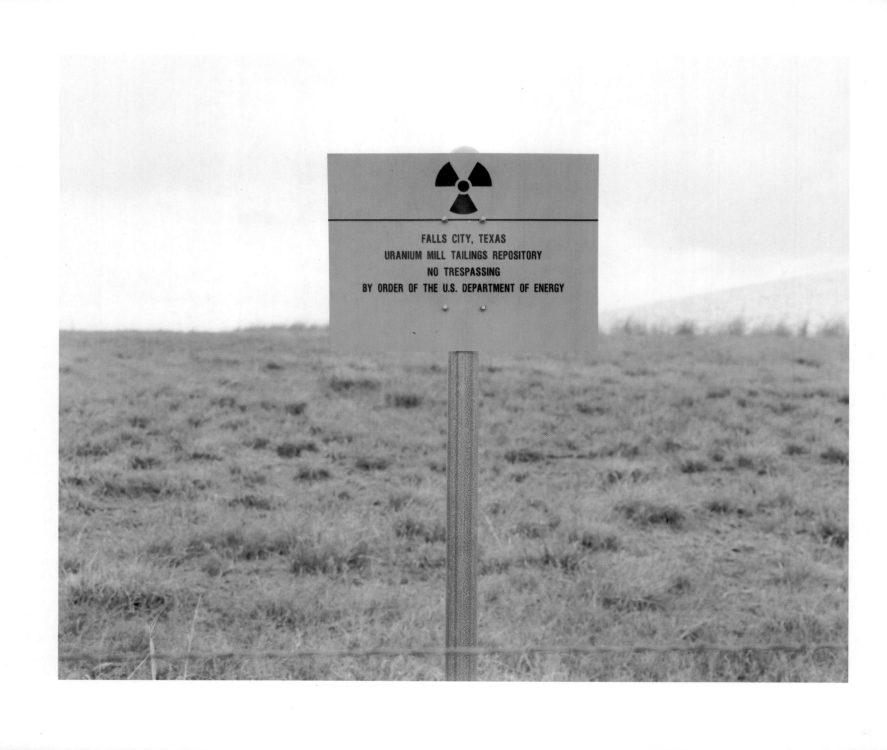

"Nobody Around Here Glows"
Uranium's Ambiguous Aftermath in Karnes County, Texas

When uranium was discovered on the coastal plain of South Texas in the fall of 1954, it was an unlikely place to look. Uranium deposits were well known in western states where the post-World War II uranium boom was already peaking, and prospectors had searched without success in the similar terrain of West Texas. But uranium was discovered in Karnes County by accident, when an oil company pilot noticed elevated levels of radioactivity while scouting for the liquid fuel.

Geologists spread out across the county to follow up on the pilot's lead. Within a year they had identified a belt of uranium deposits in south-central Texas that was 190 miles long, and the Texas uranium boom was on. The Atomic Energy Commission (AEC) opened a branch office in Austin in 1955, and the state Bureau of Economic Geology's pamphlet on uranium prospecting went through four printings in six months.[1]

Karnes County is at the center of the coastal uranium belt in Texas and contains the bulk of the mines and processing facilities. Open-pit mining of oxidized ore began there in 1959 and effectively ceased in the early 1980s, with the collapse of the uranium market in 1984. Between 1980 and 1990, the state of Texas estimates that uranium accounted for more than $1.5 billion of gross revenue in this otherwise poor part of the state.[2] Now that uranium mining has stopped, however, some of its costs are becoming clearer. The Susquehanna-Western processing plant (one of three in the county) has been designated as a Superfund site by the Environmental Protection Agency (EPA). Amelioration will be a matter of centuries. Although the mined areas are far less concentrated radiation sources, they, too, require special consideration.

All the more ironic, then, that this is also an area of where active and visually effective reclamation of the landscape effectively disguises its danger. Indeed, due to the efforts of the mining companies themselves (for mines operated under state permits after 1975) and the Texas Railroad Commission's Surface Mining and Reclamation Division (for

Signs such as this one, at the Susquehannah-Western UMTRA uranium reclamation site, are intended to warn the public away from the uranium tailings, but they do little to make the hazards of radiation visible in the landscape.

mines operated before 1975), the contemporary Karnes County landscape appears particularly benign. Waste piles are being recontoured and revegetated. Mine pits are filling with water to become stock ponds. Even massive tailings piles left over from uranium milling operations begin to blend into the large, open countryside that surrounds them when they are planted with inconspicuous grasses. Only to the initiate is there visible evidence of mining in this landscape, let alone the long-term legacy of increased radioactivity that accompanies the mining and processing of uranium.

In Karnes County the success of reclamation efforts in restoring the landscape to a visually pleasing appearance is ultimately paradoxical. This is a place where the long half-life of radium (1,600 years for radium 226, far longer for uranium 238) decrees environmental vigilance for centuries to come, yet it is also a place where concerted efforts to obscure traces of mining in the landscape have been remarkably successful. Future generations will have to depend on extremely subtle visual markers to understand the potential dangers of this apparently bucolic landscape.[3]

The uranium ore in South Texas occurred in shallow deposits. The deepest unoxidized ore pits were approximately 300 feet deep, and most were shallower. This ore was easy to strip and mine, and amenable to milling. Because little of the land in Karnes County was publicly owned, mining companies had to make arrangements with private landowners. Some sold their land outright. Others leased the mineral rights for a period of time, then took possession of the land again once it was reclaimed. The vagaries of the geological structure meant that some landowners in this rural community had viable uranium deposits while their neighbors did not. The infusion of uranium money into the local economy created sudden wealth for some but jealousy for others, who accused the more fortunate of "selling out." Even some landowners who had uranium on their property were disappointed when market fluctuations made it uneconomical for companies to extract and thus pay for the uranium after families had been uprooted from their homes.[4]

The uranium business was always volatile. The first phase of demand peaked during the early 1960s, when U.S. government uranium purchases declined. The Susquehanna-Western Mill, which opened in 1961, closed down in 1965, when the AEC had already departed from Austin. In 1965 the government of West Germany contracted to buy Texas uranium and business picked up again. The Susquehanna-Western Mill reopened and was enlarged, processing the uranium ore by acid leaching to produce the dried "yellowcake," or uranium oxide, that was the end product of Karnes County mines.[5]

Impetus for expansion of the mill included an improved nuclear reactor design in 1966, which promised to make nuclear fission competitive with fossil fuel. This created a private market for uranium to be used in power generation and helped spur further mining. In 1971 a second mill, the Conquista, operated by Conoco, was opened in Karnes County to accommodate the increased output from these new mines.

As concerns about nuclear power generation mounted and reactor projects met local opposition, that market, too, contracted. The Susquehanna-Western Mill ceased operations in 1973, and a partnership began reprocessing its tailings to extract any remaining uranium in 1977. That

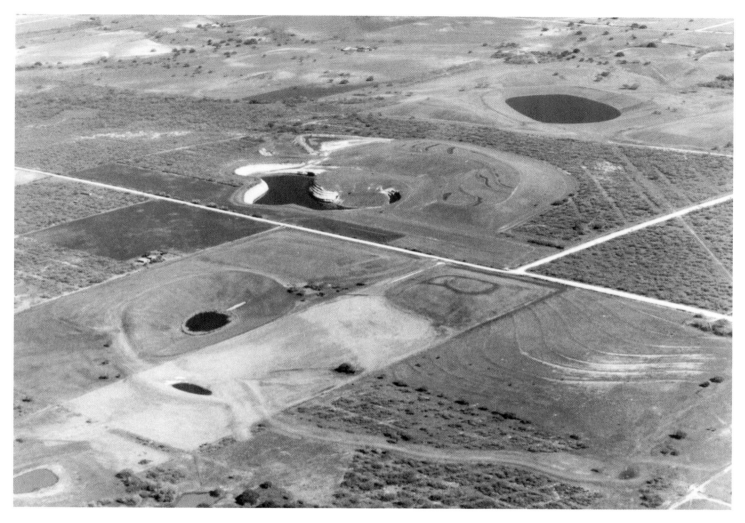

This 1986 aerial view illustrates the uranium landscape of Karnes County. Unlike western mines located on public land, most of the land in Karnes County was privately owned when uranium was discovered. Because of the nature of the deposits, mines were generally small and limited to property controlled by a single owner. They were known by the names of the property owners. The mines visible in this photograph are, from back to front, the Franklin, Brown, and Dickson-Pawelik. *Photograph courtesy of Texas State Railroad Commission, Surface Minerals Division.*

phase ended in 1982, when the site was covered with eighteen inches of topsoil and revegetated. Ultimately there were seven different tailings piles at Susquehanna-Western, and the affected property encompassed more than 700 acres.

Meanwhile, the energy crisis of the 1970s, created in part by reductions in Middle Eastern oil production, served to revive the fortunes of Texas uranium for a third time. Prices went from $8 per pound in the 1960s to $43 per pound in 1978. Uranium prospecting picked up again, new properties were leased or purchased, and Chevron opened its Panna Maria Mill in 1979.

This third uranium boom, too, quickly subsided. Cheaper

Canadian and Australian uranium flooded the market in response to higher prices, and the popularity of nuclear power generation reached new lows in the United States after the nuclear accident in 1979 at Three Mile Island, near Harrisburg, Pennsylvania. The Conquista Mill shut down in 1982, and the mill structure was dismantled and deposited in the tailings pond in 1983. The uranium market crashed altogether in 1984, and since then only reclamation activities and residual processing have taken place in Karnes County.[6]

During each of the three waves of uranium mining in Karnes County, the landscape was affected. Pits that averaged 135 feet in depth, 300 to 400 feet in width, and 1,000 feet in length were excavated on private land to remove some fifteen million tons of ore. Processing plants created huge, unlined tailings ponds of radioactive waste materials. By some estimates, 1,000 tons of this waste were generated in order to produce a single ton of saleable yellowcake. While unstable soil meant that there was little underground mining in Karnes County, by the 1970s some of the uranium was extracted by an *in situ* leaching process. This involved injection of aqueous solutions to strip the uranium (and trace minerals such as molybdenum, selenium, and arsenic) out of the ground. While leaching creates no pit or mill tailings, imperfect recovery of the injected solution means potential groundwater pollution.[7]

Responsibility for addressing these alterations varies by date and nature of the activity. Reclamation of uranium mining sites has been required by Texas state law since 1975. The Texas Surface Mining and Reclamation Law requires restoration of mined land only to "substantially beneficial use," and not necessarily to its original characteristics. Any mines operated after 1975 are required to file an acceptable plan for reclaiming the site to these standards and to post bonds to ensure its completion. Mines abandoned prior to 1975, however, are the charge of the state. Both permitted mines (with a reclamation plan) and abandoned mines (operated prior to 1975) are administered by the Texas Railroad Commission's Surface Mining and Reclamation Division. This agency began an environmental inventory and prioritization of abandoned mines in 1988, and reclamation work is currently ongoing. Various state agencies are involved in monitoring and addressing long-term effects of uranium mining.[8]

The Karnes County land affected by mining is dry brush country, where the predominant plants are mesquite, live oak, prickly pear cactus, and dryland shrubs. Typical land uses include production of livestock and feed crops. Some land is also leased for hunting. Because surface water is rare in this region, abandoned mine sites are particularly desirable to landowners. Most uranium pits intersect the groundwater table, so they fill with water that provides a welcome permanent water source for livestock and other animals. Although at least one mine site has been restored without a water feature, most landowners are eager to have the waste rock piles graded and the pit walls stabilized so that they can use the resulting ponds (see pages 70-71). Although use of these artificial lakes for recreational or irrigation purposes is not recommended by the state, residents report catching and eating fish that have been stocked in them. Distilling one side of local opinion, a woman resident defiantly reported, "Nobody around here glows."[9]

For permitted mines, reclamation plans follow a standard pattern, including five years of required monitoring post-restoration, before the site is returned to the landowner. The

general procedure is to mine with eventual reclamation in mind. The topsoil is removed and stockpiled near the site. Then the overburden (nonuranium-bearing rock) that is scraped from the pit before reaching ore is stockpiled separately. When mining at the site is completed, the overburden is graded and the pit backfilled as necessary to stabilize its walls. Any toxic overburden (uranium-bearing rock that is not removed for processing) is isolated at the bottom of the pit and covered with non-radioactive rock. The entire site is then covered with the stockpiled topsoil and planted.

A reclaimed ecosystem isn't instantaneous, however. It takes time to establish the necessary microorganisms and insects in soil that has been sitting for years. Generally, two cycles of cover crops (either oats or millet) are planted before any attempt is made to plant permanent grass. Feral pigs wreak havoc with this system because they feast on the seed produced by the cover crops.[10]

Mechanisms are similar for the abandoned mines, although the landowner must give permission before restoration can begin. Fifteen "abandoned" sites were being reclaimed in Karnes County during the late 1990s. Once the work is completed, the state may place a lien on these properties so that its costs can be recovered at the time of sale. For this reason, or others, some landowners have not given permission for reclamation to proceed on their property.[11]

Even where reclamation is ongoing, the abandoned mines don't always enjoy the luxury of properly stored topsoil and overburden to work with. Sometimes topsoil must be obtained from "borrow pits" on adjacent land. In this case contractors take half the soil (approximately six to eighteen inches from an average depth of one to three feet) to restore the reclaimed sites. Revegetation on sites without topsoil is less successful, and studies also reveal increased radiation at such sites.

Uranium mills, by contrast, generate not only more, but also more complex wastes, and reclamation of these sites is administered differently. Congress passed the Uranium Mill Tailings Radiation Control Act (UMTRA) in 1978 to address restoration of abandoned uranium mining facilities, but only for sites that sold uranium directly to the government. In Karnes County this means the Susquehanna-Western Mill, which operated only from 1961 until 1973 (although tailings were reprocessed subsequently). After 1976, when uranium could be privately sold, states became responsible for overseeing environmental remediation at these sites. Thus, both the Conquista and Panna Maria mills are regulated by the State of Texas.[12]

Because of the serious and long-term potential danger of these sites, environmental monitoring is expected to be necessary for centuries, rather than years. The Susquehanna-Western Mill was designated a Superfund site by the EPA because of the severity of its pollution. Not only ninety acres of tailings ponds but also more than 700 acres of adjacent land were found to be contaminated, and groundwater was also polluted by runoff. Although the site plan addressed the contaminated soil, UMTRA did not promulgate standards for groundwater until 1995, so potential groundwater pollution initially received little attention.

Because the existing quality of water in Karnes County was not high, devising appropriate and technologically feasible standards for remediation was a difficult task. No agency seemed eager to tackle it. The initial Department of Energy (DOE) plan relied on the idea that the aquifer would eventually flush out contaminants naturally, although this process might take 100 years. Presently the strategy adopted by DOE relies on five years of monitoring the

movement of polluted groundwater both on and off the Susquehanna-Western site. Because the tailings have been consolidated into a single "disposal cell" that is isolated from groundwater contact, the agency's operating assumption is that no further contaminants will enter the aquifer. Therefore, the only action planned at present is to monitor any changes in the three currently identified plumes of contaminated water. After the initial five-year period, in 2003, the State of Texas, the Nuclear Regulatory Commission, and the DOE will confer further about appropriate steps to take.[13]

The problem at the mill sites is not simply uranium, although mill tailings may contain as much as ten percent of the uranium originally present in the ore before it was processed. When the uranium is exposed to the air and then leached with sulfuric acid or other solvents, it releases more dangerous radionuclides, including radium 226 and 222, and thorium 230. Each of these can become airborne in the dust blowing from exposed tailings, dissolve in water, or be absorbed by plants that grow in (or into) contaminated ground.

In addition, trace elements such as arsenic, molybdenum, selenium, and vanadium are also liberated by mining. They spread through the water and are absorbed by plants that are, in turn, ingested by livestock and other animals. Elevated levels of molybdenum caused an outbreak of molybdenosis in Karnes County cattle during the 1970s. Because molybdenum blocks absorption of vital copper, the animals developed symptoms of a copper deficiency: loss of hair color, poor growth, anemia, weight loss, bone abnormalities, diarrhea, and sterility. While the cattle can be treated with a copper supplement to compensate for the excess molybdenum, consequences for humans who consume the beef or milk are unknown.

The puzzle of designing adequate measures for uranium mill reclamation is further complicated by the activities of the operating companies. Not only did processing methods change over time, but often the radioactive tailings contain wastes other than those from uranium processing. At Susquehanna-Western, for example, the contaminated mill buildings were destroyed and incorporated into the tailings ponds. At Conquista the operating company essentially acted as a hazardous waste disposal site. After the mill stopped operating, the company accepted a variety of materials from other producers, including rare-earth refining wastes that are both chemically different and much more radioactive than uranium mill tailings. The result is a situation demanding more complicated containment strategies than would be necessitated by uranium wastes alone.[14]

Nonetheless, within the limits of available science and the constraints of economic reality and environmental policy debates, reclamation of the mill sites continues. Contaminated soil and tailings are aggregated into huge piles that are now among the most prominent high points in this generally flat county. Yet, their long-term safety is not at all clear. Leakage from the tailings has been detected at all three mill sites. At Susquehanna-Western a two-foot clay liner and a series of holding ponds and rock-lined drainages are designed to contain and safely dispose of any rainwater that does make contact with the waste; but the efficacy of even these measures is uncertain, and strategies to keep the sites isolated and the monitoring intact for the required centuries until the radioactivity begins to dissipate seem inadequate.

In addition, as the excitement and possible wealth of the boom period recedes into memory, other potential health concerns multiply. High levels of radium, uranium, molyb-

denum, and selenium have been detected in the soil; but the initial Texas Railroad Commission survey of abandoned mine sites did not measure the radium isotopes that "have the greatest potential for producing radioactive doses of consequence to man" (although the Commission does conduct site characterization studies before reclamation begins, in order to dispose properly of particularly radioactive spoil).[15] Due to the presence of uranium in the ground, background radiation levels have always been high in Karnes County. Now it is difficult to determine with certainty what kind of additional danger, if any, has been created by uranium mining and milling.

In 1988 the Texas Department of Agriculture prepared a list of the potential negative effects of the uranium industry. While individually negligible in impact, they collectively constitute a sobering list:

What is of concern here are the multiplier effects of uranium strip-mining; in-situ mining in drinking water aquifers; spray-irrigation with radioactive wastewaters; open-air storage of radioactive and hazardous materials in tailings piles and ponds; crop cultivation and cattle raising on uranium- and radium-exposed lands; use of radioactive materials in construction; and transportation of ores and uranium products through the area.

Despite much speculation, and the best efforts of environmental science, much about the post-uranium-mining situation in Karnes County is simply unknown. In 1988 there was definitely radium in the Karnes County milk supply, but no one knew what the levels had been like *before* mining began. Residents nervously inventory individual cancer cases, but no epidemiological study has yet revealed a statistically significant increase in cancer rates.

Many fear that decades of uranium mining and processing have rendered the Karnes County landscape toxic, but no one is quite sure where to look for hard evidence or how long the search should last. Indeed, the scientific basis of current federal standards for radiation exposure remains under debate. Radioactivity is ubiquitous in Karnes County, but its presence is revealed visually only by a few discrete markers, and its historical levels are unknown. Meanwhile, as Panna Maria resident Andy Rives reports: "We have developed a community awareness that the uranium industry is not a benign industry. It does more than tear up the earth and leave big holes behind."[17] For the moment, however, no one is exactly sure how much more. Contradictions abound in the Karnes County mining landscape. The long-term legacy of uranium mining and milling will emerge only slowly, while visual reminders of the industry that produced it are rapidly and efficiently being expunged from the landscape.

Traces of uranium in the Karnes County landscape are difficult to discern, and will likely grow more so as time passes. This majestic live oak, a perfect pastoral icon, is located at the Susquehannah–Western UMTRA uranium reclamation site. Because the live oak is a deep-rooted species, some express concerns that it may be transporting radiation to the surface despite its innocuous appearance. Authorities with expertise in the area think the possibility unlikely, given the combination of soil texture and pH in this particular area, and the fact that most of the oak's feeder roots are likely to be near the surface. Such reassurances, however, can't alleviate the fears of those who blame illnesses on uranium mining and processing.

To the uninitiated, there is little evidence of uranium mining in Karnes County. This marker at the Susquehannah–Western Uranium Mill Tailings Repository Act (UMTRA) uranium tailings-basin reclamation site resembles a headstone and is meant to provide a permanent record of what went on in this landscape. It is unlikely to be meaningful except to an expert. It reads: FALLS CITY, TEXAS / Date of Closure—February 9, 1994 / Dry Tons of Tailings—7,143,100 / Radioactivity—1,277 Curies, RA-226.

Radioactive tailings from the uranium processing sites are theoretically isolated from the environment by means of liners and rock caps, although groundwater infiltration and contamination remains a serious concern. Depicted here are the isolated tailings pile and rock drains at the Susquehannah-Western UMTRA uranium reclamation site.

Two kinds of reclamation are taking place in Karnes County in the aftermath of the uranium boom. Individual uranium mines are being reclaimed by the State of Texas and returned to property owners. The more seriously contaminated uranium processing sites, however, require restriction from public use for periods of time ranging from 200 to 1,000 years. They are under the purview of the Department of Energy. This understated "Authorized Personnel Only" sign is located at one of the latter. The photograph looks northeast at the Susquehannah–Western UMTRA uranium reclamation area where the uranium processing plant was located.

Known locally as "Jesus of the Mines," this statue of Jesus Christ faces east on 200 acres once occupied by the Brown Mine. The property was purchased as a ranch and homestead in 1996 by Arturo Molina, who uses water from mine-monitoring wells to irrigate the squash, melon, and cantaloupes that he grows there. The statue is made of concrete, and came from Saltillo, Mexico. In fact, it has nothing to do with the mines. According to Molina it was erected at the suggestion of a Mexican worker he employed. The worker thought that the slope, which has been artificially constructed out of waste rock, or spoil, would look good with a statue on it, so together they journeyed to Mexico to get one. The three-tiered base was constructed on site, and the entire assemblage is seven to eight feet tall.

When mining is finished the empty pits naturally recharge with water and become watering holes for both domestic and wild animals. Reclamation efforts are directed in part at insuring that the water is not unduly contaminated by radiation. Residents use the resulting permanent water holes for fishing and recreation as the abandoned boat at this reclaimed uranium pit testifies.

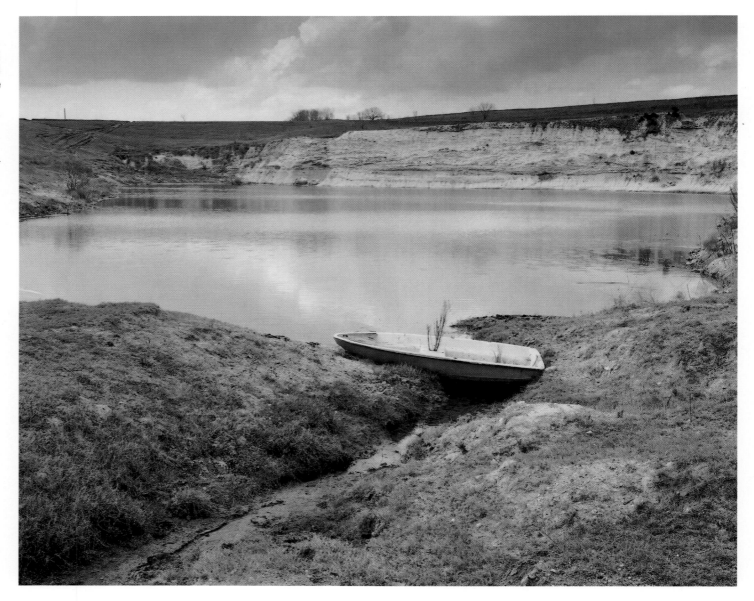

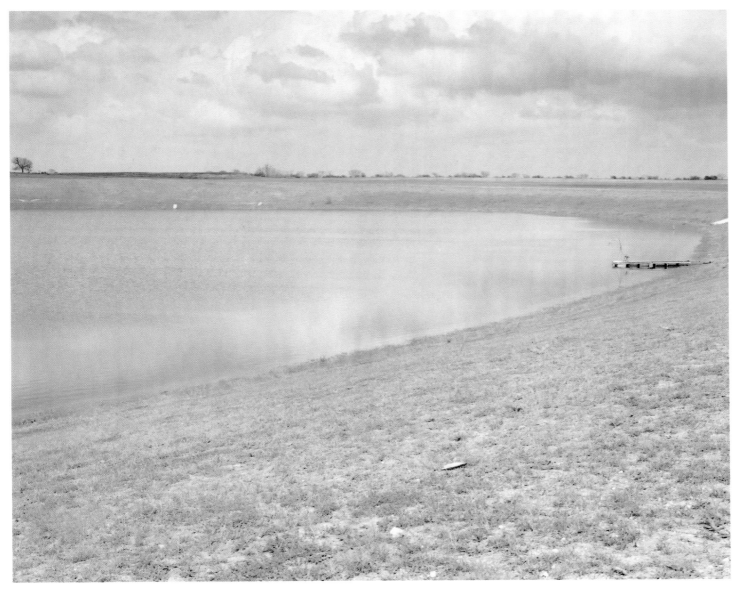

Here the property owner has built a dock for his transformed uranium pit. Natural water features are few in the coastal plains landscape and property owners welcome the addition of permanent ponds. Although the water is unfit for human consumption, it is judged safe for livestock and for limited recreational uses. Some residents report consuming fish that have been stocked in these "pit lakes."

This parasite-laden tree is in the Mueller Cemetery, located at the intersection of county roads 207 and 211, in Karnes County. Local informants report that a mine across the road extracted uranium from beneath the cemetery, but preserved the surface and the graves.

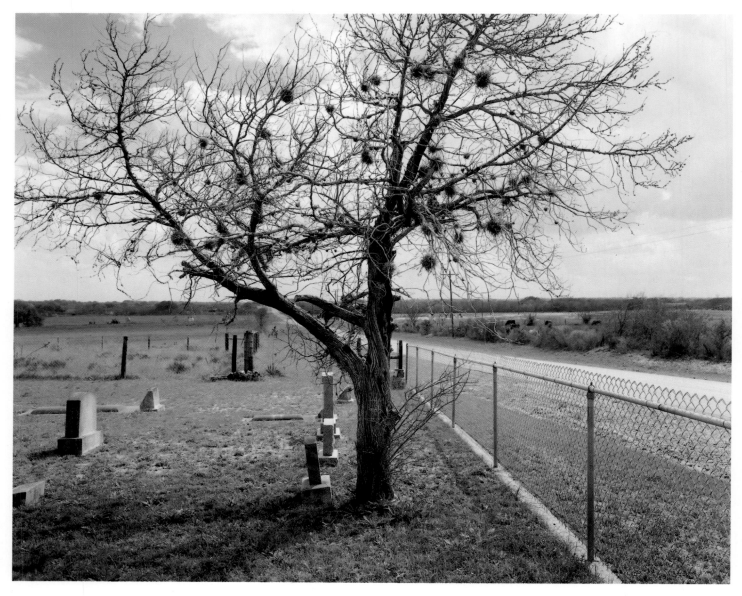

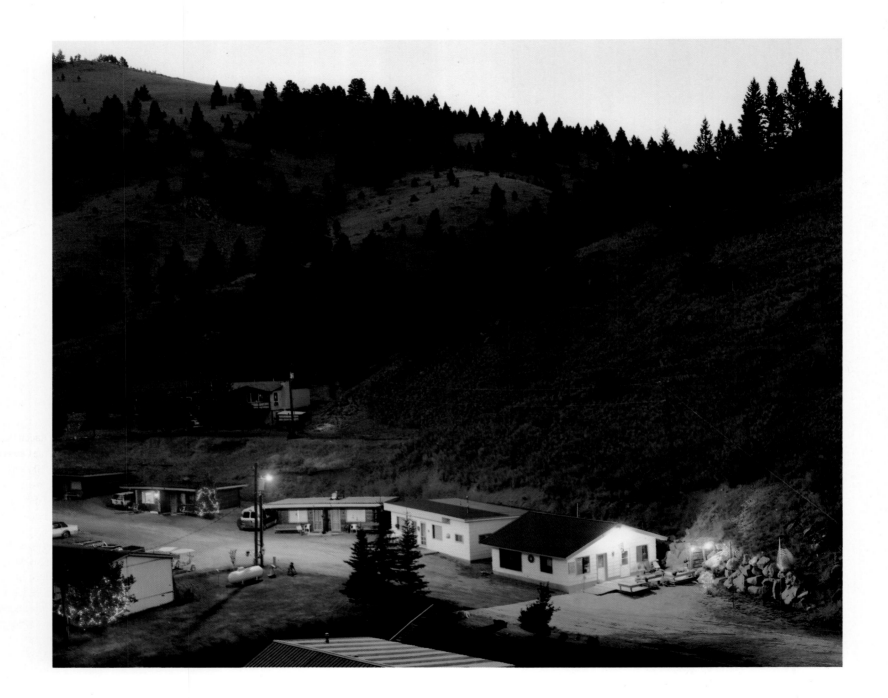

CHAPTER 4

"It's All in the Mine"
The Radon Health Mines of Boulder Basin, Montana

In southwestern Montana's Jefferson County, near the towns of Basin and Boulder, uranium was discovered in 1949, at the beginning of the Cold War boom. The area had been mined intermittently since the 1880s, producing gold, silver, lead, zinc, and copper at various times, but the uranium discovery, made by Wade V. Lewis and two partners, was something new and promising. During the early excitement of the atomic age, prospectors fanned out across the West seeking deposits of the radioactive mineral. In Montana it was first located at the Free Enterprise Mine, an underground operation originally established in 1924.

The property had produced silver and lead into the 1930s. Lewis and his partners found high Geiger counter readings in the abandoned shaft and immediately went into business as the Elkhorn Mining Company. Their Free Enterprise Uranium Radon Mine produced ore for a few years into the early 1950s. Then, in an improbable turn of events, it was transmogrified to become the nucleus of a local resort economy based on the health benefits of breathing radioactive radon gas.[1]

Today, in the Boulder Basin, mine owners are in the business of marketing radioactivity instead of mining ore. Civilian visitors rather than working miners now descend into the mine shafts, where they *pay* specifically to inhale radon gas, one of the decay-products of uranium. In contrast to Karnes County, Texas, where radioactivity suffuses an apparently benign landscape with suspicion, radioactivity in Montana is an overt tourist attraction. People venture to the vicinity specifically to inhale the same substance that the Environmental Protection Agency (EPA) warns against as a cause of lung cancer.

Names tell the story of this quirky phase of the region's mining history: Free Enterprise Mine for Health, Earth Angel Health Mine, High Ore Health Mine, Lone Tree Health Mine, Merry Widow Health Mine, Sunshine Radon Health Mine. There are variations among them. Some are "wet"

The Sunshine Radon Health Mine bills itself as "the Cadillac of the Health Mines." The entrance to its radon chamber is visible at lower right. In addition, the Sunshine Mine features extensive ancillary support facilities, including cabins, recreational vehicle park, hot tub, video rental, gift shop, and laundry room. It advertises western cookouts and outdoor recreational possibilities in addition to radon treatments.

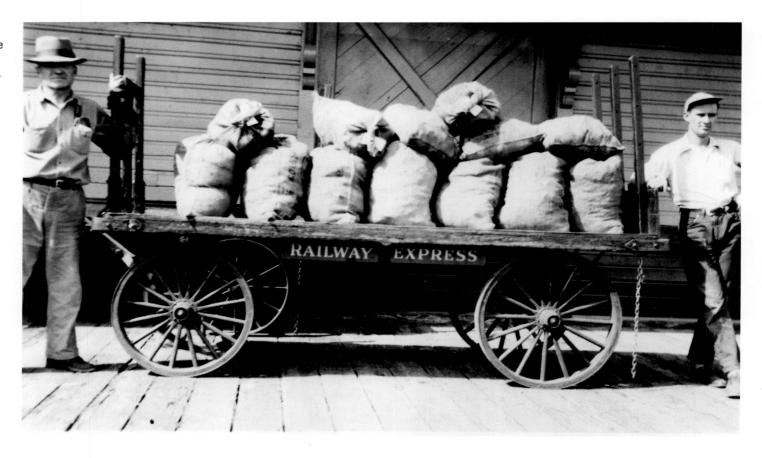

In this early 1950s view, sacked uranium/silver ore from the Free Enterprise Mine is shown ready for shipment to the Vitro Chemical Company in Salt Lake City, Utah. Owner Wade V. Lewis Jr., who later transformed his mine into the first of the commercial "health mines," is at right. Also pictured is John Giulio, Sr. *Photograph courtesy of Free Enterprise Mine, Boulder, Montana.*

mines, where springs offer the additional benefit of irradiated water for drinking or soaking. Others are "dry," which can seem less chilling for visitors who must sit in temperatures between fifty and sixty degrees for periods of up to an hour. Some properties feature drifts and shafts that were mined historically. Others, such as the Lone Tree Health Mine, have dug modern shafts for the express purpose of serving health seekers. Some are cozily furnished. Others are austere, to appeal to customers who want to feel they're in a mine. All of them, however, fly in the face of current scientific wisdom by advertising the opportunity to breathe a radioactive gas.[2]

The origins of this eccentric practice are described by Wade Lewis with great specificity:

A Los Angeles woman, visiting with her husband in the summer of 1951, asked to enter the underground workings of the Free Enterprise Mine. She descended

with the author from the surface to the 85-foot level and en route, while being lowered on a narrow mine cage platform by a steel wire rope hoist cable, admitted that she was afflicted with bursitis. Facetiously the writer suggested that radiation underground might relieve her affliction. Twenty-four hours later her husband telephoned from Helena, Montana, to Boulder stating that his wife was miraculously free from pain with no sign of bursitis.

Although her name has unfortunately been lost to history, her visit proved influential. Friends from California followed in her footsteps, inspired by her stories of recovery from pain, and Lewis and his partners soon had almost 1,000 requests for mine visits. Overwhelmed by the demand and unequipped to serve the needs of so many "civilians" in the mine, they made a decision the following year that it would be more profitable to stop mining uranium and enter the "health business."[3]

They did so by providing amenities, replacing their rope hoist with an Otis passenger elevator that descended to the eighty-five-foot level. Aboveground they built modern office facilities with a waiting room, rest rooms, and a separate sitting room where they pumped in radon-impregnated air from the mine for visitors who might feel uncomfortable descending underground. They timbered the walls of the mine itself, so the raw rock wouldn't remind visitors so forcibly of their underground location, and they installed special ventilation. In all, Lewis and his partners spent $75,000 to recast a former industrial landscape as a vaguely domestic space (see pages 86, 88–91), the more effectively to serve its new commercial purpose.

When the Free Enterprise Mine for Health opened for business on June 23, 1952, it had immediate competition. Numerous old gold mines in the vicinity reconstituted themselves as "health" mines, complete with testimonials to the efficacy of their "cures." The Merry Widow Health Mine opened the same year and the Earth Angel Health Mine in 1953. A *True Magazine* article reported "dozens" of health mines in 1955. Although the health mines today are generally careful not to claim anything more than relief of symptoms (for sufferers from arthritis and bursitis especially, but also for numerous other conditions), some earlier practitioners were less scrupulous. The Montana Bureau of Mines and Geology was asked by owners of nonradioactive mines to deliver radioactive rocks so that they could cash in on the health mine phenomenon.[4]

Almost immediately, the American Medical Association denounced the claims of the health mines as an "unfortunate promotional scheme," launching a controversy that continues to this day. The U.S. government officially identifies radon gas as a cause of lung cancer, based on studies of the incidence of that disease among uranium miners. The EPA has issued guidelines for "safe" levels of exposure (4pci per liter of air), and urges homeowners to test for its presence and take measures to ventilate spaces where excess quantities may be present. Some reputable scientists disagree with these recommendations, however, pointing to flaws in the conclusions about the original uranium miners, and to subsequent studies in Finland and elsewhere that have failed to find any link between residential radon exposure and lung cancer.[5]

Radon is a tasteless, colorless gas produced by the decay of radium, which itself results from the radioactive decay of uranium. Known as a uranium "daughter," radon, in turn, breaks down into polonium, bismuth, and lead. It is polo-

(top) Depicted here in approximately 1948, the Merry Widow Mine was being actively worked. Jesse Malone, Jr., of Kalispell, Montana, recalls his father's continuing battle with water in the mine, which "they couldn't pump out as fast as it came in." Eventually, his father gave up the effort. *Photograph courtesy of Jesse Malone, Jr.*

(bottom) Another view of the Merry Widow Mine during active mining reveals the mom-and-pop scale of the operation. Compared to properties such as Bingham Canyon or the Mesabi Iron Range, the magnitude of mining in Jefferson County was minuscule. *Photograph courtesy of Jesse Malone, Jr.*

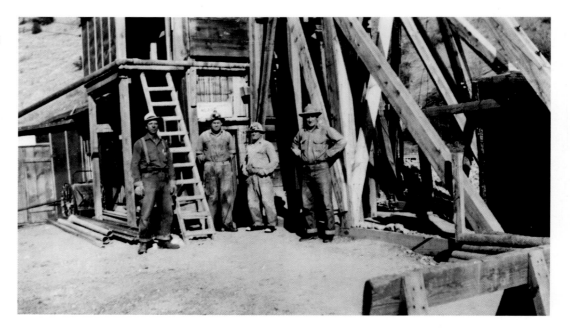

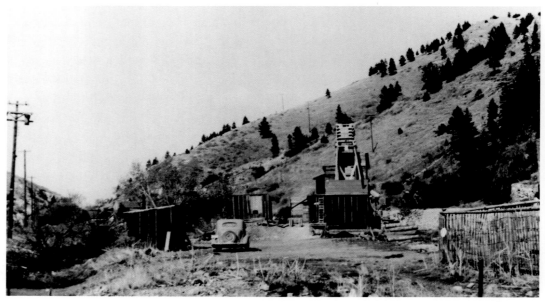

nium that is implicated in the association of radon gas with lung cancer. Radon has a half life of 3.8 days, so it dissipates relatively quickly. Based on studies of the uranium miners of the Colorado Plateau, radon is assumed to be dangerous mainly when contained and breathed for an extended period of time. In Jefferson County, however, the health mines defiantly promote the beneficial effect of purposefully inhaling large quantities of radon (concentrations in the mines range from 177 to 1,000 pci/liter). And they attract numerous, fervent believers.[6]

The business of health mining is driven by testimonials from the faithful, as it has been from the beginning. All of the health mines provide brochures that quote mine visitors in detail as to the beneficial effects of their "treatments." At least one mine offers either addresses or telephone numbers for every person quoted in their publications so that skeptics may contact them directly. Scientific medicine, however, remains dismissive. In the words of the executive vice president of the Montana Medical Association, "There is absolutely and unequivocally no scientific evidence to document the efficacy of alleged benefits."[7]

Montana state authorities are officially neutral in the matter. They do not license the mines, but neither do they prohibit them from operating. They do periodically provide official measurements of the radon exposure in each mine. According to Brian Green of the Montana Department of Environmental Quality: "There's no scientific evidence that it will hurt the people using the mines and there isn't any scientific evidence it will help them either." A district EPA official is reconciled to the mines: "They're not exposed for very long to a dose that's really dangerous. And, quite frankly, most of the people who use them are usually quite old and won't live long enough to absorb too much."

The clientele attracted to the health mines suffers from a variety of ailments, but rheumatoid arthritis and bursitis are especially common. These are often diseases of old age, and many visitors are in their late sixties or seventies. That they feel the treatments are worthwhile is obvious from the enthusiastic notes scrawled on the beams of the mines, in the guest registers, and in effusive letters to the mine owners (see pages 85 and 87). One representative example, from a pamphlet published by the Free Enterprise Mine, illustrates their tone. Marie Klassen of Winnipeg writes:

The doctors told me there was nothing they could do for me [osteoarthritis] except give me the pills for pain. Every year became progressively worse and I never had a day without pain. . . . After going into the mine for a few days the pain in my hips and legs went away—no more pills. My family and friends can't believe what they are seeing. I am now able to clean and vacuum my house and many other things which I haven't done in years. It's just wonderful to sleep all night and be able to get out of bed in the morning to another pain-free day. I believe it is one of God's ways of healing and I praise Him for it.[8]

Klassen's story is repeated in endless variations by patrons of the health mines. The common pattern includes an initial period of feeling even sicker for two or three days, then a gradual improvement. For many visitors, the real breakthrough doesn't occur until two to six weeks after leaving the mines, when, as rheumatoid arthritis sufferer Ken Curle of Minot, North Dakota, reported: "I found myself in the box of my pickup truck and wondered how I got there! Apparently I was now able to do things I hadn't been

able to do for some time." On the strength of the favorable changes such as this, many return annually.

The suggested treatment regimen is two or three daily one-hour sessions in the mines. Three to four hours of rest is recommended between these underground visits, to allow the radon to disperse from the lungs. To achieve the prescribed total of thirty-two hours of exposure on such a schedule requires from eleven to sixteen days in residence. Accordingly, many of the health mines also have RV hookups and/or rooms available for rent. The cost of the mine visits (ranging from $5 for one hour to $150 for the series of full treatments in 2003) can be included in a package rental price with the accommodations.

Since the 1950s, the fame of Montana's health mines has spread by word of mouth, and in the face of ridicule from scientific medicine. Consequently, testimonials from customers have been encouraged and circulated by mine owners. Magazine articles written during the 1950s noted that approximately sixty percent of all mine visitors (and at least one dog) reported relief from their symptoms. During the 1990s, individual mines claim that from seventy to ninety percent of all visitors experience improvement.[9]

Health mine operators are careful to specify that they are not practicing medicine. The High Ore Health Mine disclaimer is typical: "The staff at The High Ore Health mine in no way claim to be medical professionals. Proof that low level radiation is therapeutic is shown by the hundreds of mine visitors who claim relief or cure." The brochure published by their industry association, the North American Radon Mines for Health, stresses that the radon mines are "Earth's Natural Therapy," and provide "a natural and holistic approach to . . . symptom management and pain relief."

The Free Enterprise Mine for Health, the original and most scientifically inclined of the health mines, goes beyond personal testimonials in its quest to legitimize the radon treatments. Still operated by descendants of Wade Lewis, it publishes a newsletter and maintains a Website featuring scientific studies questioning the validity of EPA's conclusions about the association of radon with lung cancer.[10] These publications also feature reports about international medical uses of radon. Both Austria and Germany, for example, have spas featuring "radium hot springs," where visitors go to absorb radon through the skin and national health insurance covers eighty percent of the charge. The former location, at Bad Gastein, has been associated since 1936 with a research institute, which concludes that radon stimulates the endocrine system and causes the kidneys to increase their excretion of toxins.

The Free Enterprise newsletter traces the history of radium "bathing culture" in Europe and notes the existence of radon spas in Japan and in Hungary. It reports the establishment at the University of Ottawa of the International Centre for Low Dose Radiation Research, which will study and assess the effect of low-dose radiation on humans and animals, including naturally occurring radiation. Clearly intended for the reader who might be unpersuaded by the most heartfelt of testimonials, this publication draws on international precedent and alternative science to justify and explain the healing influence of low-level radiation.

In recent years, visitorship to the radon health mines has declined markedly. The Free Enterprise reported only 402 paying customers in 1999, compared with 1,245 in 1991.[11] Mine owners attribute the decrease to "the radon controversy," and to "new options in alternative and traditional medicines," including new medications for arthritis, which

represented "a major breakthrough not seen for over ten years." With more treatment options available to them, patients no longer depend so exclusively on the restorative effects of the uranium mines. The drop may relate as well to the failure to recruit new converts as the ranks of the older treatment seekers are inevitably reduced by death. In any event, health mine operators continue to appeal to those who suffer from joint pain. As the Free Enterprise newsletter attests: "Attitudes and science are changing and we are here to support those changes, as they give us validity in our endeavors to tell the world about the unique healing power of radon."[12]

The precise nature of that power, indeed its very existence, is still debated sharply. An Arthritis Foundation official, Floyd Pennington, dismisses it as "folklore," but true believers continue their annual pilgrimages to the radon health mines of Jefferson County. A medical expert on the benefits of low-level radiation is cautious. According to Dr. Leonard Sagan: "There haven't been properly conducted scientific studies to examine [the health mines]. That doesn't mean they're not effective. They may be, or they may not be. We just don't know."[12] While it may be that any healing properties are "all in their minds," returning health mine visitors are not dissuaded. The symptomatic relief that they experience is enough to convince them, with the proprietors of the Earth Angel, that relief from their pain is "all in the mine."

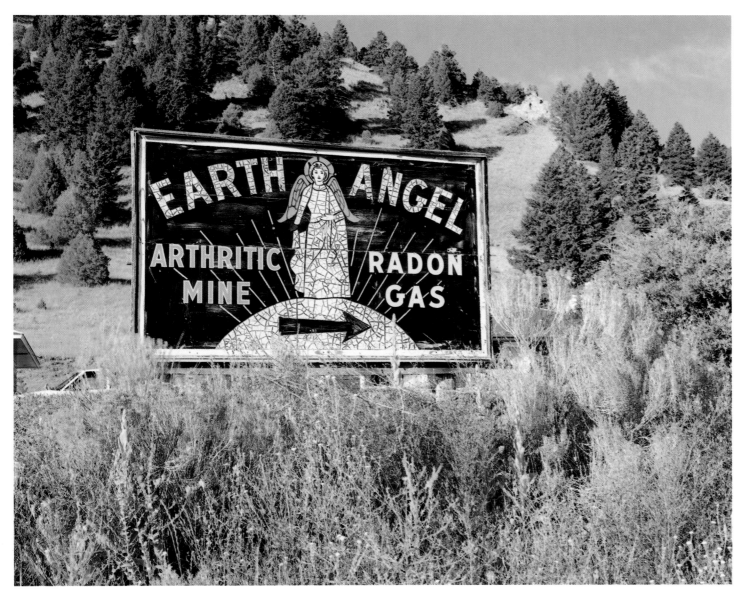

The Earth Angel Health Mine's slogan is "It's All in the Mine." The mine was opened in 1929 by miners seeking gold and silver, but has operated as a health mine since 1953. This view depicts an old sign that associates radon primarily with the treatment of arthritis. During the 1990s, the mines provided testimonials from visitors with a much wider range of conditions.

Confounding expectations about mine workings, the portal of the Sunshine Radon Health Mine features benches and chairs, blooming flowers, pinwheels, and a cheerful banner. Its literature invites visitors to "Come Join Us for 'Your Holiday to Health.'" Owner Pat Alverson is pictured at her facility in 1998.

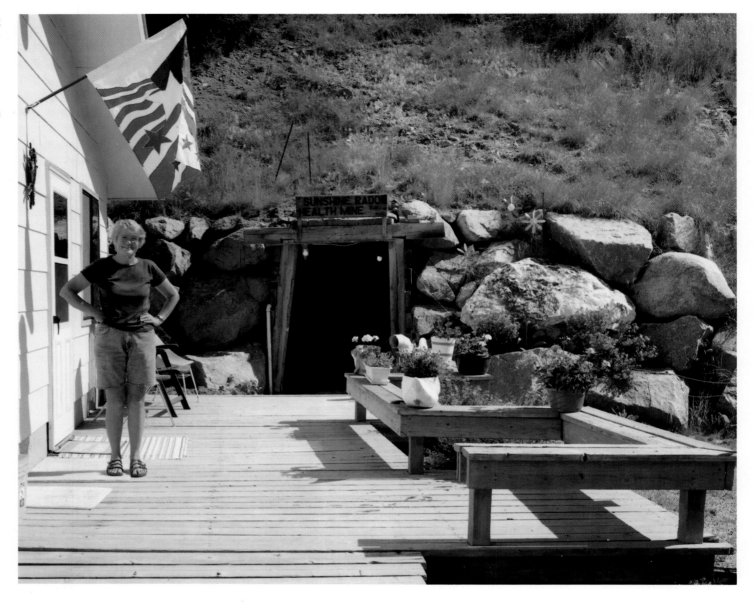

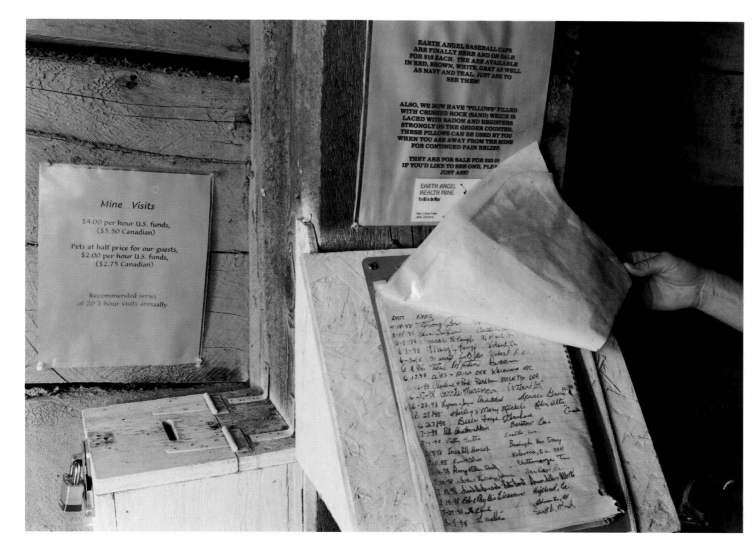

The entrance to the Earth Angel Health Mine features a 600-foot paved concrete path that makes the mine accessible for wheelchairs. In 1998, regulations and a guest register were posted at the door, along with information about the recommended "dosage" of health-enhancing radon.

The interior of the Sunshine Radon Health Mine is outfitted with plastic lawn chairs and blankets for visitors who find its constant 57°F temperature chilly. Patrons frequently read during their sessions, although many are obviously inspired to leave testimonials to their presence on the beams and posts.

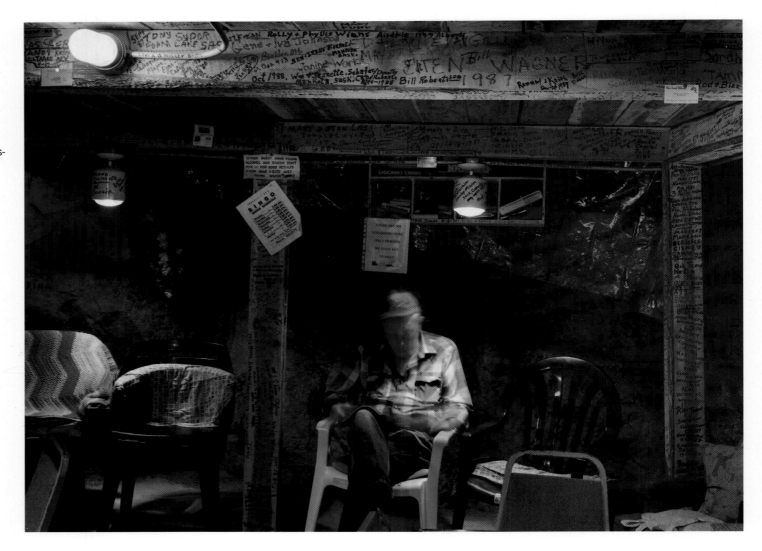

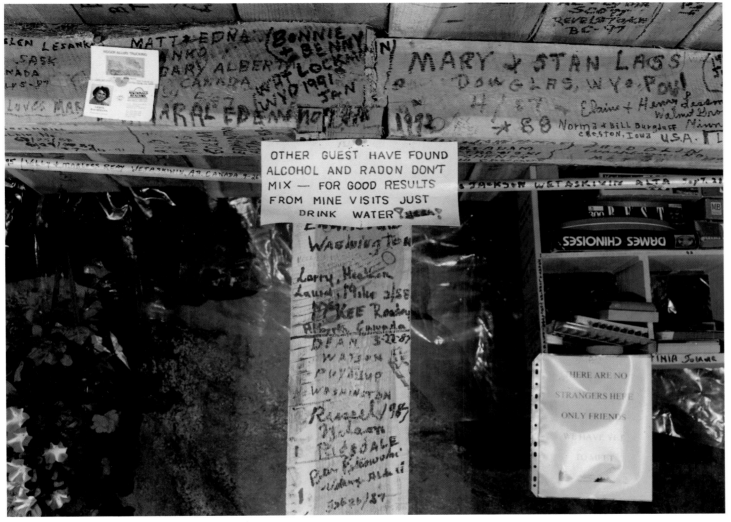

OTHER GUEST HAVE FOUND
ALCOHOL AND RADON DON'T
MIX — FOR GOOD RESULTS
FROM MINE VISITS JUST
DRINK WATER

A placard at the Sunshine Radon Health Mine admonishes visitors to stick to mine water to quench their thirst. The Montana State Department of Health tests the water and certifies that it is sufficiently pure for drinking. The state also measures radon levels and prescribes recommended maximum exposure times and visits for each mine. The standards are based on exposure levels of no more than ten percent of the EPA's recommendations for underground uranium miners. Graffiti-strewn beams and posts reveal visitors' urge to commemorate their presence on every available surface.

Bus benches at the Free Enterprise Health Mine provide a variety of colorful seating options. This is the site of the original 1951 discovery of the restorative properties of radon gas. Reached by an elevator in an eighty-five-foot shaft, it has been elaborately fitted with plywood floors and comfortable recliners, as well as padded benches, periodical racks, tables, reading tables, and chairs. Transforming a mine into an environment attractive to visitors was a major challenge (and a major investment) for owners of the health mines. The degree to which the initial industrial landscape has since been obscured varies from mine to mine.

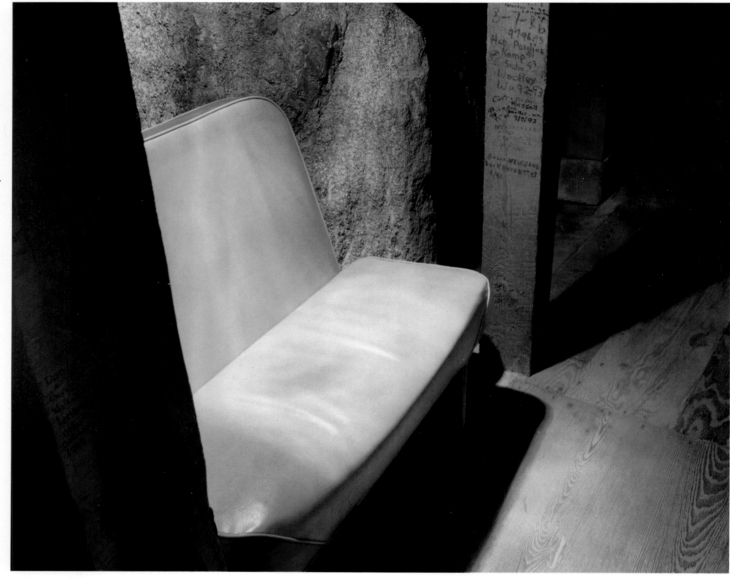

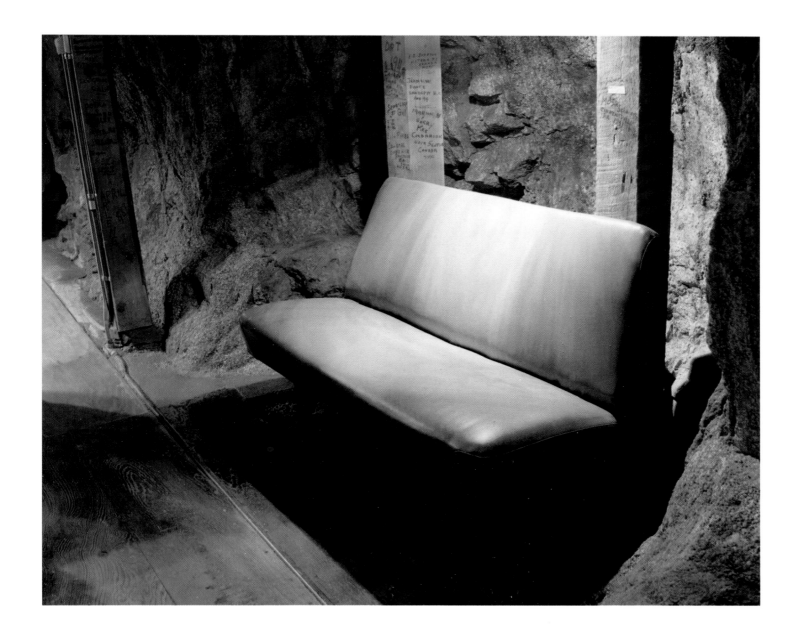

The Merry Widow Health Mine's slogan is "Health is Wealth." One customer reported expecting the mine "to be a cold, damp place," but was "pleased to see a pleasant, clean, comfortable and friendly facility." Sociability is a factor in health mine popularity. Some patrons return regularly, not simply for treatments, but also to enjoy the company of friends they have met in the mines.

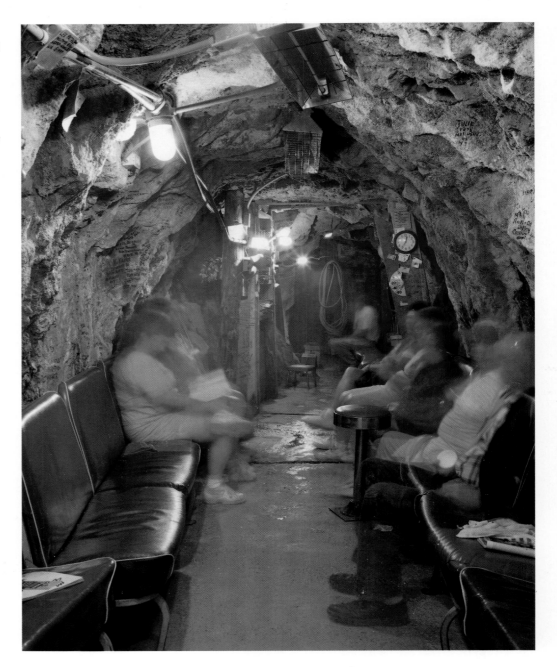

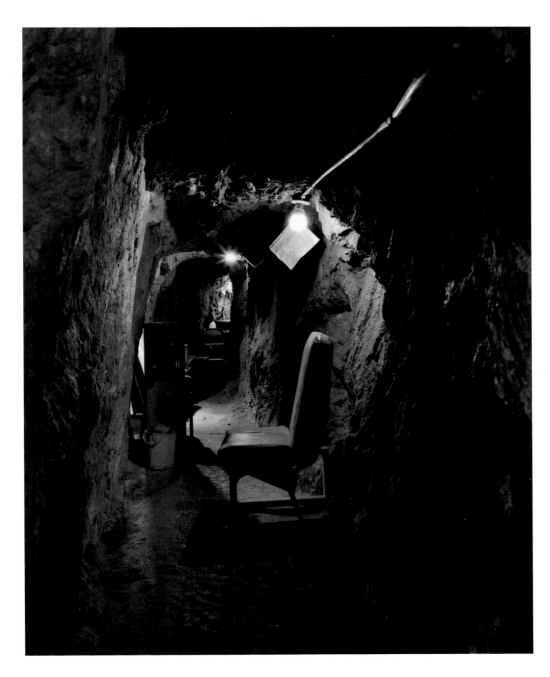

This interior view of the dry Earth Angel Health Mine tunnel reveals the constraints of trying to transform a mine into a pleasant retreat for health seekers. Earth Angel provides heat lamps for its visitors' comfort, but the overall effect remains austere.

Immersion of the affected limb in uranium-impregnated water is another alternative to simply breathing the radon gas in the treatment rooms. The small reservoir on the right was created at the end of a drift in the Merry Widow Health Mine.

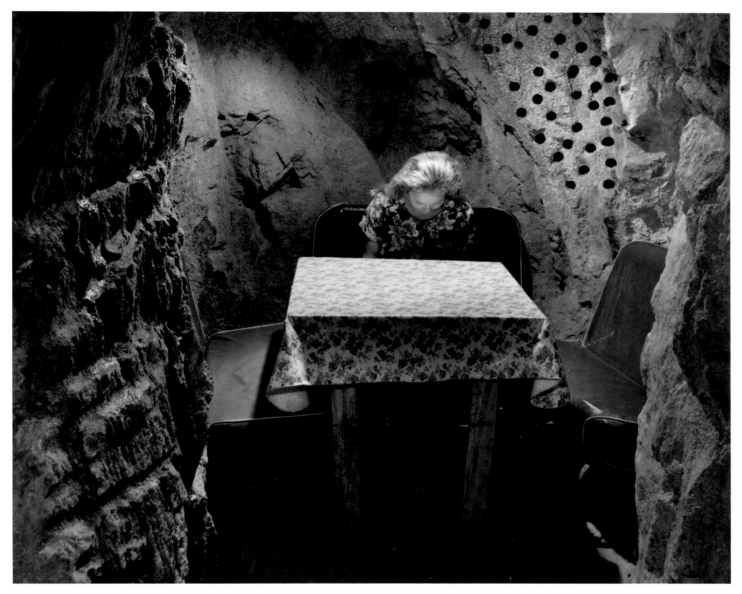

The interior rock face of the Merry Widow mine still retains vestiges of its former life. Drill holes used for blasting and prospecting are visible at the top right, and the wall at the left has clearly been worked. Here the incongruity of the domestic accouterments, including a gaily flowered tablecloth, is particularly striking.

What was a nuisance to working miners in 1948 had become an attraction for health-seeking visitors in 1998. The Merry Widow is now touted as a "wet" mine, where natural springs produce irradiated water. Some visitors drink it for its additional health benefits from fountains such as this one. Visitors divide on the desirability of water. Some find the noise of running water soothing and like to soak their appendages. Others think water makes already cool surroundings seem even colder, and prefer to patronize "dry" mines.

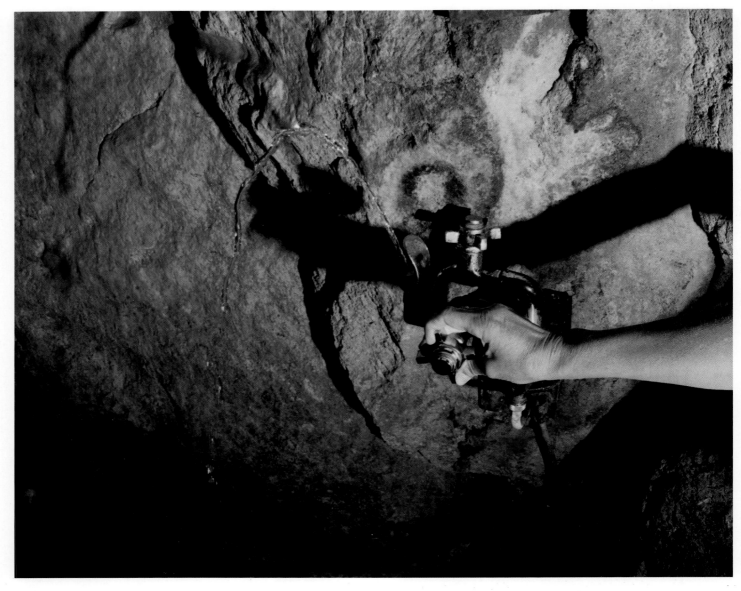

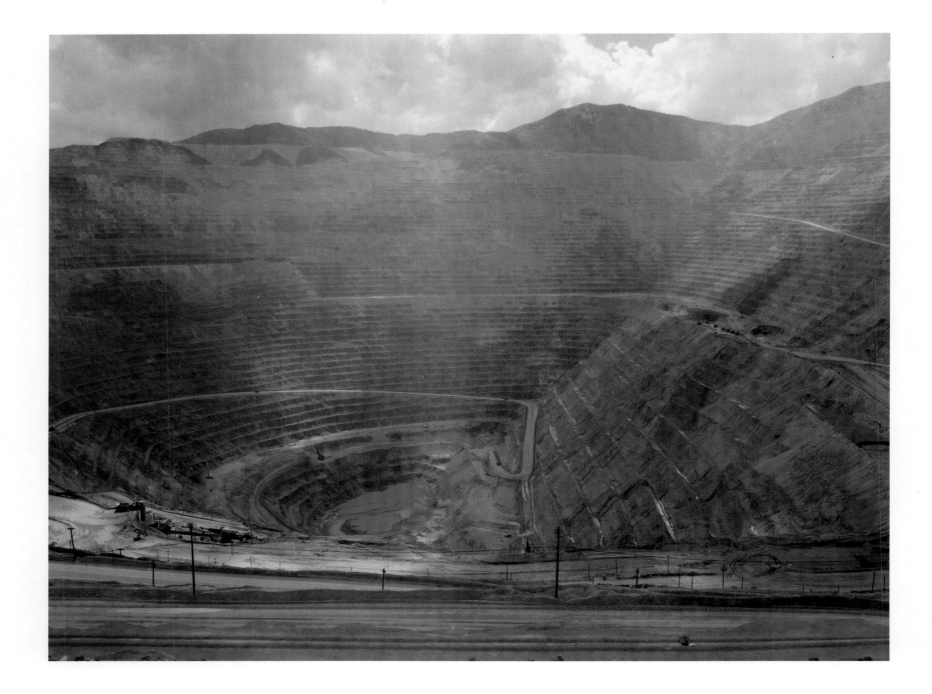

Bingham Canyon, located in the Oquirrh Mountains southwest of Salt Lake City, Utah, is perhaps the iconic landscape of American mining. There a century's diligent quest for copper painstakingly disassembled a nondescript mountain and created in its place the world's largest intentional pit. The Visitor's Center at its edge has photographs to prove that this huge hole is visible even from space, and it was designated a National Historical Monument in 1972. Numerous communities that arose over the years to serve the needs of this gargantuan mine have been destroyed in turn, as the need for ore and for space to store waste rock outpaced the desire to house miners in proximity to their work. At Bingham Canyon, the large-scale forces of industrial open-pit mining can be read in the landscape through historical rephotography, juxtaposing historical images with contemporary views of the same site. This process reveals the incremental changes of 100 years, during which mining constantly created and re-created the landscape, rendering the seven-mile-long canyon, in Thomas Power's telling phrase, an "area of industrial sacrifice."[1]

Everything about the Bingham Canyon mine is outsized. The pit itself measures two and a half miles across, and more than three-quarters of a mile deep. The Kennecott Utah Copper Company, which operates the mine, plans to extend it at least 650 feet further down before mining is completed. Because Bingham Canyon is a low-grade deposit, very little of the material that has been removed to create the pit is actually copper (or the molybdenum, gold, silver, palladium, and platinum that the mine also yields). The remainder— waste rock that contains no ore, and tailings that remain after the ore has been processed to remove its mineral values—must all be stored somewhere. As a result, huge artificial hills of waste rock, towering 1,000 feet above the valley floor, have pushed out from the mouth of the canyon; and the original tailings impoundment of 5,700 acres has recently been expanded to incorporate 3,200 acres more.[2]

This 1998 view of Bingham Canyon Pit is the one seen from the Visitor's Center at its edge. From the viewing platform it is called the "best general view." The gargantuan scale of the hole is difficult to understand from above, where huge electric shovels and 255-ton haul trucks look minuscule, but Kennecott has photographs to demonstrate that the mine is one of two human constructions visible from space (the other is the Great Wall of China). This mine is reputed to be the largest excavation on Earth.

Mining in Bingham Canyon is carried on year-round, twenty-four hours a day. Huge drills prepare for the daily blasts that slowly eat away at the walls of the pit, in areas mapped out by mining geologists to yield the optimum amount of ore. Large electric shovels load the loose rock onto trucks with a 255-ton capacity, which are driven by men and women who sit eighteen feet above the road and travel all day in an endless circle: down into the pit to load at their designated shovel, and back up to the rim to unload the rock into an on-site crusher or to dump what is waste. From the crusher the ore is mechanically transported off-site for further processing, including concentrating, smelting, and refining. Waste rock, meanwhile, is now dumped in the canyon itself, continuing the process of landscape displacement and reshaping that first began in the 1890s. The techniques of mass-producing minerals—involving mechanization and economies of scale—are now familiar, but they were first perfected on Minnesota's Mesabi Iron Range and in Bingham Canyon.[3]

Bingham was Utah's first mining district, established when non-Mormon soldiers discovered lead in 1863, in a canyon that had been named for two brothers who ranched and prospected there in the late 1840s. Gold was discovered as well, but, the leadership of the Latter Day Saints disapproved and so mining development of these claims was discouraged. Most of the gold placers were worked out by 1870. Lead and silver were produced through the remainder of the century, but the 1893 depression stopped all mining operations.

Although the existence of copper in Bingham Canyon was known, mining it was unprofitable given the high costs of underground operations and the difficulties of smelting the resulting sulfur-laden ore. Only as the demand for electricity increased did the market for copper expand. The first

smelters for Bingham ore were located nearby in Salt Lake Valley. They were closed after a decision in a 1905 case brought by farmers, who sued because the smelter smoke killed their crops. In response, the world's largest copper smelter was built, approximately seventeen miles from the mine at a site named Garfield.[4]

Steam shovels began digging Bingham Canyon ore in 1906, but ownership of Bingham Mountain was divided between two different companies, which limited the viability of the open-pit method. In 1910, with financing from the Guggenheim family, the Utah Copper Company consolidated the various copper claims on the mountain under its ownership. Utah Copper built its processing facilities some distance from the mine, where there was room to dump the extensive tailings produced in the treatment of low-grade ores, and began producing copper in earnest. The company was directed by Daniel C. Jackling, who had conducted the engineering studies in 1899 that initially predicted profitability for the new, open-pit method of mining at Bingham Canyon.

Many, including the Guggenheims, were suspicious of Jackling's innovative claims. As one Bingham resident reported: "When the Utah Copper Mine was getting started with its novel idea of open-pit mining, the individual miners were offered stock in the company as part of their wages. Not many took advantage of the offer. Most of the miners were underground men and the open-pit method of mining was not acceptable."[5] Utah Copper was absorbed by the Kennecott Copper Company, another Guggenheim interest, in 1935.

Because producing ore in this new, unorthodox way was uncomplicated, it did not require the services of highly skilled underground miners from traditional centers such as Cornwall and Wales. Utah Copper recruited unskilled laborers from

throughout the world, including 600 Japanese workers as well as French Canadians, Finns, Greeks, Mexicans, Serbians, and Croats. Although many of these workers were single men, others came with their families. The resulting work force was so ethnically fragmented that union organizing efforts faltered until World War II. Instead, the workers divided themselves into self-contained ethnic enclaves that spread up and down the narrow canyon from the original settlement at Bingham City. Bingham historian Lynn Bailey described an effect similar to the contemporaneous tenement districts of New York City: "Upper Bingham with its dark residents and equally dark businesses with puppet shows, belly dancing, smells of exotic tobacco, wines and foods, never failed to make a lasting impression on Anglo-Americans."[6]

As residents recalled it, Bingham Canyon was no melting pot. Denizens of the main town of Bingham were primarily western European in origin, while other groups colonized separate residential districts. Some of these satellite settlements were established communities, such as Copperfield and Highland Boy. Others were little more than temporary camps, places with idiomatic names such as Frog Town, Dinkeyville, and Japtown. All were unprepossessing in appearance, "unpainted frame house without yards, rundown and unkempt on the outside . . . [but] almost dust free and immaculately clean on the inside."[7] Even in Bingham, the largest and most established of these settlements, there was an open sewer running through the center of town, referred to euphemistically as "the creek":

The creek was strong with the solution of copper sulfide which was generally regarded as being antiseptic and affording all the protection against bacteria that anyone could need or use. It not only killed germs, it also eliminated odors, or so people said.[8]

At its height, the population of Bingham Canyon was more than 15,000. Only the town of Bingham was incorporated with an established town government. All the others were informal settlements.

In 1926, Utah Copper decided to build its own community, in a relatively flat area of lower Bingham Canyon. It was to be "an ideal townsite of well-built homes surrounded by trees, lawns and flowers," in marked contrast to the more plebeian communities up the hill.[9] Construction began in 1926, and continued off and on until 1949. In order to highlight the domestic possibilities of copper, homes in the aptly named Copperton had plumbing, wiring, roof tiles and nails, window screens, gutters, and down spouts all made from the metal. The houses were modern, designed by architects and equipped with electricity, central heating, and spacious yards, but rents were comparable to those in the far less luxurious Bingham.

Because of its unaccustomed amenities, Copperton was popular from the beginning. It boasted not only a park, but also a functioning sewer system and room to hang laundry. Houses had yards and streets were wide. One woman who moved there after living in Bingham, "with its steep canyon walls on both sides for over 20 years, commented that moving to Copperton was just like coming out of the dark into the light because of all the light resulting from the large amount of open space . . . for the first couple of nights she had trouble sleeping."[10] The right to occupy a house in Copperton was a prize, awarded only upon application and on the basis of hierarchy, seniority, and one's work record with the company.

Copperton's residents paid a price for their comfort, though. The town was subjected to strict company control until Kennecott sold the homes in 1955. The mine superintendents regularly monitored residents' grounds keeping, and charged them for company labor to mow unkempt lawns. A company-sponsored park was used for occasions of civic display more often than for actual recreation. Residents were happy to comply, however, to avoid the dirt and rocks of Bingham, where on damp days "the smell from the garbage and ores was almost overpowering."[11] Despite construction of a concrete sewer system in Bingham in 1936, conditions in the company town were luxurious by comparison. In retrospect, Bingham's fate was sealed when its high school moved to Copperton in 1931.

As demand for copper rose and fell with the Depression and World War II, the work force and output at Bingham Canyon fluctuated. In general, however, decreasing copper content in the rock of the canyon meant that increasing amounts had to be removed in order for Kennecott to maintain its profitability. Inexorably, the expanding mine had gnawed away at Bingham Mountain until, sometime during the 1930s, "the Hill" disappeared entirely into Bingham Pit. The problem of disposing of waste rock grew severe. Kennecott experimented with using slag for highway fill and between railroad ties, but the sheer volume of the waste material was overwhelming. Gradually the waste rock from Bingham Pit spilled out of the canyon and off the top of 1,000-foot mesas constructed as dumps to store it. Dust was ubiquitous, as the prevailing westerly winds spread it from the canyon mouth into the valley below. Eventually, Kennecott decided to sacrifice the string of irregular towns that housed its work force in upper Bingham Canyon in order to mine the underlying rock and then use the space for the disposal of waste rock.

Accompanying social changes provided a context for this decision. In the aftermath of World War II, returning veterans sought an education and better jobs. Few were willing to return to Bingham Canyon to live. The widespread availability of automobiles and improvements in roads made it possible for miners to live in Salt Lake City and commute to work in the mine, rather than occupying substandard housing on the flanks of the growing pit. More efficient mine operations required a smaller workforce to produce the copper and molybdenum that Bingham Canyon was then selling. Traditional ethnic schisms declined in importance and union representation at Bingham Canyon was finally achieved by the International Union of Mine, Mill, and Smelter Workers in 1944, after the retirement of Daniel C. Jackling. Company paternalism abated simultaneously, a development symbolized by the sale of the Copperton townsite in 1955 and the purchase of most of the homes by residents. In combination these factors meant that the towns of Bingham Canyon were gradually emptying, strangled by many of the same forces that had created them.

Thus, it happened that the Bingham Canyon Mine came to embody a paradox of the mining landscape. Ordinarily it is the *failure* of a mine—whether because of fractious ore or a contentious work force—that condemns the unfortunate nearby towns that have grown up to serve it. When the mines close, the towns die. This is a brutal fact of the industry that commonly explains the reluctance of mining companies to invest in their nearby communities. The pattern has repeated again and again in U.S. history.[12] Butte, Montana, and Ruth, Nevada, are examples within the copper industry. In Bingham Canyon, however, the

Kennecott Copper Company defied conventional wisdom. Instead of failing, the company flourished. Instead of minimizing costs, it invested heavily to modernize its mining methods. But the result for the nearby towns was remarkably similar. During the late 1950s, when the company began intentionally destroying the historic towns of Bingham Canyon, it was not a sign of failure, but success. Kennecott needed the land in order to accommodate its fabulously successful but voracious pit.

During World War II the Bingham Pit poured forth more than half of the Allies' entire copper supply. Mining engineers found copious amounts of similar ore throughout the remaining rock of the mountain. Studies conducted in the 1960s indicated that the sixty-year old experiment in high-volume, low-grade ore processing could continue at a profit for decades to come. Kennecott, as it would continue to do through the rest of the twentieth century, expended capital to modernize its facilities, and continued to dig its giant hole. In the process, it also doomed the three communities and subsidiary neighborhoods that had grown up to serve its needs in Bingham Canyon.

Kennecott systematically dismantled, first, Carr Fork and Highland Boy and, eventually, Bingham itself. The company issued eviction notices for its tenants and purchased the property it did not own. The process was expedited by a 1959 strike that reconciled many families to leaving the area and selling their homes to the company.[13] Kennecott, in turn, leveled commercial buildings and tore down homes. Businesses closed and debris encroached on those few buildings that remained, trickling from behind makeshift log barriers that seemed barely capable of holding back the weight of the impinging rock.

Although thirty-seven voters lingered in Bingham in 1965 and a few stalwarts sought to delay the inevitable until 1971, the town's fate was clear. As long-time resident Violet Boyce recalled, "When mining operations came so close that the blasting broke windows and cracked walls, the most stubborn hanger-on decided it was time to move."[14] At Copperton, however, Kennecott drew the line. Although the company owned all the land around the town, it was not immediately necessary for their operations, and acquiring private lots from individual homeowners would have been expensive. Instead they resolved to maintain their former showcase.

Refugees from the derelict towns moved to Copperton, to the nearby towns of Sandy and Midvale, and to the more distant Salt Lake City. There they wrote memoirs and recorded their impressions of Bingham for posterity. Many lamented the loss. Alta Miller, who came to Bingham Canyon in 1904, recalled it sadly seventy years later: "I have see[n] the hill come into bloom, I have seen what happened to Bingham, and now it's a ghost town. In my childhood there were 13,000 people in Bingham . . . [but] the old pit up there gets bigger and bigger and bigger and bigger."[15] A local bard composed a poem to commemorate the vanished communities:

Three cities fell with little to defray,
The homes that come in the shovels way.
It leaves one's heart in sad despair,
That knew of the homes that crumbled there.[16]

And his was not the only lament. Boyce and Harmer's charming memoir of life in Bingham Canyon, *Upstairs to a Mine*, ends with a poetic tribute to the town:

There used to be a town there,
With trestles, trains and play;
We climbed up to our homes there
'Til giants moved it away.[17]

Yet, their nostalgia for the lives and landscape they had lost was tempered by a certain pride in the forces that caused those changes. Marvin J. Hamaker, the poet of the three lost towns, recorded his sentiments in verse that extolled Copperton:

This town has a history not too old
Of how it was built from copper and gold.
From Kennecott Copper that blasts with pride,
As they move and terrace the mountainside.

His poem recorded his genuine empathy for people who had to leave their homes in the canyon, but also his faith in their future contributions to "this clean little town of Copperton":

And the three little towns in the mountain dell,
That prospered, flourished, crumbled and fell.
Look to the future as the millstreams run,
With these wonderful people in Copperton.

Hesitantly, the displaced residents conceded that success, not decline, was the cause of their misfortune. They had been supplanted, after all, by "the richest hole on earth." The mine—the giant pit that was now consuming much of Bingham Canyon—had outlasted and ultimately overpowered the people who helped to create it. They found modest solace in the fact that they had contributed to making such a behemoth.[18]

Unlike Pennsylvania's Wyoming Valley—where the historic mining landscape that is now disappearing is lamented as the only remaining vestige of a once powerful industry—in Bingham Canyon the obliteration of Canyon communities signaled continued prosperity in the fortunes of the Kennecott Utah Copper Company. Despite fluctuations in the price of copper and a complete shut-down in 1985, large-scale copper mining at Bingham Canyon is poised to enter its second century. The company was acquired by a subsidiary of British Petroleum in 1981, and later sold to RTZ Minerals, another British company, in 1988. During this interlude the two controlling companies invested hundreds of millions of dollars to build new processing facilities, both within the mine and at its associated processing sites. The result is a mine that not only employs fewer workers to produce more ore, but also does so in a more environmentally sensitive fashion than it once did. As a result, Bingham Canyon, which has already produced fifteen million tons of copper, has a predicted useful life of at least twenty-five additional years ahead of it.[19]

This longevity means that, at Bingham Canyon Mine, large-scale operations have also become long-term. Mining practices that were acceptable during the nineteenth and early twentieth centuries are anathema in the twenty-first century, as the full extent of their environmental consequences becomes clear.

Thus, Kennecott is struggling not only to minimize its current environmental degradation, but also to mitigate the effects of more than 100 years of mining lead, silver, and copper. Its own earlier decisions have now come back to

haunt the company, as groundwater pollution from acid mine drainage affects communities to the east, and dust from the waste rock dumps must be constantly suppressed.

As a consequence, the expenses of mining at Bingham Canyon now include elaborate water diversion systems to minimize contact between rain and snow melt and the mining and processing operations. Historic waste rock and tailings from lead and silver mining are being removed from the vicinity of Bingham Canyon and replaced by clean soil capable of supporting vegetation. The giant tailings pile to the north, at Magna, is being painstakingly reclaimed and revegetated. While the company points proudly to its conscientious retooling of the processing plants, highlighted in all forms of publicity about the Bingham Canyon Mine, lawsuits from the local water district challenge its strategies for addressing the polluted groundwater.[20]

Traditional gauges of a mine's success have been recalibrated. Kennecott, a company that literally moved mountains to produce vital industrial minerals, is now more likely to be judged harshly for its previous environmental sins than to be admired for its present industrial accomplishments. Remediation is expected. As one environmental activist put it: "We've inherited these mines that as a people we have to do something about . . . but the only hope for cleaning up this piece of earth is for Kennecott to clean it up."[21] While Kennecott's generally conscientious efforts suggest that it agrees, struggles over the extent and the time frame for this gargantuan task continue.

A century of mining in Bingham Canyon has irremediably altered the landscape. Towns have come and gone and a mountain has disappeared, but copper mining has also affected areas miles away from the giant pit, as processing operations have denuded or smothered distant terrain. Now, although it faces daunting environmental challenges, the Kennecott Utah Copper Company is once again bent on remaking the landscape, this time in the name of restoration. No longer simply "the richest hole on earth," the Bingham Canyon Mine has assumed a new aspect as a costly network of interconnected environmental engineering works. Their extent and complexity suggest that, at least in terms of its effect on the landscape, the true size of the Bingham Canyon Pit considerably exceeds its impressive physical dimensions.

A panorama view of Copperton, Utah, looking west on Cyprus Street from First West Street. Bingham Canyon is in the background, and its looming waste rock dumps can be seen in the rephotograph at the right. Copperton was built by Kennecott as a company town, starting in 1926. At the beginning, residents were primarily supervisors and skilled personnel, because living in Copperton was considered a benefit. Houses were built with extensive copper fittings and were meticulously maintained. The historical photograph was taken on June 15, 1938. In 1998, long-time employee Gary Curtis could still name all the families who once lived in the home pictured here. Compared to the total obliteration of historical landscapes in Bingham Canyon, Copperton has remained astonishingly stable, even though Kennecott sold the homes to residents in 1955. *Historical photograph courtesy of the Utah Historical Society, in Salt Lake City. Used by permission, all rights reserved.*

The historical image shows the town of Bingham during the 1920s. This important junction, where Carr Fork departed from the main Bingham Canyon, was the mercantile center of the principal settlement in the canyon. The town was incorporated in 1904 and inhabited until 1971. It has now entirely vanished as the surrounding landscape is endlessly destroyed and re-created by the expanding Bingham Pit. Only the contours of the distant horizon, particularly the saddle visible at the right of each image, reassures the modern photographer that the view is the same in both photographs. *Historical photograph courtesy of the Utah State Historical Society. Used by permission, all rights reserved.*

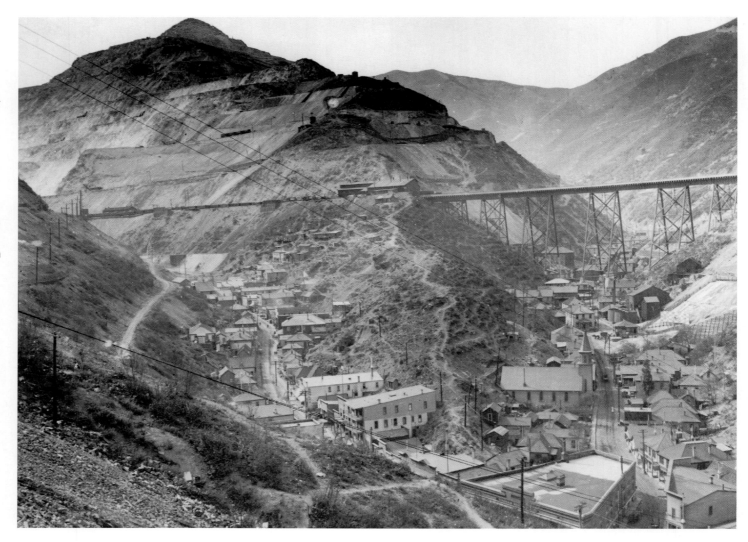

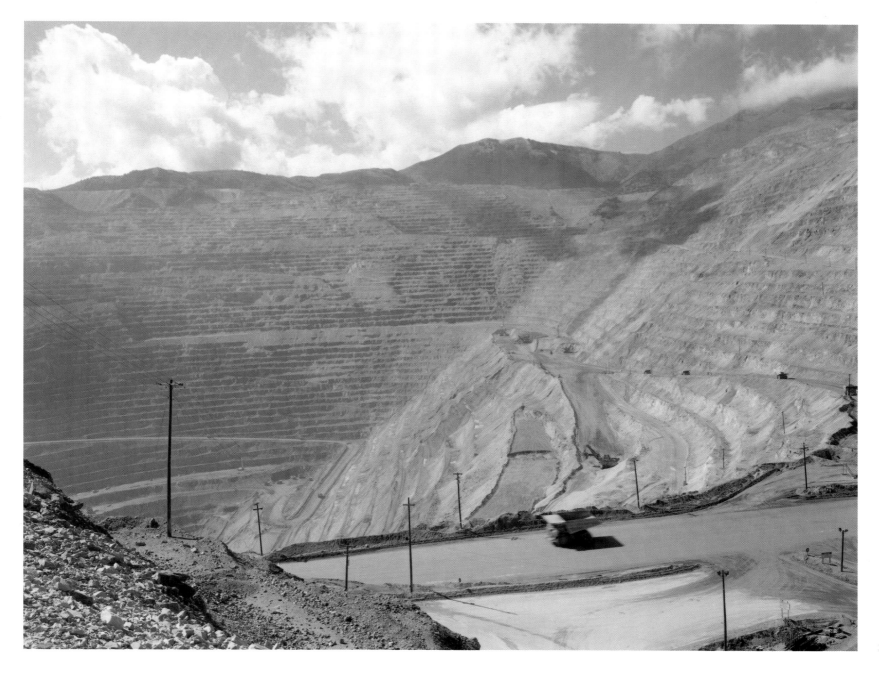

The historical image illustrates the narrowness of the canyon and the paucity of level land available for building. Visible on the hillside are the numerous rail lines that once hauled men and ore throughout the Bingham Canyon complex. The modern rephotograph again depends on distant hillside contours to approximate the original photographer's location. The relative dearth of buildings and people in the contemporary view is typical of developments in modern mining where far fewer people are needed for vastly increased ore production. During the late 1990s, Bingham Canyon Mine employed approximately 850 individuals, of whom only two were classified as miners. *Historical photograph by I. E. Carlson, courtesy of the Utah State Historical Society. Used by permission, all rights reserved.*

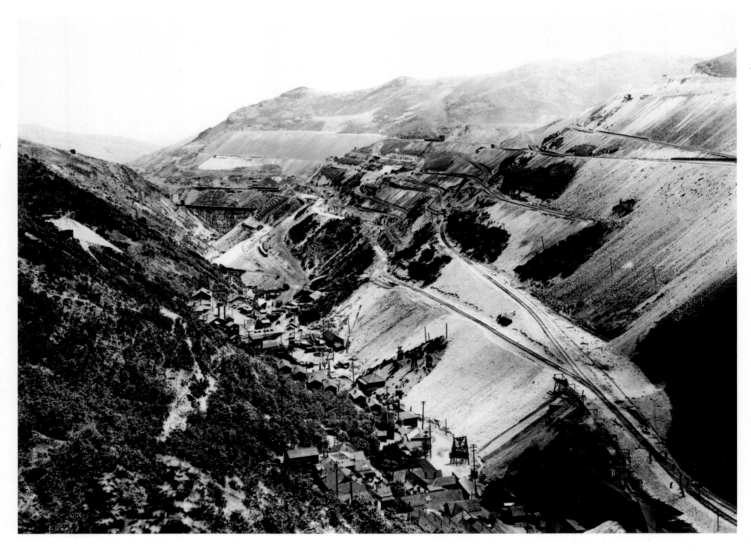

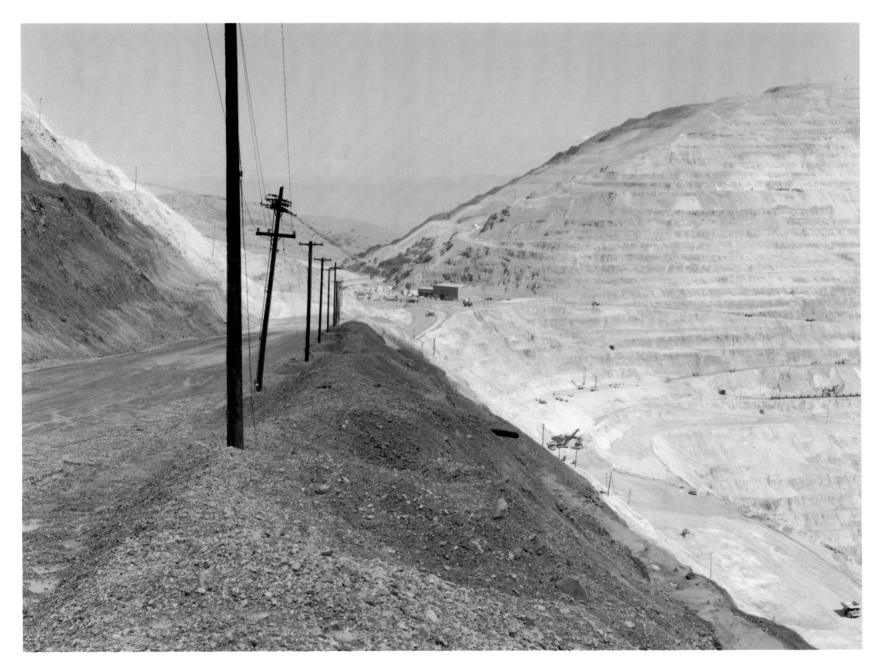

The historical image is captioned: "South Slavs in the Bingham area congregated at Highland Boy on the slopes of upper Bingham Canyon." As operations at Bingham canyon expanded in the early twentieth century, miners were recruited from throughout the world, creating an ethnically diverse industrial work force. As in Wyoming Valley, Pennsylvania, each group tended to settle together in distinct neighborhoods. By local accounts, Highland Boy was a particularly rough neighborhood. The density of its buildings testifies to the size of the population in the canyon, which was estimated to be approximately 20,000 people at its height. Not only the town of Highland Boy, but also the site from which the historical photograph was originally taken have now disappeared from the landscape, removed to accommodate the constant expansion of Bingham Pit. *Historical photograph courtesy of the Utah Style Historical Society. Used by permission, all rights reserved.*

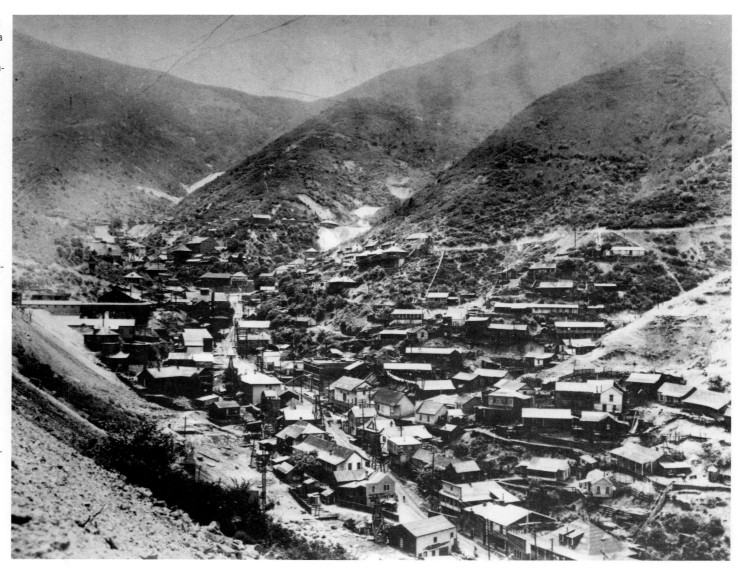

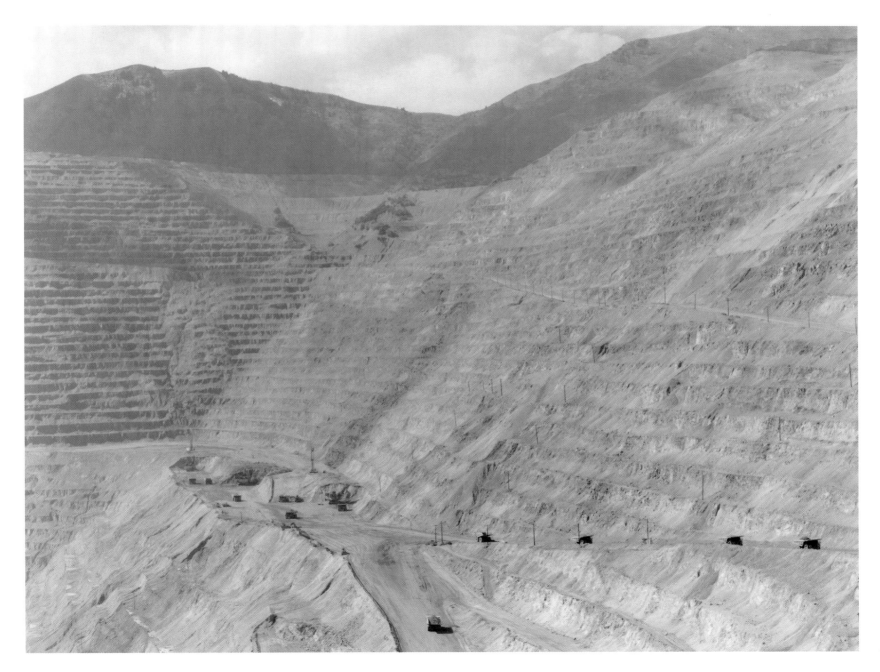

This historical view, by photographer I. E. Carlson, looks "down canyon" from Bingham's commercial center. The "up canyon" view can be seen on page 106. A few of the rock outcroppings and rail lines are still visible in the modern rephotograph which overlooks the mine's administrative offices and shops. The mountain from which the original photograph was made has, once again, been completely eliminated by mining operations. Finding one's bearings in the canyon can be difficult. Since Kennecott began using the canyon as a dump for its waste rock, the level of the ground has risen approximately 300 feet above the buildings pictured in the historical image. *Historical photograph from the A. L. Inglesby Collection, courtesy of the Utah State Historical Society. Used by permission, all rights reserved.*

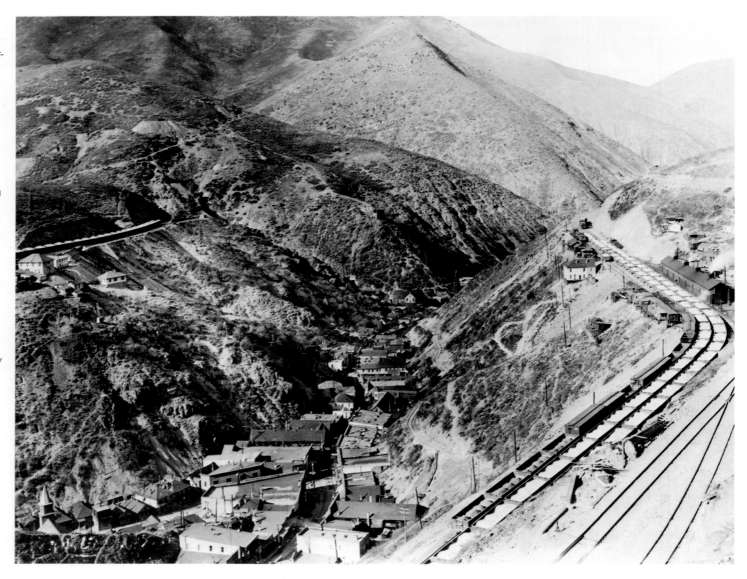

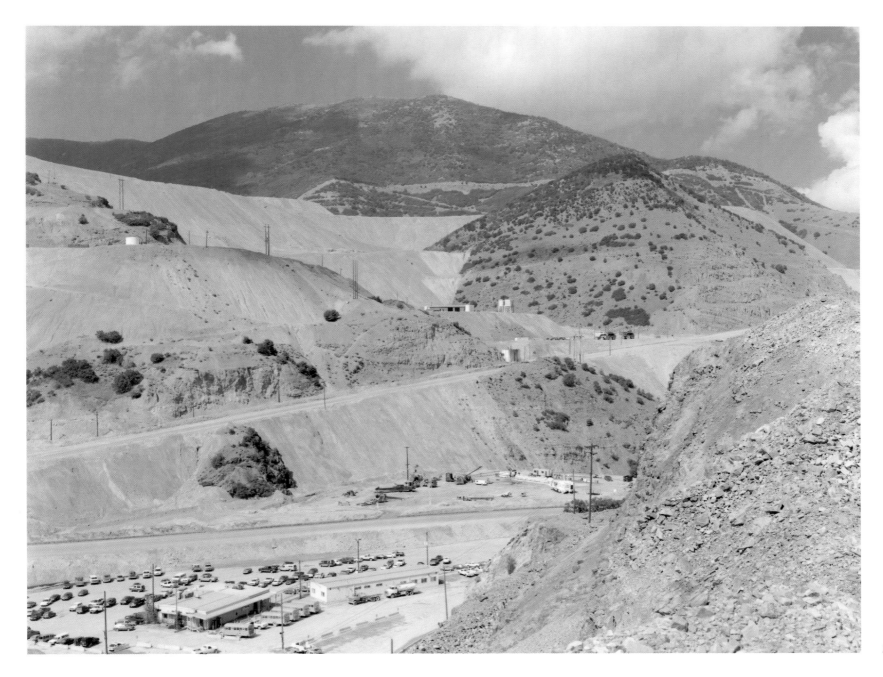

113

Mining at Bingham Canyon is routine, a year-round rhythm of drilling, blasting, and mucking, which is loading the loosened rock into giant trucks for transport out of the pit to the crushing and concentrating facilities. Twelve electric shovels are in the pit, each operating at different levels. Their numbers mark distinct locations, so that workers will describe themselves as being "at the 49," referring to the shovel they are closest to. Two to four daily blasts are required in order to supply the working shovels with rock to load into trucks on a round-the-clock basis. The largest shovel can pick up ninety-eight tons of material in each scoop. In this view the drill patterns consists of eighty-six holes shot at the 4,990-foot level of the mine. According to the blast crew, each drill hole in the pattern is fifty-five feet deep and twelve and a quarter inches in diameter. Each detonation contains more explosives than were used to implode the Alfred Murrah Federal Building in Oklahoma City.

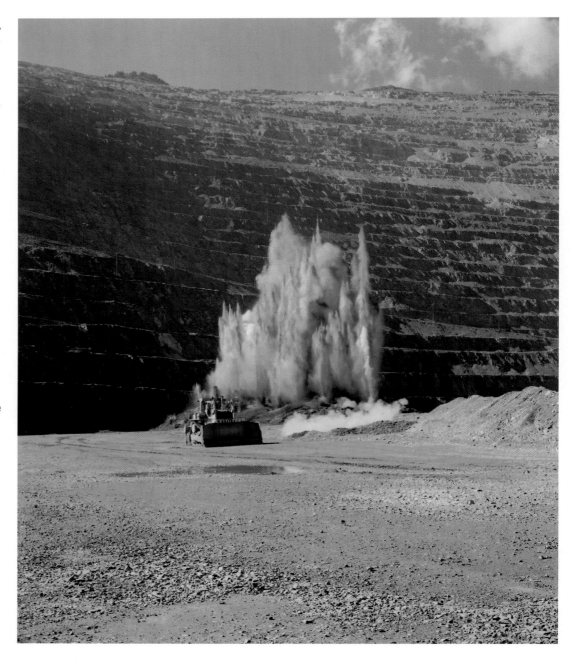

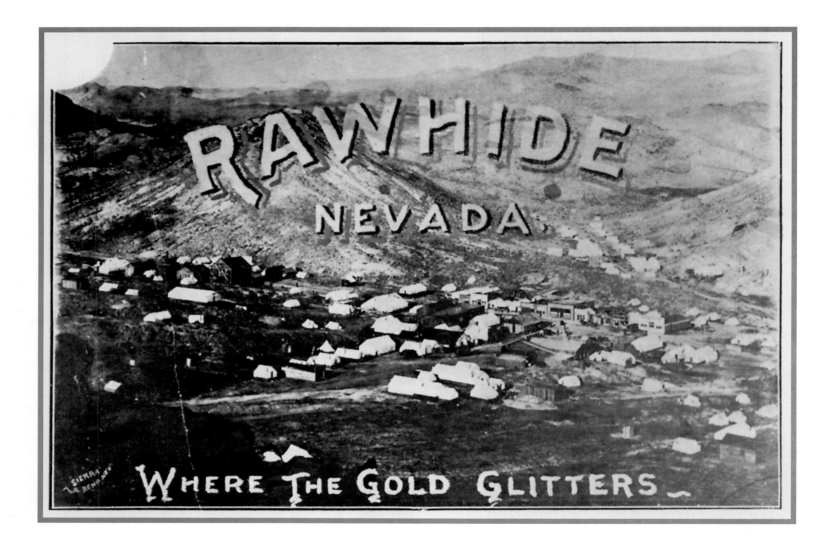

At Rawhide, Nevada, as in Bingham Canyon, a mine has transformed a landscape almost beyond recognition and displaced a town in the process, but there the similarities end. In contrast to Bingham Canyon, where mining has been steady and profitable, Rawhide is an extreme example of mining's capriciousness. Famed as a mining town for a few years in the early twentieth century, when it was touted by newspapers as "The Youngest and Richest Gold Camp on Earth," Rawhide never managed to live up to its reputation until the 1990s.[1] The active mine depicted in this chapter, by contrast, is just over a decade old and mining, ceased in 2003. Reclamation work is scheduled through 2005.

Rather than Bingham's semipermanence, Rawhide exemplifies the relentless boom-and-bust cycle that has stigmatized the mining economy. It is a prime example of mining speculation and promotion, a place that was the self-conscious creation of resident press agents seeking to sell stock rather than the creation of "mining men." Analysis of both historical and contemporary images of Rawhide reveals an interesting case of the mining landscape being used as a self-reflexive promotional device.

The modern Denton-Rawhide Mine in Rawhide is a typical open-pit operation where few of the original contours remain. This gold and silver mine is owned by Kennecott Corporation and two partners. In a story that has become familiar in recent years throughout the western United States, low-grade ore, with gold values averaging only .04 ounces per ton, has become profitable to mine by means of a new cyanide-based, heap-leaching technology. The technique is particularly widespread in Nevada, which has extensive deposits amenable to this form of treatment. As a result, Nevada is the state with the largest percentage of personal income and employment derived from the mining industry.[2]

In heap-leach mining, low-grade ore is removed systematically from a huge open pit. After blasting to loosen it, the rock is crushed, treated, and then piled on a leach pad. There a drip irrigation system distributes a cyanide solu-

N. E. Johnson's *Rawhide Nevada, where the Gold Glitters* is an exemple of early Rawhide promotional materials that made heavy use of photographs to publicize the camp's prospects. *Original courtesy of Kennecott Rawhide Mining Co. All historical photographs in this chapter are from this source, unless otherwise noted.*

tion over the heap to extract the precious metals, which are then precipitated out of the solution and processed in an electric induction furnace. A system of liners and drains captures the cyanide solution for reuse, and keeps it from contact with the local watershed. The Kennecott Rawhide Mining Company, which operates the Denton-Rawhide Mine, anticipated moving and processing eighty to 100 million tons of ore and waste rock at this site.[3]

The ratio of waste to ore is tremendous and the physical transformation of the landscape absolute. Disorientation is almost inevitable. The town and its original canyons have disappeared as entire hillsides are fed into the crushers. As part of the mine's reclamation plan, new artificial hillsides are being created nearby from waste rock. Yet straightforward dislocation is not the only consequence. The town of Rawhide had atrophied long before the arrival of the current mine operation, and seems to have assumed more importance in retrospect than it ever held in actual fact. Richard Francaviglia has observed this phenomenon: "If every culture needs ruins to emphasize its past accomplishments and its relationship to nature, then our once-prosperous mining towns are among the most powerful of our cultural symbols."[4] Rawhide, Nevada, a boom town that didn't experience a genuine boom until eighty years after its founding, and long after its physical disappearance, is surely among the more curious of such cultural symbols.

Due to spotty and refractory deposits, mining in early Rawhide never produced much gold. Instead the town was largely the product of ambitious promoters. Men seeking to encourage investment in Rawhide capitalized on early discoveries of rich gold ore to position their camp as the next

Tonopah or Goldfield, more distinguished and genuinely wealthy Nevada towns that had boomed nearby in 1901 and 1904 respectively. As a London geologist tartly summarized the matter in 1909, when the district was already in decline, "In the wild excitement of its younger days Rawhide won fleeting and intermittent fame that rose alternately from gold production and ink consumption."[5]

Rawhide, in short, was famous for being famous, depicted almost from the moment of its establishment as a stereotype, the quintessential western mining boom camp. In contrast to the process described by Duane Smith, however, in which glamorous images of the mining industry were created by outside observers, Rawhide's myth was cynically produced by men and women intimately involved in the industry and the place. It was not a creation exclusively by or for touring outsiders.[6]

In an extraordinarily short life cycle—from its birth in late 1907, through a heady period of crowding so great that people could barely move in its streets, to its virtual demise only three years later following a serious fire (see page 125) and then a flood—Rawhide achieved neither great nor permanent production from its ground. Yet the tantalizing lure of wealth, sustained by perplexing deposits of jewelry-grade ore scattered amid generally unpromising rock, enticed skilled promoters such as George Graham Rice. Rice was imprisoned for a fraudulent Nevada stock selling scheme in 1910, and recounted his escapades from prison in a book entitled *My Adventures With Your Money*. In concert with several partners, his efforts made the town into an overnight sensation, a locus for consumption and desire vastly disproportionate to the actual yield of the mines.[7]

Rawhide was, in fact, a mining boom town in which relatively little mining occurred, but it was impossible to know

that from any published accounts. Rice championed his Rawhide properties by means of what he called "press agenting," arranging to place in newspapers stories that prominently featured the camp and its potential richness. In one widely circulated tale, for example, it was reported that a chunk of ore loosened by a random dynamite blast in Rawhide broke a window in a nearby bank, and was worth enough that the banker accepted it in payment for the broken glass. Rice, the probable source of these and other such stories, reported himself "pleased in contemplating the fact that very little false coloring, if any was resorted to."[8]

Instead he used occasions such as the visit of popular British novelist Elinor Glyn, then infamous for her risqué book, *Three Weeks,* which had been banned in Boston. Glyn was invited to visit Rawhide by Tex Rickard, a well-known saloon and gambling house operator who later went on to manage the original Madison Square Garden in New York City. Rickard had earlier operated in Goldfield, where he promoted the famous 1906 Gans-Nelson championship prize fight and built the Northern Saloon. When the 1907 panic struck the latter town, and news arrived of a new gold strike at Rawhide, Rickard departed in search of new opportunities. As a contemporary reported it:

> When Rickard heard that gold had been discovered at a place called Rawhide, he along with his partner Nat Goodwin decided to dramatically publicize and promote the strike in order to create the kind of boom psychology that had so recently boosted places like Goldfield and Tonopah. In this way he hoped to draw in new hordes of fortune hunters and thereby bring profits to his various ventures. . . . Which is to say that he understood more clearly than anyone else

that on the mining frontier there was at least as much money in alcohol and cards as in gold. Stock companies were, as usual, created in large numbers by exciting and inflated stories which were given out to newspapers all over the country about the enormous riches presumed to lie beneath the desert around Rawhide.[9]

Nat C. Goodwin was the third member of Rawhide's publicity triumvirate. A popular comic actor from New York City who had also invested in Goldfield, he headed a brokerage house—Nat C. Goodwin & Co.—that boosted mines owned or controlled by Rice.

Glyn was already touring the U.S., and was visiting in Goldfield, accompanied by Raymond T. Baker and Utah mining magnate Sam Newhouse, one of the developers of the mine at Bingham Canyon. Seeking to capitalize on her notoriety, Rickard, Goodwin, and Rice invited her to experience the new camp in addition to the more established, four-year-old metropolis to the south. She arrived on May 27, 1908, to witness a staged high-stakes poker game that ended in an apparent double murder, and an elaborate ceremony in which she was appointed a deputy sheriff and presented with a pistol. According to one skeptical resident, the publicity machine was operating at its best: "No one recorded whether Miss Glyn's tongue was in her cheek, or a twinkle in her eye, as she thanked them for an unforgettable experience. But the bash has gone down in history as the ultimate in histrionics."[10]

Glyn's adventures in Rawhide (which was disguised as the town of Moonbeams) were duly reported in her subsequent book, *Elizabeth Visits America,* published in 1909. There she makes clear that her tongue was, indeed, planted firmly in her

cheek, as she recalls how the Nevada men told her "delightful things of shootings and blood-curdling adventures, and all with a delicious twinkle in the eye as much as to say, 'we are keeping up the character of the place to please you.'" Nevertheless, her highly romantic novel climaxes with the excitement of a robbery and deadly shoot-out in Moonbeams/Rawhide. And because Glyn was a celebrity, her travels were also widely reported in the press. As Rice blithely declared, accusations of fakery made no difference: "Every knock's a boost. Just the fact that we could get anyone as prominent as Elinor Glyn to visit us will impress people with Rawhide's growing importance."[11]

As predicted, Rawhide gained national prominence in the aftermath of Glyn's visit. Throughout 1908 it attracted what Rice described as "an ever shifting kaleidoscopic maelstrom of humanity," made up of "fashionably tailored Easterners, digging-booted prospectors, grimy miners, hustling brokers, promoters, mine operators and mercantile men, with here and there a scattering of 'tin horns.'"[12] All of them contributed to the town's aura of feverish excitement and self-proclaimed importance, as well as its escalating need for commercial services such as saloons, hotels, and banks.

But Glyn wasn't the only source of publicity for the young camp. Rawhide in 1908 was the subject of popular music ("In Rawhide Where Young and Old Are Finding Gold" by Glenn W. Ashley and Fred E. Jones), of promotional poetry ("Rawhide" by William Tompkins, the Rawhide Booster), and, most notably, of Riley Grannan's Funeral Oration, delivered by one-time Methodist preacher W. H. Knickerbocker. Grannan was a noteworthy gambler whose exploits "furnished sensational headlines for newspapers for many years," due to the remarkable size of his wagers. When he died in Rawhide in April, 1908, of pneumonia, the event was of national interest to the sporting set. His funeral, reportedly bankrolled by Tex Rickard, was held in the back room of a saloon. The eulogy was reprinted in numerous pamphlet and text versions, reportedly based on the shorthand notes of a California reporter who conveniently happened to be present (although a contemporary observer says that no one took any notes at the time, and that Knickerbocker spoke extemporaneously).[13]

In any event, the resulting paean to the efforts of a less-than-perfect man, who did the best that he could, proved to be far more enduring than the town itself. Grannan's eulogy was reprinted as recently as the 1970s, and exists in numerous versions in archival collections. The net effect of these various publicity efforts was to keep Rawhide's name constantly before the public, and to lure both the attention and the money of eastern capitalists. Not coincidentally, Rice and Goodwin were poised to sell stock to anyone who might desire to participate personally in the excitement of Rawhide.

Visual images were also an important, though sometimes neglected, part of that promotional effort. Views of Nevada's newest mining district, which Rice and Rickard hoped would be a successor to Goldfield, were circulated not only in numerous mining publications, but also in general periodicals. A special photographic booklet by N. E. Johnson, *Souvenir Views of Rawhide* was published in Los Angeles in 1908, at the height of the promotional frenzy. Another collection, *Rawhide Nevada, Where the Gold Glitters,* was published by the same photographer around the same time. The photographs of the mining

landscape contained in these volumes depicted Rawhide as the prosperous mining community it aspired to be rather than the evanescent boom town it was in fact.[14]

In a series of carefully selected views, Rawhide was revealed to the viewer as it progressed with lightning speed from camp to fully developed town. Rawhide's status as a "real town" was perpetually at issue, and newspaper articles frequently recited the number of businesses, frame houses, and leases in operation, in order to distinguish the settlement from a mere camp that might flourish temporarily but would then wither and die. The foreword to *Souvenir Views*, for example, assured the reader that "the publishers

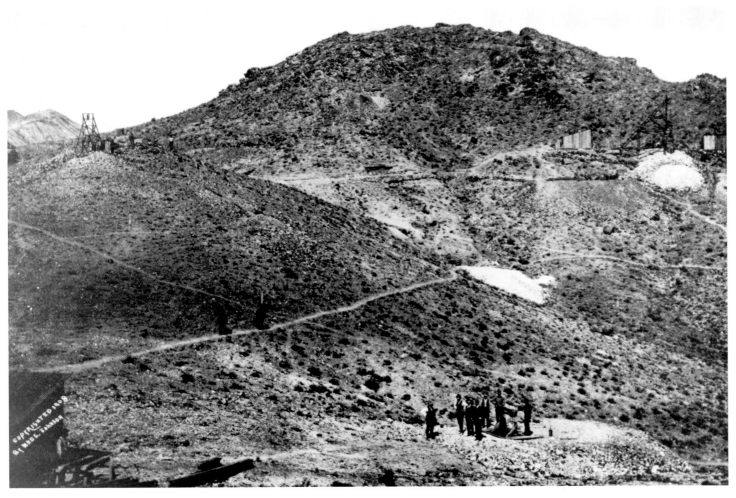

This 1908 view, by photographer Ned E. Johnson, shows Owl Leases 1, 2, and 3 of the Rawhide Operating Syndicate. It aptly illustrates the difficulties of making the raw mining landscape look impressive to uninitiated viewers.

. . . have no other object in view than to show the public at large, the marvelous growth of the camp from the time of its inception to the present day." One of the most thorough journalistic accounts of the town placed considerable emphasis on its acquisition of "the forms and institutions of settled life," including public utilities such as a water company, an electric light franchise, and a railroad (the latter planned but never built). All of these were considered to be symbols of a permanent town, a place that warranted further attention, even financial investment. In the words of the Rawhide City Directory for 1908–1909, "The influx into Rawhide goes on a record as a worldbeater in the history of mining camps."[15]

The difficulties of visualization were manifold. Even the most prosperous mines were difficult to glorify visually, as few viewers could be expected to understand the complicated interplay of headframes and hoists, development work and active mining for shipment. In Rawhide, as in most Nevada desert mines until recently, familiar elements of the technological sublime were missing. Absent an impressive mill, the mechanical works of individual mines actually seemed rather puny. Even the most impressive technical accomplishments at Rawhide scarcely registered in the immense surrounding landscape. Frail and apparently temporary, they failed to evoke the sense of mastery over nature that was the essence of the celebratory sublime.[16]

This representational dilemma in mining photography gave rise to a new repertoire of visual symbols to convey the meaning of Rawhide's mining landscape. A few examples suggest the nature of that vocabulary. The St. Ives lease reveals few signs of mining beginning to emerge on the landscape. Instead it prominently features the principals in the company, clustered to admire what is presumably an extremely rich sample of ore from their ground. Their rapt attention makes what is otherwise nondescript rock into an object of apparent significance. Similar ore had actually created several millionaires in Goldfield a few years earlier, but Rawhide's deposits were notoriously shallow and unreliable. As one mining observer cynically commented: "It is not uncommon to see very rich hornings on any and all of the principal leases. When one knows the streaks and seams, the richest kind of rock is readily found for the visitor. Many a visitor leaves the camp with the most glowing yarns of the hornings that have been made for him."[17]

The ploy was remarkably successful. Although a few critics remonstrated that they were never allowed to sample systematically at Rawhide but shown only the jewelry-rock—the richest streaks that occurred without apparent pattern throughout the area—many were willing to believe that Rawhide was a new Goldfield in the making. Rawhide's population actually peaked at approximately 4,000 people in 1908, but published reports claimed that as many as 10,000 had arrived in the town. As the local newspaper editor put it: "Rawhide is in the air. . . . Rawhide is bewildering. It is day all day in the daytime and there is no night in Rawhide. The streets in the chill of the dawn are as thronged as they are at midday. Everybody is in a hurry and everybody has a mysterious secret to whisper to everybody else. . . . Pockets are laden with specimens and location notices. Brains are full of air castles. No one is poor in Rawhide even if he hasn't a cent in his jeans."[18]

The photographs gave visual form to the spirit of excitement, dwelling on the huge teams and wagons devoted to hauling sacks of ore from Rawhide. Such canvas bags of ore were a kind of visual mining shorthand, signifying to the

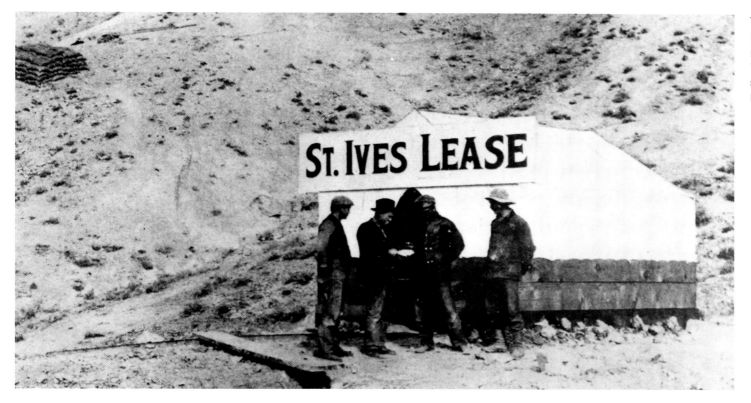

The St. Ives Lease, on Balloon Hill, was depicted in photographer Ned E. Johnson's *Souvenir Views of Rawhide.* Note the stacked bags of ore in the upper left background.

observer that the companies had located rock sufficiently precious to justify the labor and the considerable cost of transporting it out of the camp by wagon for processing and refining elsewhere. Only ore of substantial value would justify such expense. In written accounts of the mining districts, reporters were careful to specify the number of ore bags amassed on each lease they visited.

More careful observers questioned the prevailing pieties. One anonymous commentator in the industry journal, the *Mining and Scientific Press,* commented shrewdly: "I saw some twenty or thirty sacks of ore on the hill, but no claims are made that any has ever been shipped. . . . On one lease some twenty sacks are piled, and at two other places from five to ten sacks. These have been on the ground for several months. One lessee claimed $12,000 per ton for his six sacks— but no care was taken to prevent theft! This is a sample of the 'dope' that is handed out."[19] In fact it was true that, as it soon became apparent, the bulk of Rawhide's ore was not of shipping quality. Even the construction of three small mills by 1909 didn't bring wealth. But the visual images promised prosperity in the form of those laboriously filled ore sacks.

More successful in representing mining success at Rawhide was the photograph of the Grutt Hill–Truitt Mining

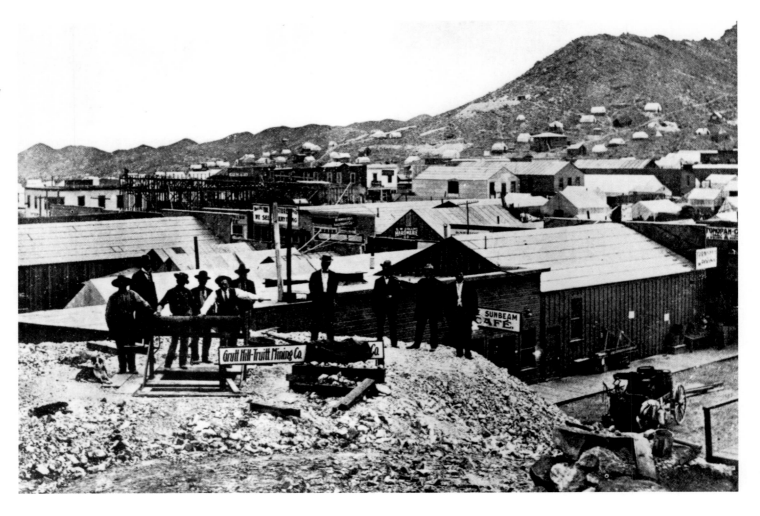

The Grutt Hill–Truitt Mining Company has little in the way of equipment to show, but its proximity to the burgeoning town of Rawhide—now with many frame buildings—is meant to reassure viewers that its prospects are good.

Company. Grutt Hill featured the first major producing mine of the district, and this prospect was intentionally juxtaposed against the urban growth that it had presumably spawned. Views such as this one magnified the importance of the small hillside shacks of the St. Ives Lease, instructing the observer about the crucial link between the mines above and the substantial residential and commercial development evident in the canyon below. In topographical views such as this one, Rawhide mining companies took on aspects of a commercial, if not a technological, sublime.

Even at the height of the rush, in 1908, the most generous estimates of actual mining employment in Rawhide fluctuated between 250 and 500 men. Many observed that the

masses of humanity attracted to Rawhide were hangers-on, not miners, "idle men" who filled the dozen gambling saloons to overflowing. Although Rawhide at the time boasted two exuberant newspapers, ten brokerage houses, two banks, five restaurants, and fourteen saloons—and competitors at Goldfield proclaimed it a "New World Wonder"—in the end it proved a mere flash in the pan. In the words of one of its residents: "In general the promoters were selling stock and not mining."[20]

Compressing the normal lifespan of a mining town from years into months, Rawhide busted almost as quickly as it boomed. The townsite was laid out in September, 1907, and population peaked in March, 1908. In September, 1908, a disastrous fire nearly destroyed the entire camp, burning most of the business section. Stories quickly circulated of the miners who, lacking a source of water to extinguish the fire, had attempted to save the timbering in one mine by pouring beer on the flames. Although many owners rebuilt, the economic depression and collapse of both banks dampened enthusiasm for potential riches in Rawhide. Some of the speculators and gamblers drifted away to more prosperous surroundings. In August of 1909 a cloudburst flooded the narrow canyon housing the town, sweeping buildings, tents, and equipment away in its path. From this disaster Rawhide never recovered. The steady population of 500 dwindled to about fifty, and although some mining continued, the few remaining buildings gradually subsided into a state of decay or were moved away to be used elsewhere.[21]

For roughly seventy years, until the 1980s, Rawhide was quiescent. The last permanent resident moved away in 1966,

This view of the Rawhide fire in September, 1908 was reproduced on a postcard now in the collections of the Nevada State Historical Society, Reno. The fire began in a pharmacy and destroyed numerous commercial buildings and homes. Although the town was rebuilt, the fire marked the beginning of Rawhide's precipitous decline from its glory days as a famed boom town. *Photograph courtesy of Nevada State Historical Society, Reno.*

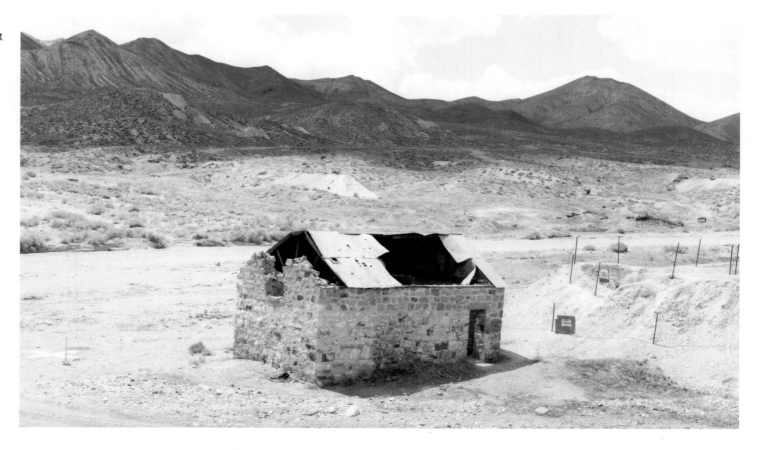

and Reno newspaper headlines mourned the town's demise in 1950: "Rawhide Now Is Deserted and Barren."[22] Photographers lingered lovingly on the few physical remains of the boom period, which were themselves more speculative than solid. The aging equipment and stark headframes became prime visual examples of what Richard Francaviglia has labeled "technostalgia," a romanticization of the remains of the industrial past.[23]

Yet in the long period of "genteel decline," the romance of Rawhide's reputation as "the last mad camp of that mad de-

cade" lived on. In a 1941 obituary for the town, occasioned by the announcement that its post office would be closed, the *Reno Evening Gazette* forthrightly admitted that Rawhide "was, in a truer sense, more of a promotion camp, founded on speculation and hope, than it was a bonanza."[24] That it failed as a mining proposition, however, did not affect its mythical status.

What the paper glorified in retrospect was the same thing that the town's backers promoted in its early prime—its potential, the promise of wealth that it represented to the many

who flocked there, and to the many others who sent money to be invested. In the words of the *Gazette*: "These camps never die because there will always be prospectors who envision a discovery that will restore them to their former status. Sometimes these dreams are realized. Even Rawhide may rise again to some measure of the heights it reached for a few brief months in 1908."[25]

Prescient in ways that could scarcely have been imagined in 1941, the Reno paper was referring to nearby deposits of tungsten, which was a strategic wartime metal at the time. In fact it was precious metals, gold and silver, that finally brought Rawhide the mineral wealth that so many had confidently predicted in the first decade of the twentieth century. In the process, however, the earlier mining landscape that had been painstakingly created and exuberantly promoted as an icon of prosperity was completely obliterated, as documented in the accompanying photographs. Indeed, the landscape that had once been Rawhide was so drastically altered during the 1990s that mine managers were uncertain about the identity of photographs only six years old.

Perhaps mindful of the ironies inherent in celebrating a heritage it prepared to obliterate, Kennecott invited several descendants of early Rawhide claimants to attend the dedication for the Denton-Rawhide Mine in October, 1990. One of them was Eugene Grutt, whose father named Rawhide's Grutt Hill and continued to operate there into the 1930s. According to press reports of the event, Grutt pronounced himself satisfied that Rawhide would now experience, "for the first time, a sense of mining stability." A colleague, eighty-year-old Horace E. Dunning, declared that while Rawhide had "'always been there,' . . . it is only with the recent mine development that he has felt its mining future has been 'made.'" During the 1990s Rawhide at last became what its founders had always planned for it to be, a fabulously lucrative mining district. At that same moment, it began to vanish altogether from the face of the earth.[26]

The new mining technology of heap leaching involves the physical destruction of entire mountains, which are pulverized, stripped of their minute ore content, and redeposited in new configurations. The new landscape of Rawhide genuinely incarnates the technological sublime that its predecessors never manifested, but it simultaneously erases human scale altogether.

Indeed, the boom town that has now come to life after so many years of anticipation is no longer a town at all. In a final act of reconstituting identity, Rawhide's sole remaining building, a stone jail, was refurbished by Kennecott and removed to the county seat of Hawthorne, some forty miles distant (see page 138). There it sits in splendid isolation, in the corner of a parking lot, one last example of Rawhide reinventing itself for public consumption. A commemorative marker proclaims the place, against all odds, "one of the most authentic western mining towns in the state of Nevada."

By now the "authentic" Rawhide is no longer the physical setting in which profitable mining currently occurs, but the spectacular image that was self-consciously created to represent that place. As the archaeologists who assessed the district for the Bureau of Land Management remarked in 1993, Rawhide "was one of the highly publicized places that helped to form the present widespread notion of what a mining town in the 'old west' was like."[27] The fact that such a past never really existed—that it was a fiction of skillful promoters and that Rawhide never achieved the permanence or the prosperity it so desperately sought—is ultimately irrelevant. The landscape that once constituted Rawhide has been obliterated by the modern Denton-Rawhide Mine, but its multiple and incongruous cultural vestiges persist.

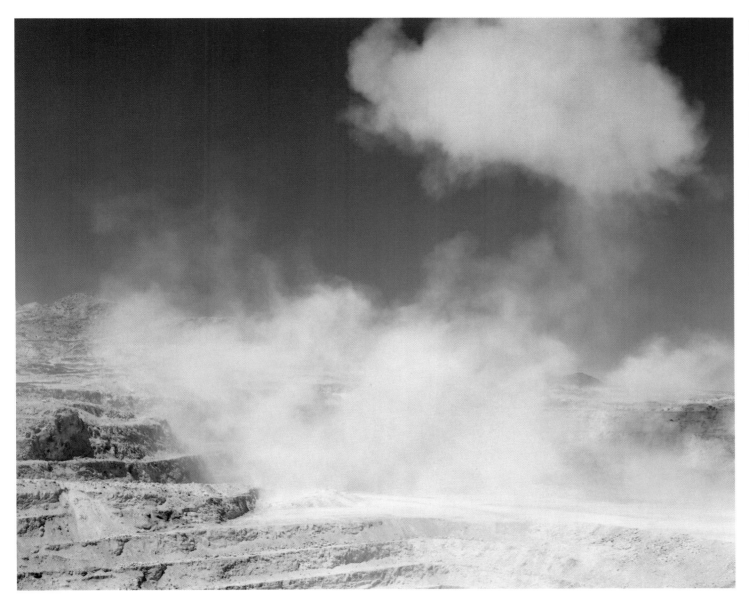

The oxymoronic name "Murray Hill Pit" reveals the nature of modern mining's transformation of the Rawhide landscape. This 1995 blast created a huge area of loose rock. Ore is mapped out by mining geologists before a bench is shot, and the area is marked with colored flags. Material without potential as ore is waste rock, carried directly to dump sites after it is loaded into trucks. Ore is loaded into other trucks and carried out of the pit for crushing and further processing, before being placed on the leach pad for infiltration with cyanide.

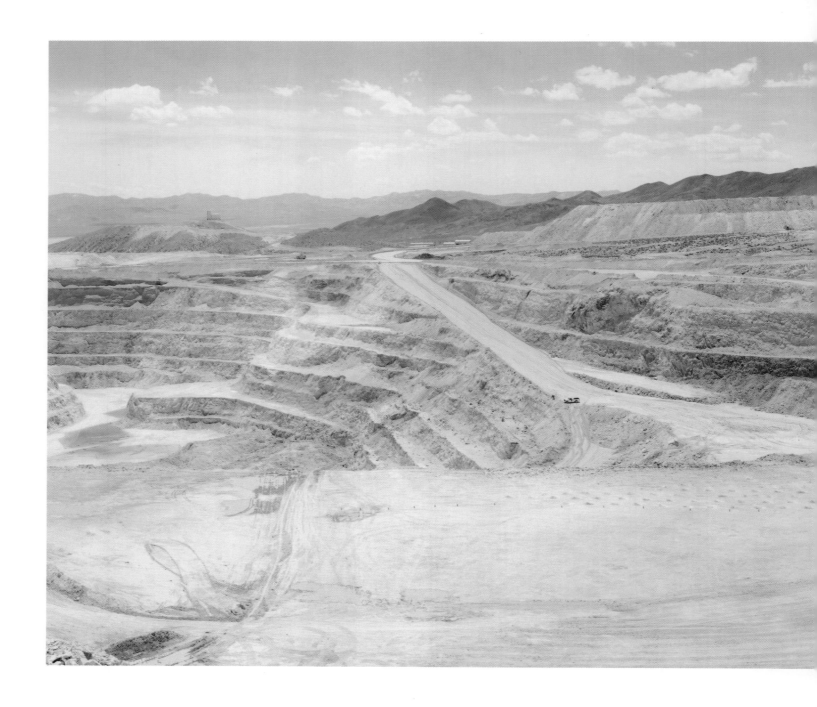

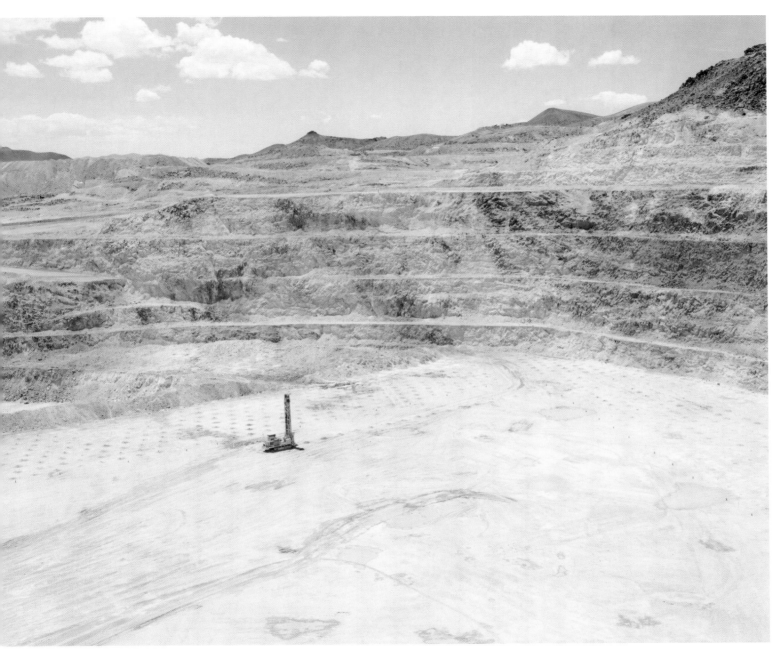

In 1995, when these photographs were made, the Denton-Rawhide Mine moved an average of 1.33 million tons of material monthly. Visible in the right foreground of this panorama is the drill rig, surrounded by a uniform pattern of blast holes that it is preparing for the next shot. The mine buildings can be seen in the center distance of the left panel, where a sizable utility vehicle nonetheless seems dwarfed on the road into the pit.

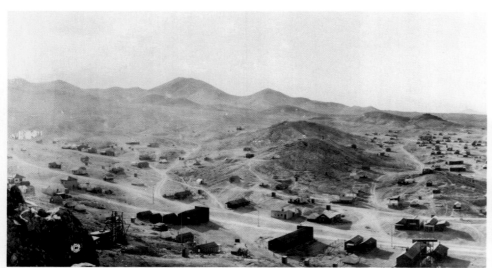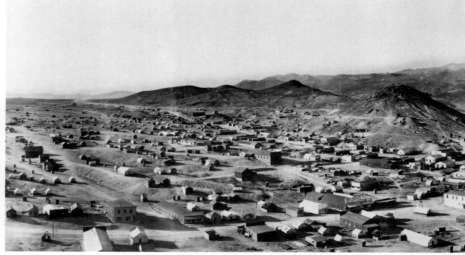

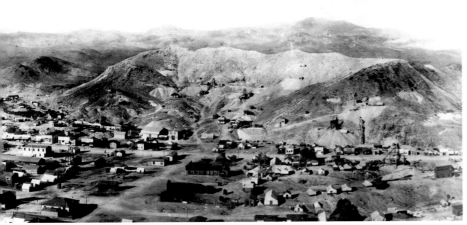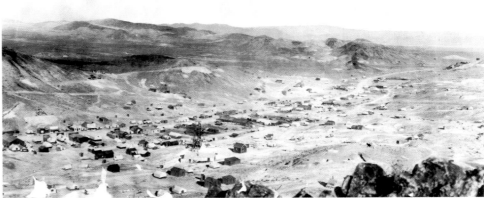

This historic panorama of Rawhide, Nevada, consisting of four images, was taken from Hooligan Hill. It was likely made by the photographer Ned E. Johnson, who published earlier souvenir booklets promoting the town. Most of the mining activity is visible in the third panel from the left. Dating the panorama is difficult, but an analysis of mining activity and urban structures suggests a date after the fire of 1908 and flood of 1909, or circa 1910. Despite the evident decline of the town, this panorama still reveals a sizeable collection of substantial buildings. Fewer tents are visible than in earlier views, and some two-story commercial buildings are in evidence. *Photograph from the collection of Peter Goin.*

This pair of photographs depicts the gradual dismantling of Grutt Hill, once the principal location of Rawhide mines. The left view is from 1989, before the Denton-Rawhide Mine had begun full-scale operations. The right view was made in 1994, and shows Grutt Hill from nearly the exact vantage point as the 1989 view.

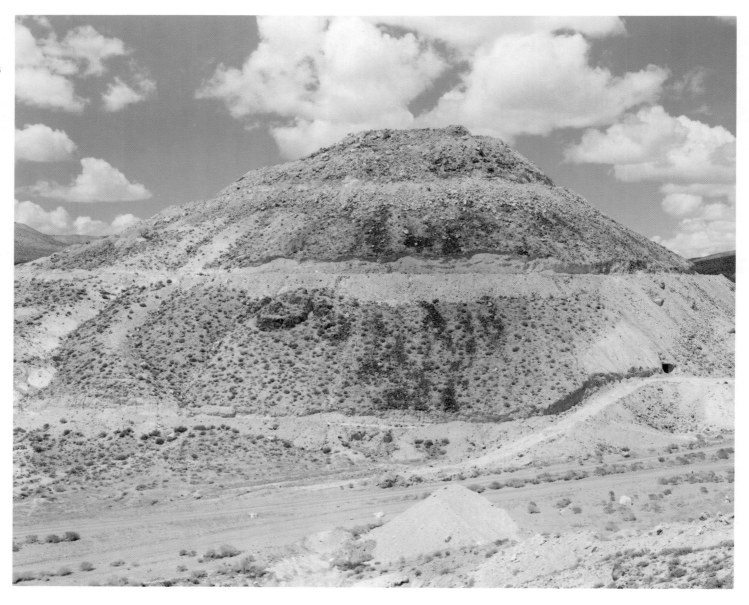

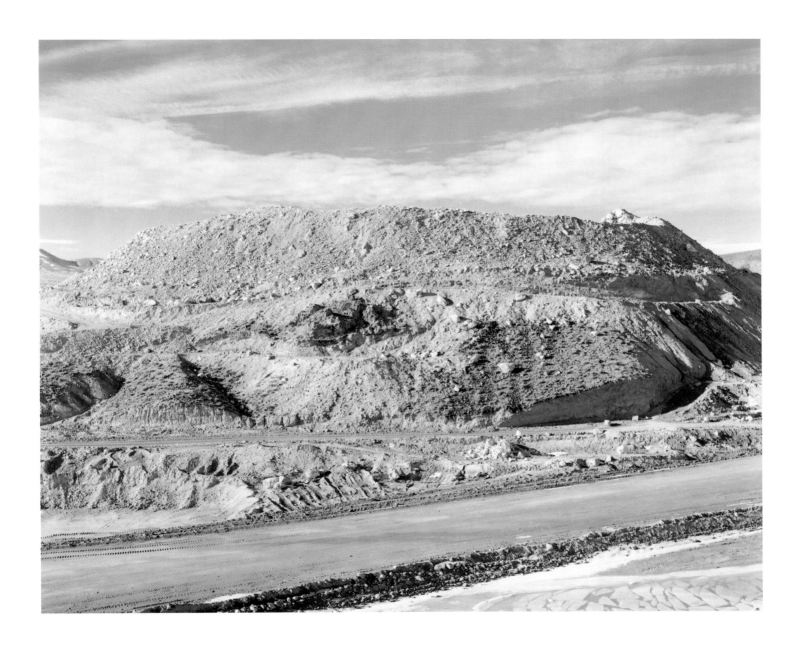

This view of Grutt Hill was made in 1995. Note that the horizon is now visible. The apparently minuscule haul trucks are capable of holding more than 150 tons.

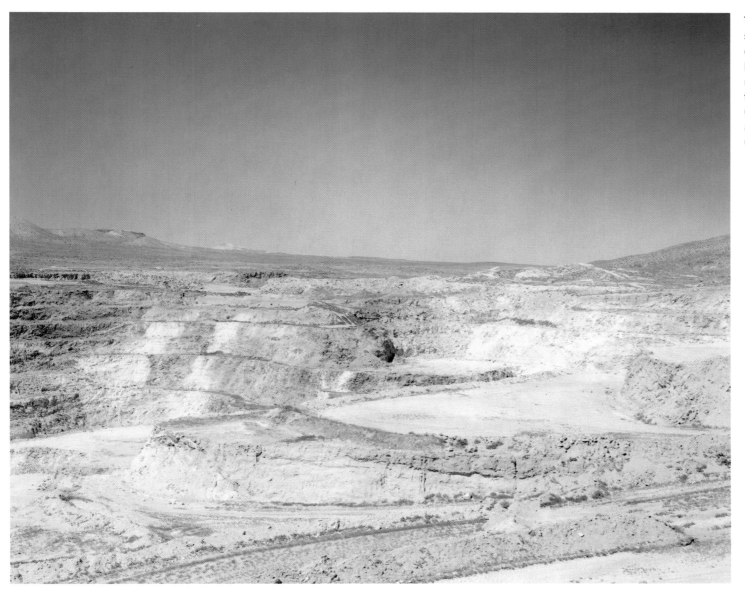

This fourth image in the Grutt Hill sequence shows the dramatic consequences of mining at Rawhide. This photograph was made in 1998, three years later than the image on the left. Grutt Hill is no longer, and the area is now referred to as the Grutt Hill Pit.

The Rawhide Jail has received iconic status as the embodiment of local mining legend. It has now been reassembled in Hawthorne, Nevada, approximately forty miles from its original site. The marker on the building encapsulates the mythological history of Rawhide. It reads, in part: "The Rawhide jail building was originally constructed in 1908 in the town of Rawhide, Nevada. Between 1907 and 1910 Rawhide, located in northern Mineral County, hosted a population of 7,000 miners and their families. It became one of the most authentic western mining towns in the state of Nevada, and the center of much commerce, industry, and hope. These hopes were dashed by fires, floods, and the advent of WWI, and ultimately Rawhide diminished to its ghost town status. Nothing substantial occurred in the form of commerce or mining, from the late 1920s until the late 1980s. During this sixty year period, the town deteriorated but the Rawhide jail stood. It became the symbol of the old town of Rawhide and the wild, tough, way of life that was epitomized by its name."

A Mine Is a Terrible Thing to Waste
Eagle Mountain, California

In the Mojave Desert of Riverside County, California, a former iron mine is now surrounded on three sides by Joshua Tree National Park. Like both Bingham Canyon and Rawhide, the Eagle Mountain Mine is a huge open-pit operation, variously identified as the second-largest iron mine or the fourth-largest open-pit mine in the nation.[1] Unlike Bingham Canyon or Rawhide, the mine at Eagle Mountain was no longer active when photographed by Peter Goin. This area is definitively a post-mining landscape whose next incarnation is the subject of considerable controversy. A 1990s proposal to reclaim the mine by using one of the pits as a waste disposal site was twice blocked by state court rulings over the effect of the landfill on the nearby park, and opposition continues.

At first glance, Eagle Mountain appears moribund. The mine is no longer operating, but its towering waste dumps and industrial buildings still litter the landscape. The property has even been used as a movie set to represent post-apocalyptic America (see pages 156 and 157). The town that once served the mine is mostly boarded up (see pages 152 and 154). The principal local employer is a private security prison that opened in 1989 and is still in operation. This facility was located at Eagle Mountain precisely because the isolation of the abandoned site seemed ideal for incarcerating criminals.

Yet, visual dereliction is not the only story of the landscape at Eagle Mountain, and many are reluctant to consign it to oblivion as a marginal or wasted place. Indeed the future of Eagle Mountain is bitterly contested. Landfill proponents seek to repopulate the town, urging the rationality of reclaiming a mine pit by filling it with domestic waste. Opponents decry the potential effects of both garbage and people on both endangered tortoises and Joshua Tree campers seeking solitude in wilderness. Both sides envision redemption of the post-mining landscape, but by different means and to divergent ends. Meanwhile, former residents gather in cyberspace to commemorate a community life that they found idyllic; and nearby organic jojoba farmers

This 1996 view of an abandoned street in the Eagle Mountain townsite looks northwest. Revival of the town is part of a contentious landfill proposal, while former residents of the town maintain their community in cyberspace, by means of a website named "Eagle Mountain Refugees."

champion an alternate, agrarian identity for the region. At Eagle Mountain, it has proved difficult to build consensus about the proper use of a former mine.

The site was first claimed in 1881, when the ephemeral town of Moore City was established nearby. These first claims were allowed to lapse, however, and new locations were made in the 1890s. Mine names such as the Iron Age and Iron Chief clearly indicate that the presence of iron was recognized, but these properties were being worked for gold in the late nineteenth and early twentieth centuries. The occasional lumps of magnetite (hard, magnetic iron) were considered a nuisance because they fouled the crusher that was preparing the gold ore. They were known as "spuds," because of their resemblance to potatoes, and almost caused closure of the property in 1907. It was this iron, and not the spotty gold deposits, that brought Eagle Mountain to the attention of the Southern Pacific Railroad. In 1912, the property was acquired by E. H. Harriman, who eventually combined 187 claims to form the Iron Chief Mining Company, a railroad subsidiary. Estimates at the time placed the reserve at forty to seventy million tons of ore, at an average of fifty-four percent iron content.[2]

Although the iron deposits at Eagle Mountain were recognized as the most significant in the state of California, they were not mined during the years of Southern Pacific ownership. Some copper was produced at the Black Eagle Mine during the 1930s and early 1940s, but the fifty-one miles between the mine and the nearest railhead, at Ferrum, were an obstacle to economical iron production. Instead other land uses prevailed in the Mojave Desert. In 1930 Joshua Tree National Monument was established to protect and preserve a notable stand of the unique desert trees. During World War II, General George Patton brought his troops to the nearby town of Desert Center to train for the military campaign in North Africa. The presence of the iron produced no significant landscape changes until the escalation of wartime demand.[3]

In 1944, Kaiser Steel Corporation purchased the Iron Chief properties from Southern Pacific to supply its Fontana Steel Mill near Los Angeles. Kaiser had just completed the first vertically integrated steel mill in the western U.S. and needed a reliable supply of iron. The Southern Pacific claims contained fully one-third of the iron reserves in the state, enough to supply the blast furnaces for a considerable period. The heavy magnetite was also used as ballast for ships. Kaiser renamed the claims for their location in the Eagle Mountains and set about to develop a modern iron mine. It began building in 1947, including railroad connections to Ferrum, housing for workers, mine offices, maintenance shops, and ore crushing and loading facilities. The first ore was shipped in August of 1948. In 1950, the land for the townsite was officially purchased by Kaiser and removed from the Joshua Tree National Monument.[4]

Gold had been mined underground at Eagle Mountain in a series of shallow tunnels and shafts. Iron, however, was mined in open pits. The first of these was the Bald Eagle Pit, followed in 1951 by the North-South Pit. These were combined in 1958 into the East Pit. As the percentage of iron contained in the rock declined, the size of the pit steadily increased, and the configuration of the mine changed continuously. In 1957, Kaiser built beneficiation facilities at the mine. The new plant concentrated the ore—which averaged forty to forty-five percent iron when it came out of the ground—to the sixty percent level that constituted "shipping grade." When ore was

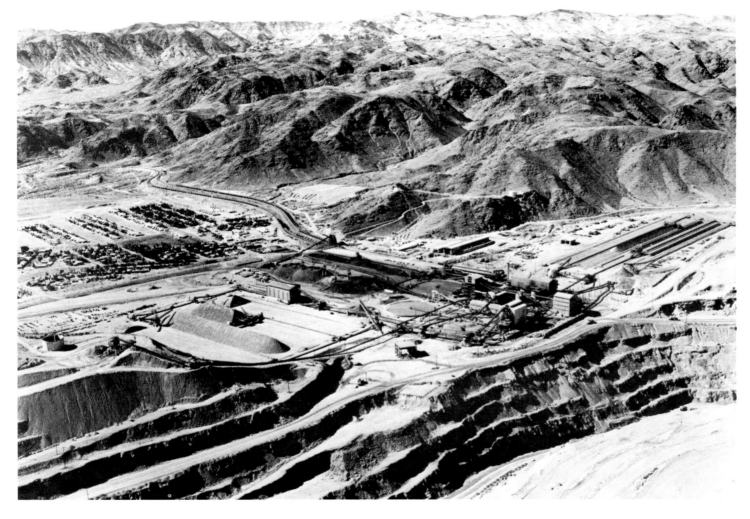

The oblique aerial view of the Eagle Mountain mine and town illustrates their proximity to each other. *Photograph courtesy of Kaiser Ventures Eagle Mountain, Inc.*

discovered beneath the plant in 1960, it had to be moved, and the pits were reconfigured once again. A second, West Pit, was opened in 1966, five miles to the west of its predecessor. Here the ore was even less concentrated than in the East Pit, but was intended to feed a new pellet plant that opened in 1965. In a process similar to the treatment of taconite on the Mesabi, Eagle Mountain's pellet plant processed lower-grade ore into round pellets that were sixty-five percent iron. These pellets were used in new, improved blast furnaces that Kaiser was installing at Fontana.[5]

Kaiser's investment in its operation at Eagle Mountain was not merely technological. In a booming post–World

War II economy, attracting and retaining workers in a remote location was a constant challenge. Kaiser set out to entice to Eagle Mountain not simply miners, but miners with families, who were likely to be a more stable workforce. The company's principal recruiting tool was the model town that it constructed. Beginning in 1949, Kaiser built a total of 416 comfortable, suburban-style homes for its workers. These houses ranged in size from 700 to 1,400 square feet and were insulated and air conditioned. They had lawns and sprinkler systems. Kaiser paved and lighted the streets, piped in water, and built a sewer system. The company picked up the trash, and paid the electricity, propane, and water bills. Residents who sought more space simply put their names on the waiting list for a bigger house, although the largest home was always occupied by the mine superintendent. During the 1960s Kaiser touted

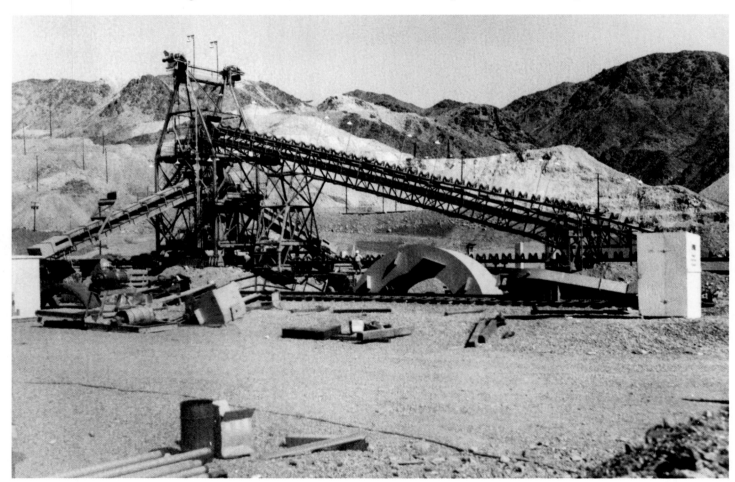

In this 1965 image of a conveyor belt at Eagle Mountain, the eponymous range is visible in the background. *Photograph courtesy of Kaiser Ventures Eagle Mountain, Inc.*

its success in transforming its distant corner of the Mojave Desert into a suburban American haven. "The cool, shady streets, well-manicured lawns and fresh, neat homes of Eagle Mountain," it proclaimed, "are a refreshing sight in the shadeless brown of the Colorado desert."[6]

The town of Eagle Mountain was always intended to be more than a dormitory. Kaiser provided a swimming pool, recreation center, playground, and early cable television. It built an elementary school in 1956, and a high school in 1962. The town had a small shopping center, a clinic, a service station, and a Bank of America branch. Both the Methodists and the Church of Jesus Christ of Latter Day Saints built churches on land donated by the company. For many who lived there, Eagle Mountain was an oasis, "a place where everyone knew everyone and *everyone* cared. It was a Norman Rockwell town before we knew to call it that."[7]

Residents remembered leaving doors unlocked and keys in car ignitions. There were scout troops and square dancing clubs, parades and dune buggy races. People even became accustomed to the daily blast at the mine and the noise of the large diesel trucks. Steve Moore recalled "the constant background sound of the mine in operation and how eerie the silence was when the mine would shut down."[8]

Not everyone appreciated Kaiser's paternalism, of course. Disaffected single workers interviewed in 1975 characterized Eagle Mountain as "a cross between a prison and a desert island." Accommodations for unmarried workers were far less commodious than the houses, and company control was more oppressive. Rules prohibited women from entering the dormitories and trailers that constituted the bachelor quarters, and many single workers were disinclined to

Eagle Mountain's 1980 homecoming parade featured a baton class called "The Merry Minerettes." Many Eagle Mountain residents reported that a generous spirit of community characterized the town in its active years. The town's square dance club was called the Merry Miners. This historical photograph has been enhanced by adding the red color to restore the vibrancy of the original snapshot image, which had faded seriously over time. *Photograph courtesy of Chester and Sharon Brenneise.*

"join the Eagle Mountain establishment," which they portrayed as "having dogs and babies and satisfying oneself with television and a six pack, year in, year out." Nonetheless, for many workers, friendship and family were the essence of the place. At its peak, approximately 3,700 people lived in Eagle Mountain, and the town could not house all who wanted to live there. As one resident summarized: "Kaiser Steel owned it, but it was our town."[9]

Iron production at Eagle Mountain continued to rise through the 1960s, averaging six million tons per year by the end of the decade. In 1970, however, a prolonged dock strike in Oakland, California, prevented Kaiser from shipping steel to Japan, one of its principal markets. By the time the strike was settled the Japanese contracts had lapsed, and Kaiser's steel production began a steady decline. Eagle Mountain was shipping only three million tons

of iron per year by the end of the 1970s. In September of 1981, Kaiser had 1,200 employees in Eagle Mountain. A year later there were only 300, and 160 houses were empty and boarded up. The last truckload of ore left the East Pit in October of 1982. By the end of December only seventy employees remained and 249 houses were boarded. Mining operations ceased altogether in 1983, a decision that the mine manager attributed "not [to] one single factor, but a combination of many factors: high environmental costs (both state and federal), high utility costs, high labor costs, high manufacturing and mining costs, as well as high iron ore costs."[10]

Linked as they were to the fortunes of Kaiser Steel Corporation, both the town and the mine at Eagle Mountain were doomed by the company's difficulties. Mine manager John Englund bluntly explained the realities of life in a company town to a high school yearbook reporter in 1983: "Our primary function is to furnish iron for their (Fontana's) blast furnaces, and if they find it uneconomical to operate their blast furnaces and have no further need for iron ore, then they have no further need for Eagle Mountain." Kaiser's woes worsened. The company declared bankruptcy in 1987, leaving more than 7,000 retirees without pensions or medical benefits. Eagle Mountain became a ghost town even more swiftly than it had originally grown. The experience left former residents bereft. One lamented: "They cut off all our roots when the place closed up."[11]

By the early 1990s Eagle Mountain was almost unrecognizable to those who knew it as the cozy and prosperous desert subdivision it had been during the 1960s and 1970s. In 1999, Mike Babb recounted his wrenching experience as a visitor: "I went back for the first time some 5 years ago and thought I was going to die. The town was dead, houses torn up, no green grass or pretty trees, no trailer park, no baseball field across from my house. I thought I would cry. I miss my little town so much." Although some houses were occupied by employees of the private security prison, and the high school building was reopened as a grade school for their children, evidence of abandonment is everywhere. Eagle Mountain is no longer the "bustling desert community" that Kaiser publications once extolled.

With Kaiser's bankruptcy, the mine property, including the townsite, reverted to a successor company, Kaiser Ventures. Its goal was to realize some return from the remaining assets for Kaiser Steel creditors. Prominent among the latter were the former employees whose pension funds and medical insurance had vanished in the bankruptcy. Kaiser Ventures leased the water rights at Eagle Mountain, rented the dormitories and houses to employees of the prison, eventually leased the mine structures for a movie set, and diligently sought some economically viable use for the mine pit.

The latter quest was complicated by changes in the status of nearby Joshua Tree National Monument. When Joshua Tree became a national park in 1994, its boundaries were extended so that only about a mile and a half and the 2,000-foot Eagle Mountains separated it from the Kaiser Ventures property. The monument had been a neighbor to the north and west, but the new national park surrounded the minesite on three sides. The park's proximity makes it extremely unlikely that Eagle Mountain will ever again function as a mine.

Accepting that Eagle Mountain was now necessarily a post-mining landscape, Kaiser Ventures pursued another strategy. It formed a subsidiary, Mine Reclamation Corporation (MRC), which developed a plan to use part of the

Eagle Mountain pits as a waste disposal site for household garbage from southern California. The project was grand in scope, with a useful life estimated to be between forty and 100 years, and a proposed capacity of twenty tons of garbage per day. In 1992, the Riverside County Commissioners approved the proposal, apparently convinced by statistics provided by MRC that landfill space would be at a premium in the coming decades. A 1989 California law required counties to recycle twenty-five percent of their waste by 1995 and fifty percent by 2000. Riverside County was in need of recycling facilities, but the commissioners were no doubt also swayed by the anticipated employment of more than 1,300 workers and $3.4 billion in new economic activity over twenty years.[12]

A draft version of the Environmental Impact Statement (EIS) was presented in 1991 and finalized in 1993. Browning-Ferris Industries, the giant waste processing company, was a partner in the venture. The plan was that nonhazardous solid waste would be shipped from throughout southern California to Eagle Mountain by rail. A transfer station would be constructed to sort and process the waste. There useable materials would be extracted for recycling and the remaining garbage would be transferred to trucks and hauled two miles to the landfill site in the mine pit. The latter would be prepared by means of clay liners to receive the waste without contaminating the groundwater. Each day's waste would be compacted and covered with tailings and overburden from the mine, thereby depleting the waste piles surrounding the pits. Monitoring wells would extract and use methane gas generated by the decaying garbage. Gradually, as the landfill changed the contours of the pit and surrounding canyons, graded slopes would emerge and be revegetated. MRC promised that "over the life of the land-fill the site will be reclaimed and returned to near natural contours."[13]

There was opposition to the landfill from the beginning. Numerous environmental concerns about the park were voiced by the National Parks and Conservation Association. It worried that noise, odor, and light pollution from the site would spill over into nearby Joshua Tree National Park. Since the landfill was proposed to operate around the clock, trains and trucks would be traveling at all hours, and bright lights at Eagle Mountain would obscure the stars in the night sky. It feared blowing trash and noxious odors, and a population explosion among predators lured by the food source at the landfill. These included kit foxes, coyotes, seagulls, and ravens. The first and last on this list were known to eat young desert tortoises, an endangered species.

Area residents Donna and Larry Charpied, who were raising organic jojoba on ten acres near Eagle Mountain, also opposed the dump. They focused in particular on the danger of groundwater pollution. Since they irrigated their fields with well water, they were concerned about the adequacy of provisions to separate the landfill runoff from the Chuckwalla Valley aquifer. There were concerns as well about the detrimental effect of expanding the Eagle Mountain townsite, which was to be revived in order to provide on-site housing for workers at the transfer station and the landfill pits. Landfill opponents joined forces and filed suit against MRC and Kaiser Ventures, alleging that the EIS failed to address adequately these concerns. In 1994 a California Superior Court judge agreed with them and ordered preparation of another EIS, which would require court approval. Browning-Ferris Industries withdrew from the project and MRC lost its appeal of the judge's ruling in 1996.[14]

Undeterred by its legal setback, the company moved forward again to amend its plans and prepare a second EIS. In particular, it met with officials from Joshua Tree National Park to address worries about negative effects on park visitors and endangered species. At the end of 1996, the two sides announced an agreement that would provide the National Park Service with additional monitoring capabilities to assess the impact of the landfill if it should be approved. These included equipment to monitor night sky visibility, provisions to minimize odor and shield lights, reduced operating hours, and mitigation efforts to offset potential increases in predator populations (see page 159).[15]

In addition Kaiser Ventures agreed to convey without charge 190 acres of mining claims that it owned inside the park and to provide new water sources for the desert bighorn sheep that would be displaced by its operations. An environmental mitigation fund of $1 per ton of garbage would be set aside for monitoring and research. Ten percent of this fund would be made available to the National Park Service, and office space would be provided at Eagle Mountain. Landfill opponents howled that the National Park Service had "sold out," and park superintendent Ernest Quintana continued to oppose the landfill project "on principle," as an inappropriate neighbor for a national park; but MRC went forward.

The second EIS was further modified to address objections raised in the 1994 ruling. Both the total area and the proposed daily tonnage of the landfill were reduced. Kaiser Ventures assumed liability for any environmental cleanup that might be required. The landfill's active life was projected at fifty years, rather than eighty to 145. Environmental protection and monitoring procedures were more elaborate. Thus reassured, the Riverside County Board of Supervisors approved the revised EIS in August, 1997. MRC declared the dump "considerably more sophisticated than a big hole in the ground filled with trash." Opponents decried the hubris of locating "one of the world's largest garbage dumps" on the boundaries of a national park.[16]

In September the Bureau of Land Management (BLM) announced its approval of a land exchange that would give Kaiser 3,481 acres scattered around the landfill site in exchange for some cash and 2,846 acres of property elsewhere that had value for recreation or habitat for endangered species. Despite a demand by opponents for judicial review of this land exchange, MRC seemed once again to be on track in its plans to reclaim the Eagle Mountain landscape through garbage. In February of 1998, however, Superior Court Judge Judith McConnell rejected the second EIS. She ruled that the document insufficiently considered the landfill's threat to the park's wilderness. According to McConnell, among other things, MRC had failed to substantiate its claim that the effects of its operations on the desert tortoise could be mitigated.

Landfill opponents celebrated their victory, but MRC and Kaiser Ventures again appealed the ruling. In 1999, they were more successful. Proponents of the dump seemed to gain the upper hand in this ongoing dispute when the BLM rejected protests that had been filed against the land exchange, and the California District Court of Appeals overturned Judge McConnell's decision. The appellate court's dismissal of a request to reconsider its decision affirming the second EIS cleared the way for Kaiser Ventures and MRC to proceed with the permitting process necessary to begin landfill operations at Eagle Mountain. Final approval for

the $115 million project was granted in December, with operations projected to begin after 2003. Although opponents proposed suing the BLM, MRC representatives prepared to seek customers for its waste disposal service. Barring further legal challenges, the Eagle Mountain landscape may be reconstituted once again.[17]

Whatever the ultimate outcome of the landfill proposal, the disagreement about it reveals the multiple, sometimes surprising, interpretations given to a single mining landscape. In its statements about the proposed dump, MRC relied implicitly on the notion that mines are wasted places. It assumed that filling the East Pit with garbage and covering it with tailings would be an overall improvement. MRC adopted the rhetoric of restoration to defend its plan for further massive alteration of the site. Ruination inflicted by mining would be redeemed by garbage.

Kaiser Ventures, too, could construe the landfill plan as a kind of expiation. By making its asset productive once again, the company served the interests of the former mine employees, among others. While the latter might never recover their pleasant little desert enclave, they could at least hope for some restoration of their lost benefits. And the revived town of Eagle Mountain would provide jobs and desert homes for several new generations of workers.

Opponents, by contrast, blasted MRC's "reclamation" project in the name of "nature." For them, protection of the desert tortoise and night sky views was of more consequence than the fate of the four miles of pits gouged out of the Eagle Mountains. If the town remained moribund and the pits simply collapsed in place, then park visitors could safely maintain the illusion that they were in a place unaffected by human activities. MRC's plan to take action at Eagle Mountain was thus an affront to the romantic landscape values celebrated by the adjacent national park. Restoration of the mine simply wasn't worth the potential risk to the implicitly more important terrain of the park.

Meanwhile, in cyberspace, former residents of Eagle Mountain convened in 1999 to establish their own virtual community. The name of their Website, "Eagle Mountain Refugees," epitomized the loss they experienced at the sudden demise of their town. For them, competing proposals for the post-mining landscape were equally irrelevant. They lamented the vanished historical mining landscape, but with no sense of technostalgia. To these former residents Eagle Mountain was a mine that was also home. It offered memories of "the real 'leave it to beaver' existence. That's what it was, a storybook tale that couldn't be real." Sherry Raines Watson described her sorrow at witnessing its demise:

> The time foremost in my mind is the worst memory, watching it die. Not leaving until '81 meant I had to watch the houses come down, the trailers pull out, the plants in the mine shut down, and the plants growing throughout the town start to die. . . . It's tuff in a company town. Other places, when the main industry leaves, at least leaves behind a town, however devestated it may be. But we don't even have a town left.[18]

Their Eagle Mountain—beloved in retrospect—has been irretrievably lost, even as the contest over the proper post-mining landscape rages on.

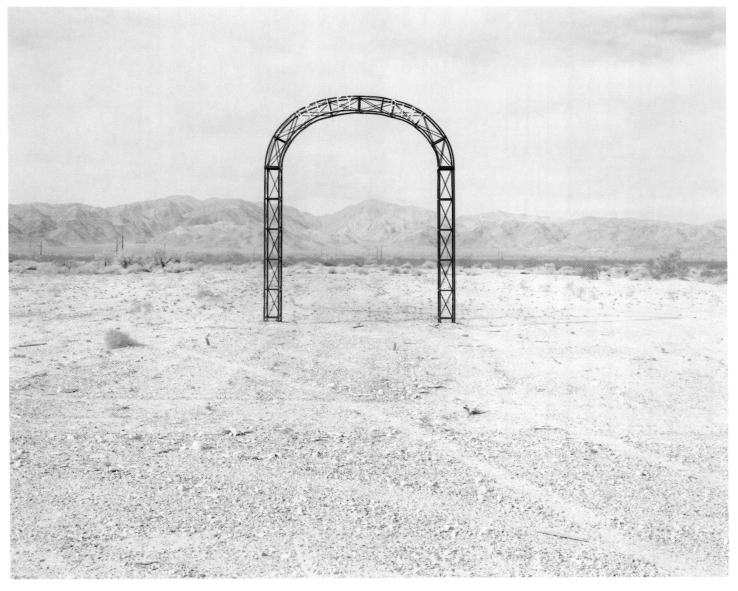

The incongruous Kelley Park arch is now located in an apparent desert about two miles from Eagle Mountain. It originally belonged to a small trailer park called Lake Tamarisk West. Although it was not part of the town itself, this development died along with the town that spawned it when Kaiser Steel Corporation stopped mining iron.

The Kaiser Steel Corporation built houses at Eagle Mountain from 1948 on. The smallest versions were only 700 square feet with two bedrooms. The most elaborate had four bedrooms. Period snapshots depict them as cheery, inhabited spaces, surrounded by lawns, automobiles, bicycles, and children's toys. Unoccupied, they appear stark and desolate.

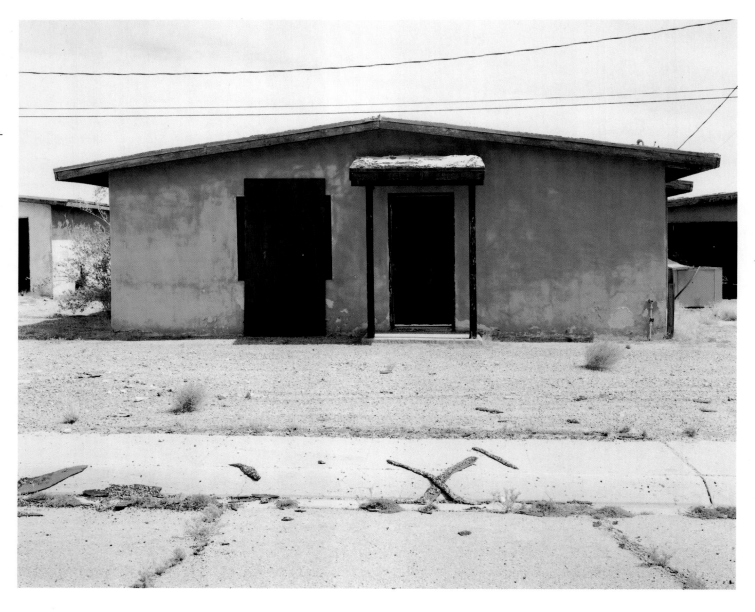

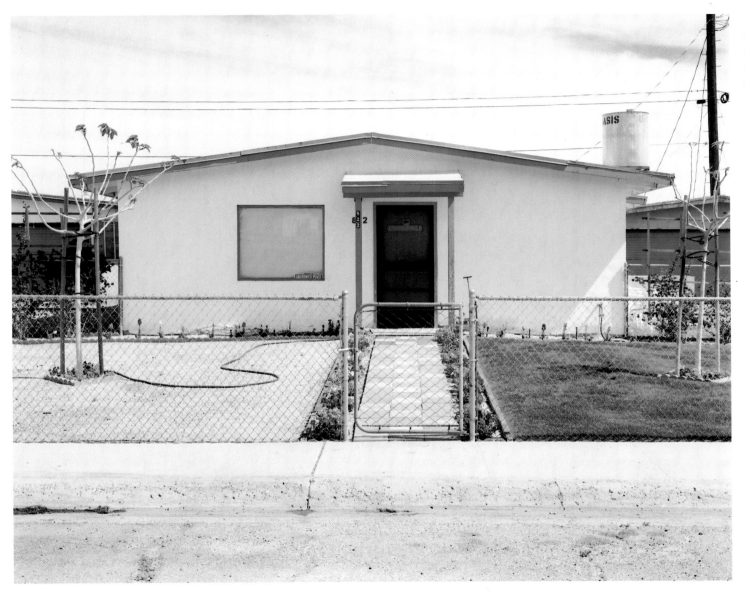

Among the many abandoned and shuttered homes at Eagle Mountain are occasional occupied ones, where maintained greenery and fresh paint are vivid, almost startling signs of life. This home on Paloverde Drive was photographed in 1997.

This view from an alley looks south-southeast toward the street. It gives a sense of the cozy proximity of Eagle Mountain's houses.

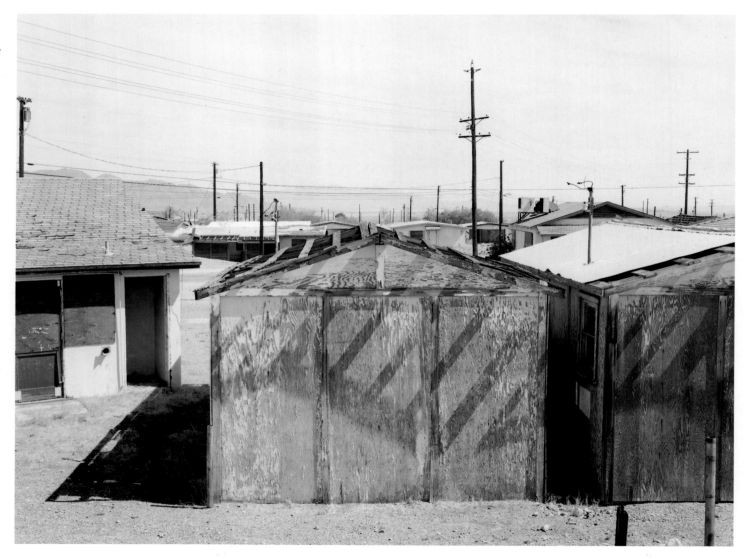

These garages were removed from the townsite and stock-piled, but they have not been put to use.

A scene from the movie, *Termina-tor-2: 3D Battle Across Time,* which starred Arnold Schwarzenegger and was directed by James Cam-eron, features decommissioned ore processing facilities at Eagle Mountain Mine. This twenty-minute film was produced in 1995 for the Universal Studios theme parks in Hollywood, California, and Orlando, Florida, and for a similar theme park in Osaka, Ja-pan. It is one of the top attrac-tions at the two U.S. parks, which together attract more than thir-teen million visitors a year. *Photo-graph courtesy of Virgil Mirano, copyright Digital Domain.*

(opposite) Photographed without supporting scenery and actors in 1997, the structure pictured here is also visible in the movie scene. It was altered during the course of production in order to appear more sinister. As part of the recy-cling of the post-mining land-scape at Eagle Mountain, it is ulti-mately to be crushed and used on the site as a road base.

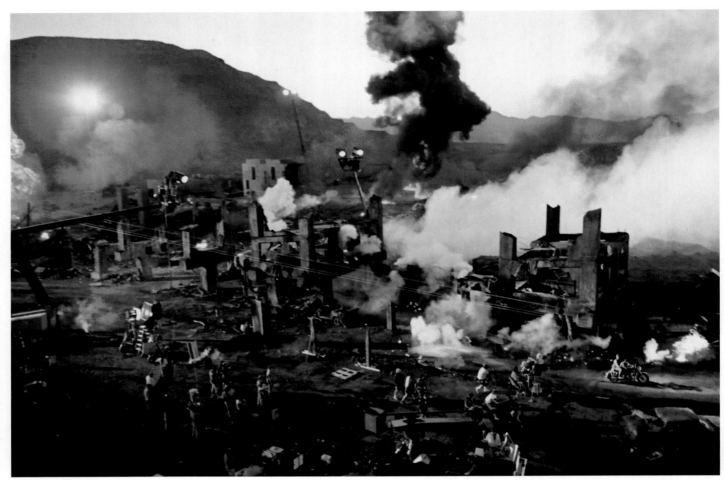

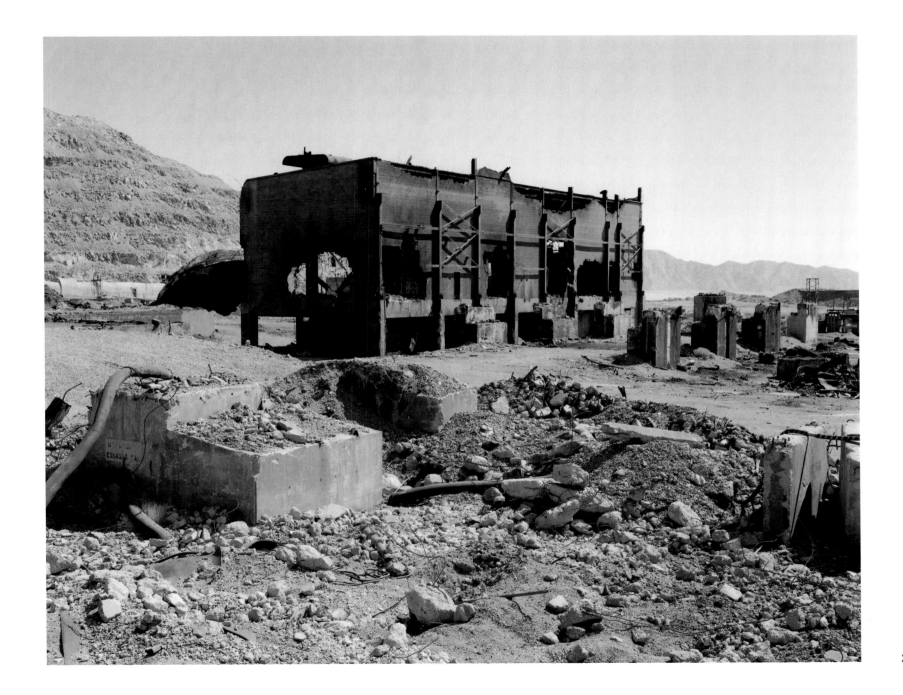

This 1997 view from the Central Pit of the Eagle Mountain Mine looks east at the radio tower that was used for communication relays. The entire mine site, including the pits, overburden piles, and tailings mounds, stretches for a distance of about four miles. Only the eastern portion will become part of the proposed landfill.

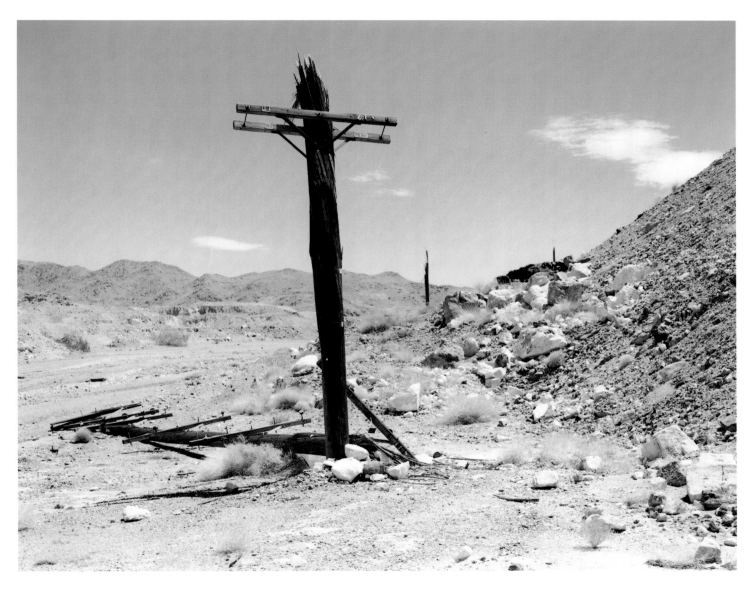

Permanent power poles at Eagle Mountain will ultimately be removed in compliance with the site reclamation plan. The first stage in the process is to "shred" the top of these poles in order to discourage native birds from building nests. Otherwise these human artifacts risk creating a natural imbalance by providing too many nesting sites for ravens, which are notorious predators of the endangered desert tortoise.

This solitary bush is a hardy volunteer at the east end of the Central Pit. In the hot, dry climate of the Mojave Desert natural vegetation is sparse. Revegetation of most mine sites is an extremely slow process, unlikely to occur without significant human intervention. At Eagle Mountain the challenges are far greater than in the Wyoming Valley of Pennsylvania or the Mesabi Iron Range of Minnesota, and the outcomes are more uncertain.

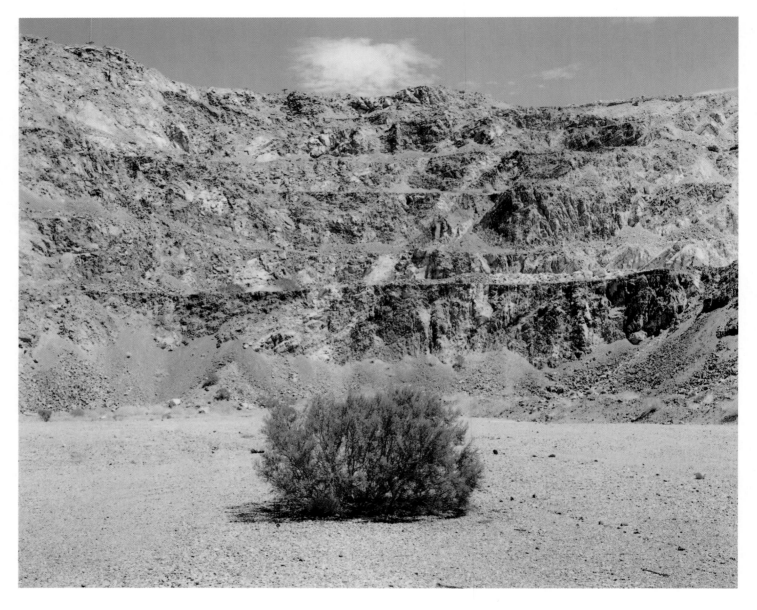

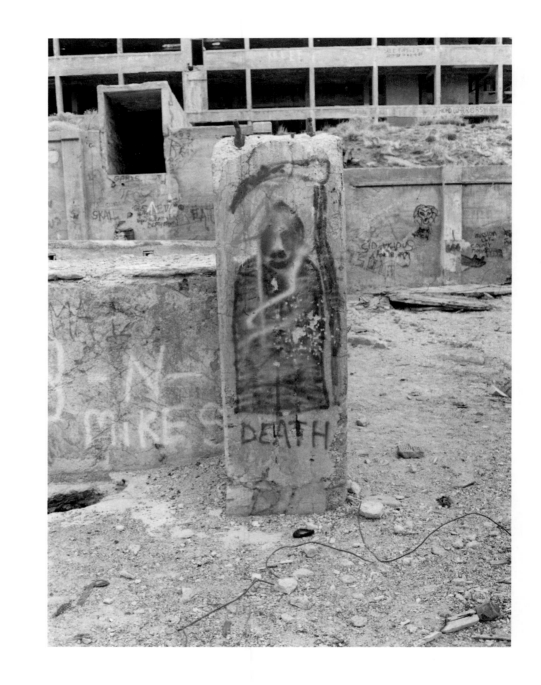

Physical Graffiti
Variant Versions of American Flat, Nevada

When the wife of nineteenth-century publishing magnate, Frank Leslie, visited Nevada's Comstock Lode in 1877, she was appalled by what she saw. The towns were dreary and the terrain daunting: "Nowhere does one find a level—the vision loses itself among the crowding brown peaks and waving mountain ranges, never coming to any resting point of level or of greenery, before the horizon line closes the dreary scene—like a magnified Yosemite trail with all the attractiveness left out." Despite being graciously entertained by her host, and seeing numerous sights in the company of luminaries, she did not tour the famous silver mines themselves. The descent by elevator into the shaft of the California Mine reminded her too much of death. The whole experience was one of chaos and disruption: "We saw machinery enough to drive one crazy, and were almost suffocated with its hot, oily smell and steam."[1]

Other travelers were more intrigued by what they saw on the Comstock. Grace Greenwood, writing four years earlier

than Mrs. Leslie, was at first put off by the unfamiliar landscape, the "great brown hills" that seemed "gashed and scarred and marred and maltreated in every way. But in happier days succeeding, these same bleak hills grew to have for me a sort of grim grandeur and attractiveness." Indeed for Greenwood the boldness and daring of the entire mining enterprise was exhilarating. Visiting in the early days of the 1870s boom period that came to be known as the Big Bonanza, she witnessed a heady renewal of mining excitement on the Comstock, when "the talk [was] constantly of new discoveries." Unlike Leslie, Greenwood actually climbed down into the Chollar-Potosi mine and clambered about its workings. After the fact, she reported the experience was rather like visiting the Roman catacombs, without the latter's characteristic musty smell.[2]

The ambivalence about mining voiced by these two nineteenth-century women is hardly surprising. Contemporary observers of mining landscapes still note the pre-

In the 1980s American Flat became a free access zone for various illicit forms of recreation, including a phantasmagoria of graffiti.

163

vailing tendency to characterize them as waste places, "a kind of elitism that prevents us from understanding what such places really mean to the people who create and inhabit them."[3] Such meanings change over time and vary among inhabitants, but they are often more difficult to recover than the impressions of tourists and visitors such as Leslie and Greenwood. While the latter obligingly recorded their views for posterity, the vernacular understandings of mining landscapes are often lost. Rarely are ordinary mining town residents so obliging as to establish a website filled with their reminiscences, as the former denizens of Eagle Mountain did. Sometimes, however, the physical contours of a place can provide evidence of its meaning and uses. One striking example is located on the Comstock Lode, in the subdistrict known as American Flat.

Part of the area that Leslie and Greenwood visited in the 1870s, American Flat has had a long, but sporadic history as a mining site. Approximately one mile square, the area is located west of the main Comstock silver mines, which were in Gold Hill and Virginia City. American Flat was first worked in the 1860s, shortly after the silver discovery to the east. Reportedly the place received its name because the miners who labored there were American, rather than the Mexicans and Chinese who predominated elsewhere in Gold Canyon at that time.[4]

The district was formally established in 1864, and the settlement of American City grew up around it. Available water, always a scarce commodity on the Comstock, was among its attractions; and it briefly competed to become the capital of the new state of Nevada in the mid-1860s. The American Flat mines proved disappointing, however, and America City remained small. Its post office was discontin-

ued in 1868, and the last mines closed in the late 1880s after they flooded. The buildings were removed or decayed in place. It was not a place featured on either Greenwood's or Leslie's tour of the Comstock sites in the 1870s.

During the early twentieth century, however, American Flat enjoyed a revival. At the beginning of the nineteenth-century Nevada silver boom, in the 1860s, Americans lacked "the same subtlety to extract all the metal which Welsh and German mills have attained." So considerable value was left in the dumps of waste rock and processing tailings that littered the landscape near Virginia City. Seeking to recover this value, a group of Nevada mining engineers organized the United Comstock Mines Company, obtained eastern capital, and bought up rights to mines throughout the district. Their goal was to reprocess both tailings and low-grade ore deposits on the Comstock.[5]

In order to recover this metal, in 1920 the new company built at American Flat what was reputed to be the largest cyanide mill in the world; it was certainly the largest in the western U.S. The United Comstock Merger Mill had the capacity to process two thousand tons of ore a day, and opened in 1922.

Clearly anticipating a long and prosperous future, the owners built with the newest materials and techniques. At the time the mill's concrete and steel construction was unique, designed to be both solid and permanent. A new company town called Comstock grew up around the mill to house, feed, and entertain its workers.[6]

Unfortunately, this second town of American Flat was more short-lived than even its predecessor. It disappeared by the end of the 1920s when prices collapsed and mill owners failed to locate any new high-grade ore bodies.

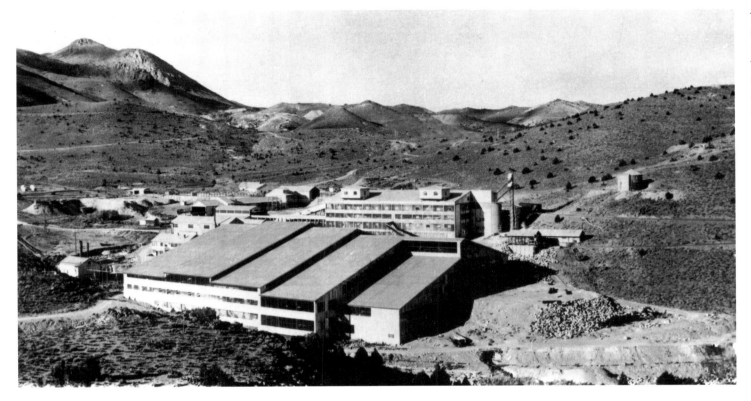

The United Comstock Mill complex at American Flat incorporated the most advanced ore treatment methods available in 1922, when it began operations. *Photograph courtesy of Denver Public Library.*

Hovering at the time the mill was completed around $1 per ounce, silver prices dropped to sixty cents by 1926, and twenty-five cents in 1929. The impact was predictable. In 1927 the post office closed once again, and the machinery of the once magnificent plant was dismantled and sold for scrap. By the 1970s the site had again subsided into ruin, and economic uses were replaced by recreational ones. People came to American Flat to use the concrete remains as a shooting gallery or a hideaway, a site for illicit activity and a canvas for graffiti. While no Greenwood or Leslie arrived to chronicle American Flat at this period, there is mute evidence of its changing functions and meanings in the photographic record, and in the radical physical transformation of the mill structure.

In 1980, American Flat was revived for a third time, again as a milling site. Houston International Mineral Corporation had arrived on the Comstock in the late 1970s. Its operations included a controversial open-pit mine at historical Gold Hill and some underground exploration. At American Flat the company build a sodium-cyanide mill, a far less substantial structure than its predecessor, prudently designed to be dismantled. Shortly afterward the properties

were sold to United Mining Company. Conforming to a now familiar pattern, the latter company stopped production in 1985, and put the American Flat mill up for sale. All mining and milling operations there have once again ceased. This time the remains of a cyanide processing pond have been added to the landscape of American Flat.[7]

During the 1990s, as in the 1970s, American Flat resumed its alternate identity, to become the locus of various socially marginal amusements. Adaptive reuse here gained new meaning, as the seventy-year-old remains of the United Comstock mill buildings became a public access space for various alternative recreations, including motorcycle gang gatherings, paint ball games, performance art, and a sprawling collection of graffiti. Two movies were even filmed amid the colorful industrial ruins, which are located on public land.[8]

The terrain at American Flat is contested, however. The 1996 death of a man, whose rented all-terrain vehicle flipped over while he was attempting to climb the ruins, triggered public outcry about the danger of the mill's ruins and epitomized the complications: the place that the Storey County sheriff denounces as an "attractive nuisance" is also eligible for listing on the National Register of Historic Sites. Vernacular and official landscape interpretations jockey for dominance as the Bureau of Land Management (BLM) struggles to develop a suitable management plan for a site to which, as the agency observes, "the public attracted . . . both for its historic and visual features and for nontraditional uses such as paint ball games, graffiti, climbing, medieval warfare games, parties, etc."[9]

Residents are similarly divided. Some vigorously deplore the mill's reputation as a party place. Others recall its his-tory as a landscape of labor, and celebrate its graffiti as art. Travel writer Rick Moreno describes American Flat as "a fascinating place to explore," and he continues:

> The multi-story main building looks more like an abandoned parking garage and there are other strange and intriguing shapes in the twisted, hulking concrete ruins. . . . Standing under the graffiti-covered cement archways adjacent to the creek, there is a kind of disquiet and unease in the air—as if the site knows it deserves a better afterlife than the one it has been given.[10]

And yet many are attracted to the site at American Flat precisely *because* of the outlaw afterlife it has assumed.

Amid such ambiguity and worried about its legal liability in the event of future accidents, the BLM in 1996 began the official process of restricting access to the mill at American Flat. The *Federal Register* notice of the proposed closure disapprovingly described a place "popular for numerous undesirable public uses and unlawful activities." On the list of activities to be newly prohibited were campfires, possession or use of paint and spray paint, off-road use of motorized vehicles, detonation of explosives and rockets, and discharge of firearms. Instead, a draft version of a 1997 site guide primly suggested that American Flat visitors engage in more sedate activities, such as picnicking, walking, historical study, and photography.

Simultaneously the agency internally conceded the inadvisability of "chain link or high protection fencing," because "any fencing without extraordinary measures such as guard dogs or electricity will not keep out those that choose to willfully violate the closure." The subtlety of the signage

strategy that they ultimately chose to employ (see page 178) is perhaps lost on adherents of the old style of open access to the recreational facilities of American Flat.

As the BLM struggles to "interpret" this multi-faceted mining site, the various cultural meanings of American Flat continue to jostle uneasily against each other, as they have for decades, since Leslie and Greenwood encountered the Comstock 125 years ago. In more ways than one, the landscape at American Flat can be considered a kind of physical graffiti, the record of an ongoing, popular cultural debate about the control, uses, and meanings of one particular mining landscape.

In 1995, in a further ironic twist, there were proposals to develop a fourth version of American Flat, this time as a commercial amusement park. Proponents planned to build the Silver Spur Heritage Cultural Center, a "theme-town/movie studio" that would combine commercial recreation for tourists with a "wild west" theme town available to movie production companies in "a living history lesson." To date no construction has commenced and residents' informal use of the site continues unabated, albeit officially forbidden. If the Silver Spur Center is ever built, however, the Comstock Lode will have spawned its own historical simulacrum, and all previous meanings of American Flat—not only as a functioning landscape of mining, but also as a free expression zone—will once again risk erasure and radical reconstruction.[11]

The black-and-white photographs show the mill at American Flat during its mid-1980s incarnation as a free access zone for various illicit forms of recreation. Seen here is the coarse crushing mill, looking north.

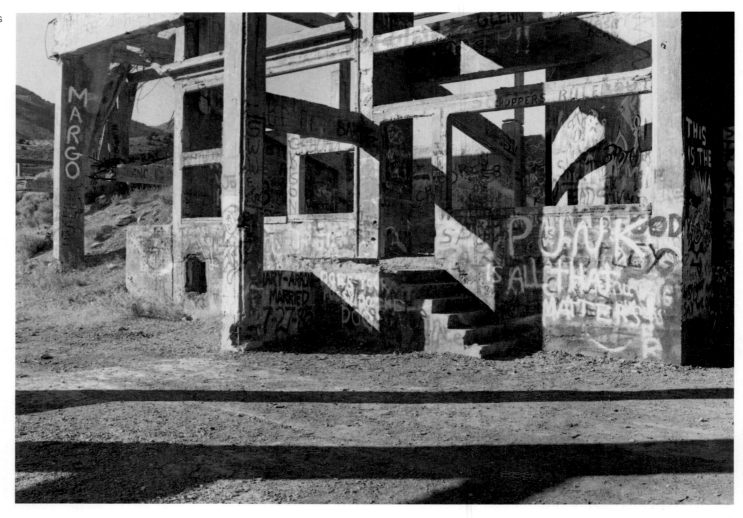

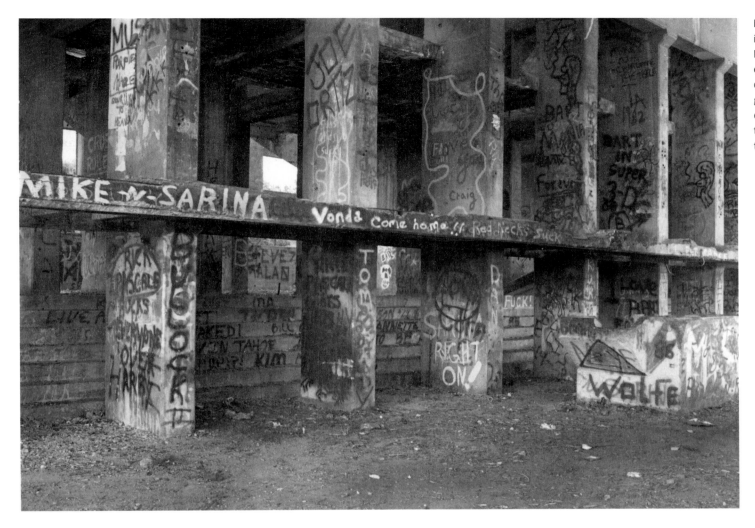

Reminiscent of the testimonials inscribed on the beams in the Montana radon "health mines," every accessible surface of the concrete mill ruins is covered by graffiti, attesting to the presence of numerous visitors. The structure seen here is the interior of the fine-grinding plant.

The ruins of the tank house, located below the fine-grinding plant, give a sense of the abandoned industrial forms that are present at American Flat. The mill buildings were built to last. Eighty years later, the skeleton of the industrial complex remains remarkably intact, much to the dismay of public land managers charged with controlling access to it.

(opposite) The warehouse storage building is seen here in the mid-1980s.

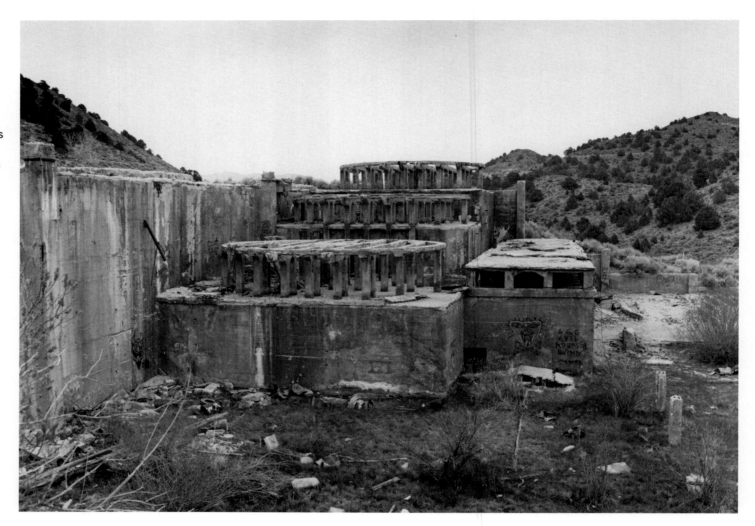

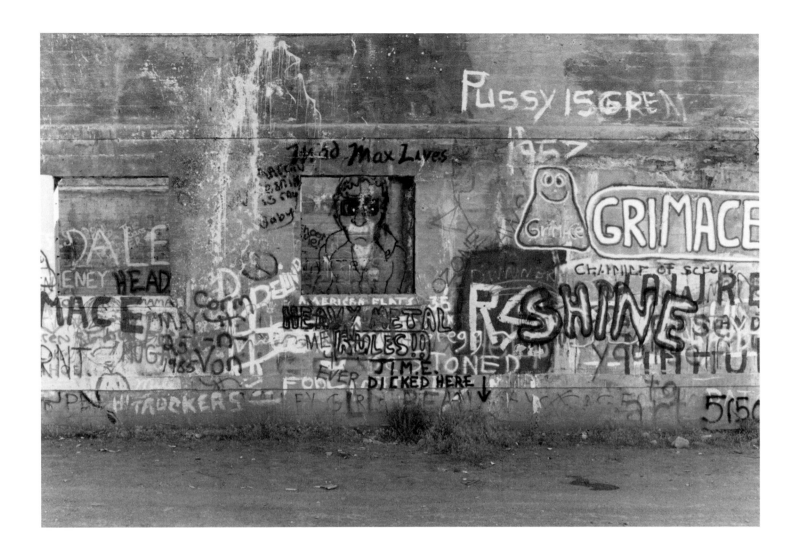

Color photographs of the complex at American Flat depict a later phase of the site's development, in the late 1990s. Here wall graffiti on the same building shows the influence of gang-style graffiti.

(opposite) By now the warehouse building has become a graffiti palimpsest.

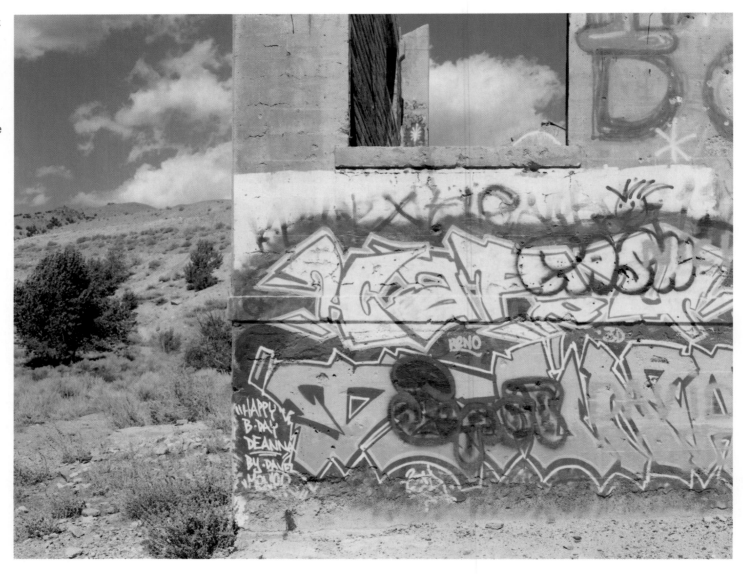

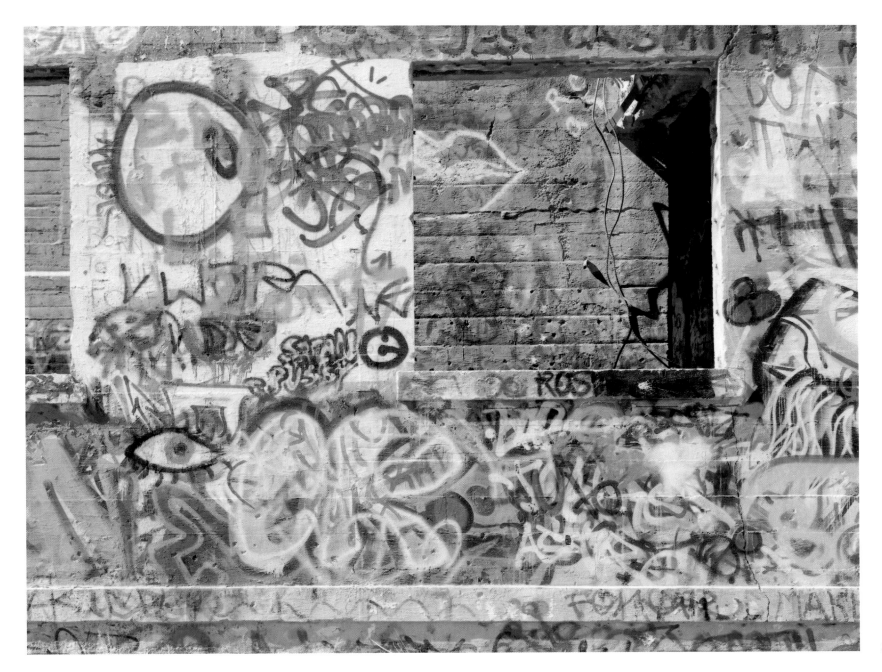

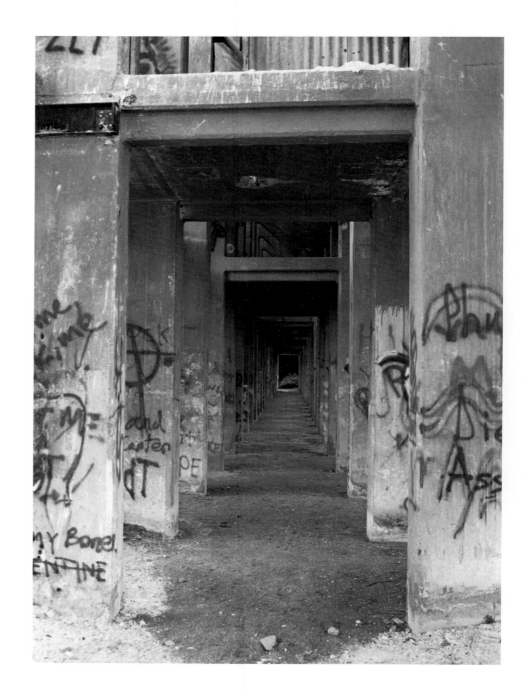

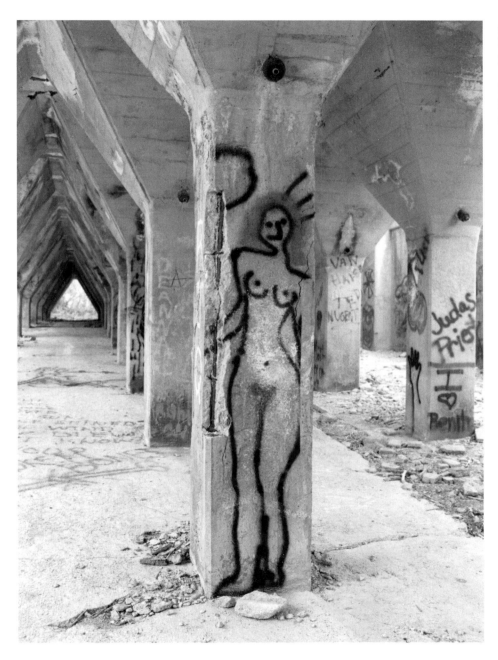

(opposite) Geometric repetition looking north within the fine-grinding plant.

Drawing of a naked woman, an interior view looking north within the ruined precipitation and refining unit.

Looking north within the fine-grinding plant, on the second level. The possibilities for paint ball are obvious.

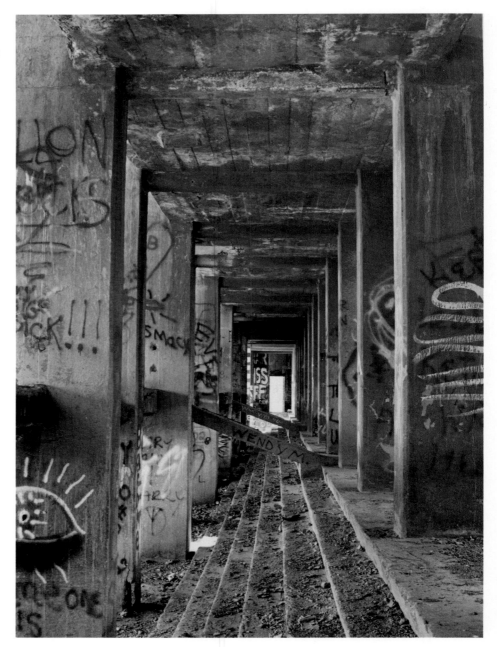

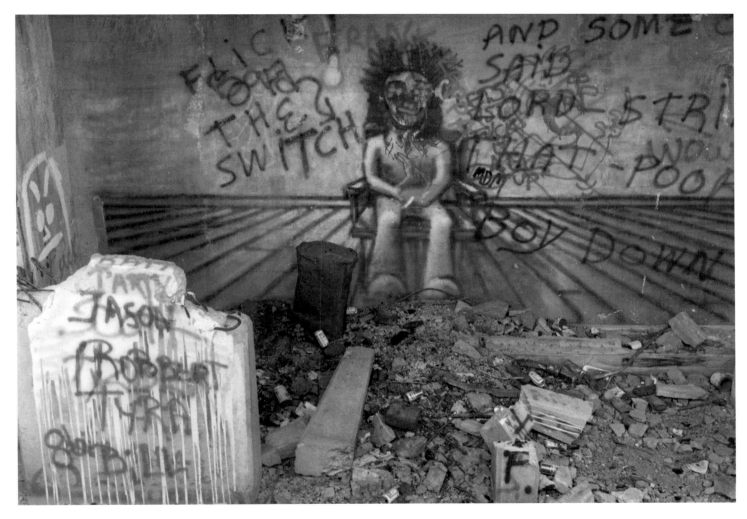

Violence is a constant theme at the American Flat mill. Evidence of paintball wars abounds. Here, in the basement level of the fine-grinding plant, is a graffiti graveyard, including a figure in the electric chair.

In the name of public safety, the Bureau of Land Management sought to suppress long-established, if illicit, recreational uses of the public land. The agency's closure strategy took the form of subtle instructional signs. Dwarfed by the massive ruins surrounding it, this carsonite stake is located at the southwest corner of the fine-grinding plant. The text reads: "Closed Area, No Shooting, other than the lawful pursuit of birds and mammals."

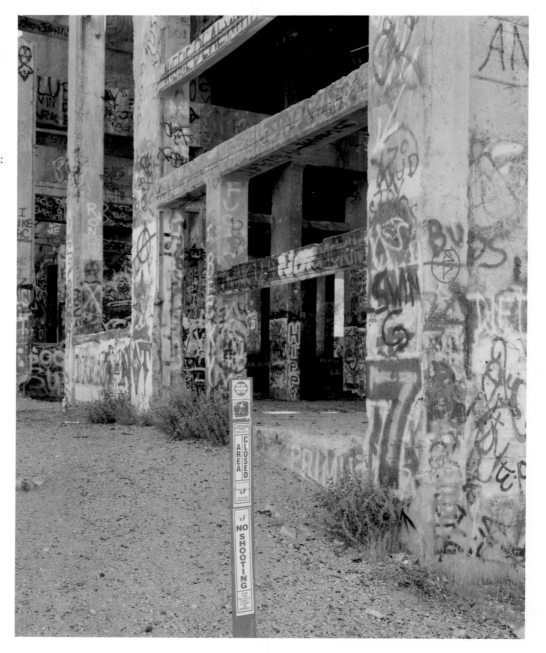

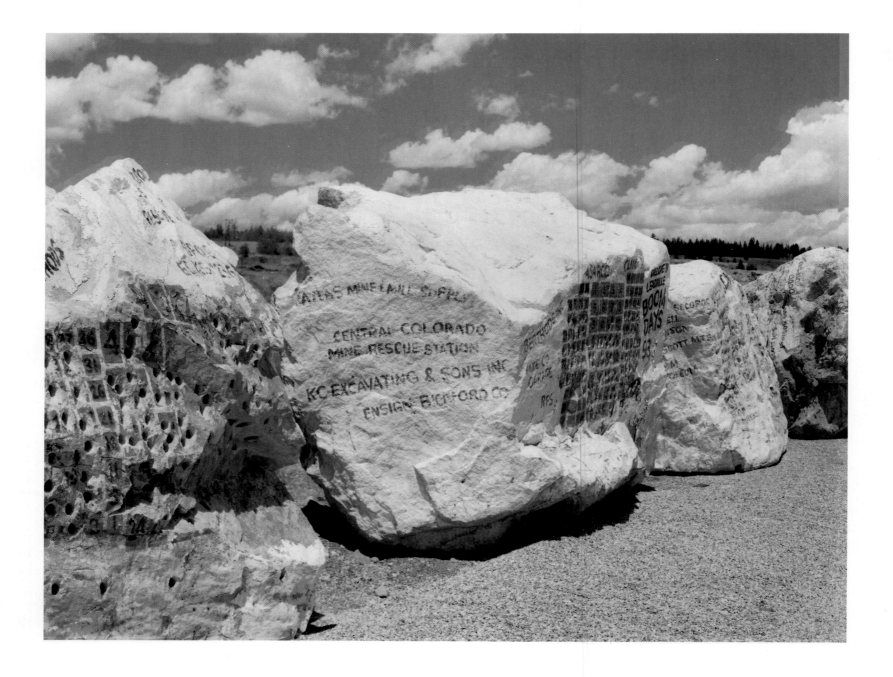

CODA

These essays only sample the tremendous diversity of American mining landscapes, but they illustrate the complexity of mining's role in contemporary culture. Mines present a tremendous paradox. Understood by many as permanent geographical features, they are only stages in the long and evolving history of the landscapes in which they are located. Mines are reviled places. In 1997, the industry ranked even lower than tobacco in American public opinion.[1] Yet, adaptive recycling and reuse of mine sites is a constant feature of the American landscape. Although the phenomenon scarcely registers in the public imagination, our work revealed several other intriguing examples. Consider, for example, recent efforts in Anaconda, Montana, to attract golfers to play a novel mining-theme course built on the Superfund site of a former smelter. Equally interesting is the western Pennsylvania limestone mine where the famous Bettmann photographic archive, now owned by Bill Gates, is permanently stored for safekeeping. The latter site was provocatively described in the *New York Times* as "a postapocalyptic city designed to outlast human life."[2]

We hope our efforts here will stimulate further critical attention to the subject of mining and its multiple effects on both landscape and society. In many respects the legacy of mining is a dark one but the industry remains vital to twenty-first-century life. It is unlikely to disappear as long as customers demand modern amenities such as computers, polypropelene, and central heating. Under these circumstances, the relative absence of scholarly scrutiny seems surprising.[3] *Changing Mines in America* makes no claims to be exhaustive, but, as the examples above suggest, there is surely much more to be said.

Two general observations seem worth highlighting. First, common stereotypes about mining frequently interfere with seeing and understanding actual mining landscapes. Mining is not confined to the actual place of ore extraction, but includes an entire complex of transport and

Many western mining towns celebrate their economic roots with festivals featuring the skills of historical hard rock mining, including hand drilling. These competition rocks, assembled for the Boom Days festival at Leadville, Colorado, in 1996, display the names of sponsors as well as laboriously produced holes left by the drillers.

processing facilities, worker housing, and waste disposal. According to the tenets of classic American landscape aesthetics many of these appear quite dismal, but that is surely not the only relevant lens through which to view them. The perspectives of the workers at Eagle Mountain and the former residents of Bingham Canyon also deserve acknowledgment.

As Peter Goin's photographs make plain, mining landscapes can occasionally be beautiful, sometimes magnificent. They offer instruction and, improbably, entertainment. Not all of them are derelict or polluted. Even the most utilitarian have contributed to both life and death. These are evocative places that deserve to be taken seriously and analyzed more thoroughly than they have been.

Second, mining should be appraised as simply a stage in landscape evolution, not its culmination. As the chapters on Karnes County, Texas, and Boulder Basin, Montana, demonstrate, "post-mining landscape" does not have to be an oxymoron. People do continue to live in mining areas such as Pennsylvania's Wyoming Valley and the Mesabi Iron Range in Minnesota. Despite effecting alteration on a massive scale, mining does not literally consume the earth. At some point mining ends, and the place where the ore was still remains. In a society that is heavily dependent on the products of mining, the intelligent reinvention and reintegration of such sites is imperative. Attention to their local meanings and their history, as well as their economic activities and environmental consequences, is called for.

The recent record of the mining industry demonstrates considerable ingenuity in restoring mining landscapes and remediating harmful environmental effects of ore extraction and processing. Mined landscapes will never be pristine places, but they are hardly alone in that, and modern societies show no appetite for foregoing the technological advancements and the comforts made possible by mining. The industry remains essential for our current standard of living. Given this fact, more attention to the technical and artful processes of reclamation and restoration is called for, particularly at historical mining sites where production ceased long before modern rehabilitation methods were developed and implemented.

In contemporary mines, restoration is planned as the final phase of operations before a single cubic yard of earth is moved. Reclamation is often proceeding at the same time as ore extraction, a process that Thomas C. Hunt refers to as "closing the circle."[4] Companies such as Kennecott have invested heavily at Bingham Canyon in an attempt both to redress historical problems and to continue modern mining in an environmentally responsible fashion. Such efforts massively transform the landscape, and their success can arguably be judged only by future generations. Nonetheless, exacting attention to these sites should be given by a generally oblivious public. It is insufficient simply to dismiss them as waste places. Given the American appetite for the products of mining, it behooves us to understand and appreciate both the intricacy and the physical and social legacies of their production.

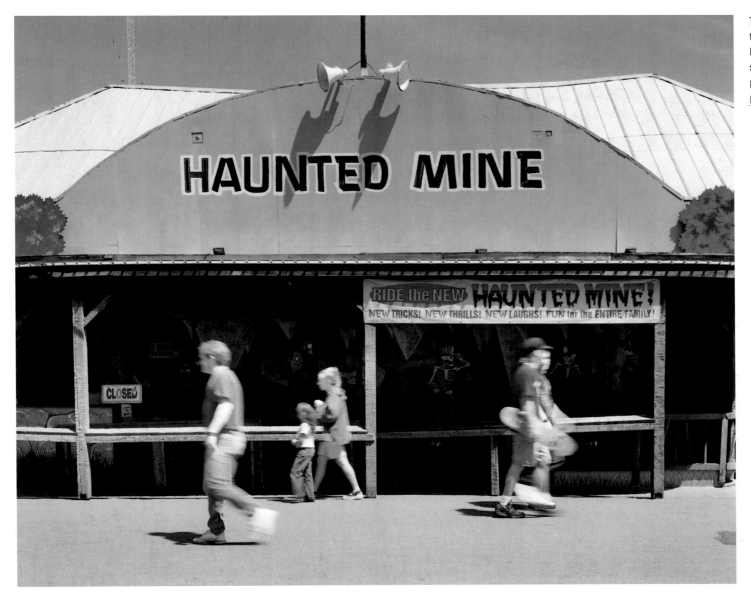

The Haunted Mine ride is part of the Oak Park Amusement Park in Portland, Oregon. Stink bombs set off inside occasioned its temporary closure at the time of this photograph in 1997.

An industry eager to present itself favorably to the general public, mining actively supports visitor education. Rachel Collins is a guide at the Meikle Barrick Goldstrike Mine, north of Carlin, Nevada. Her job is to make a highly technical and heavily automated work site comprehensible to casual visitors. Shown here in 1999, Rachel is posing with calcite crystals.

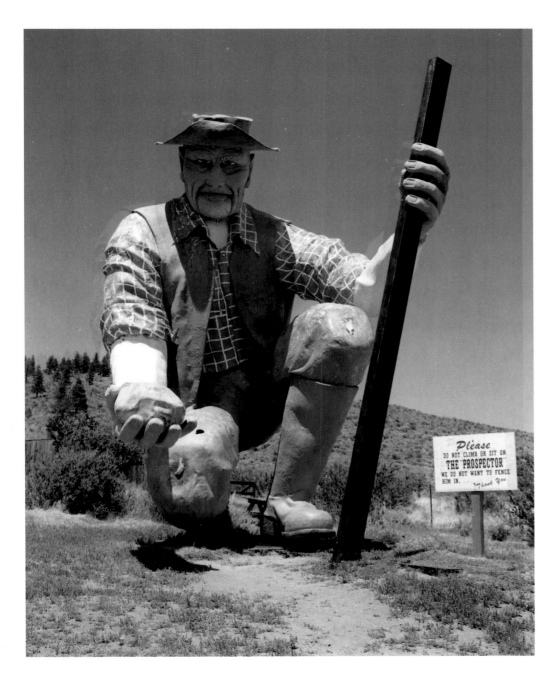

Mining imagery is an integral part of American popular culture. This giant fiberglass prospector figure once graced a Nevada casino of the same name. Somewhat the worse for wear, it rested in 1996 next to the Chocolate Nugget Factory in Washoe Valley, Nevada, with cautioning signs designed to protect it from overzealous customers. Note the picnic tables behind his boots.

Miner's Hat Realty, near Kellogg, Idaho, testifies to the pervasiveness of mining icons in the western American landscape. This company is located in the Bunker Hill Superfund site, where lead pollution from silver mining and smelting has left a legacy of spoiled soil and pervasive health concerns for residents. During the late twentieth century this area somewhat uneasily recast itself as a tourist destination, where local recreational opportunities are contextualized by the historical legacy of mining.

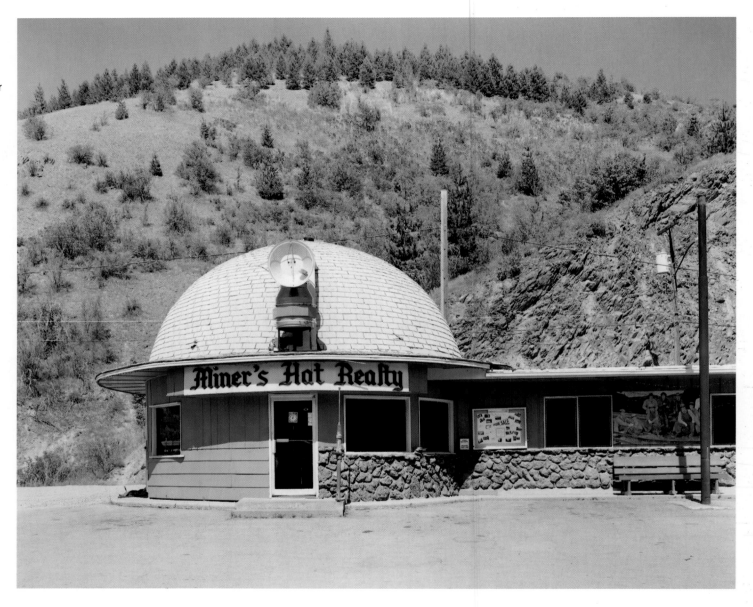

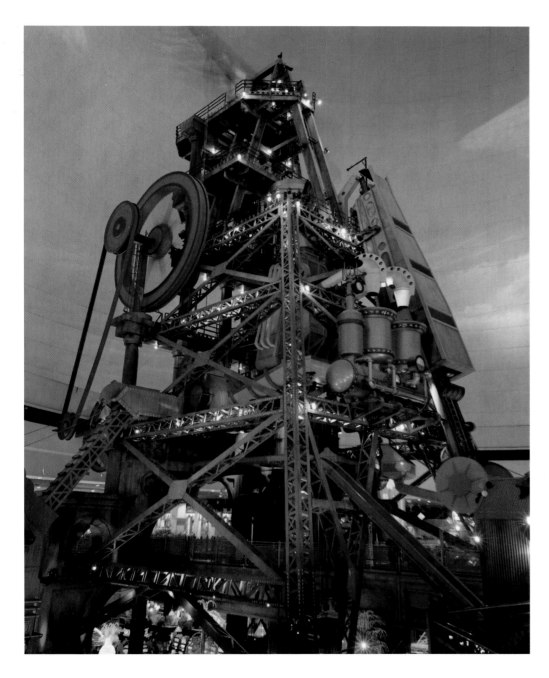

The Silver Legacy Resort and Casino in Reno, Nevada, has created an ersatz mining machine of enormous proportions, weighing 170 tons and measuring 120 feet tall. Ostensibly linked to a fictional mining baron, Sam Fairchild, the machine is a complete fake. With working ore carts, turning wheels, and functioning bellows, it simulates the production of silver coins that cascade from the machine at intervals throughout the day, but it has only a tenuous connection to the mechanics of actual mining, either historical or contemporary. Thunder and lightning against a painted mural sky provide the backdrop for the Silver Legacy's fantastic "mining rig."

This view of the Yellow Jacket Mine epitomizes "technostalgia" as seen from Room 10 in the Gold Hill Hotel, which is located on Nevada's Comstock Lode, near American Flat. The 1859 stone hotel is the oldest in the state, and is furnished with period furniture. It attracts guests interested in the history of a mining settlement now recast as a tourist town and designated a National Historic District. Occupants of Room 10 are promised a mining view, and its doorway neatly frames the surviving remnants of one of the Comstock's most notable silver mines. When the Yellow Jacket was functioning, however, such proximity would not have been an attraction for visitors seeking to rest. Historical mining tourism does not reproduce the noise, smell, or pervasive dust so characteristic of the actual experience.

NOTES

PROLOGUE

1. Mining is a highly technical endeavor, with its own professional lexicon that we recognize, but do not always adopt, in this book. The term "tunnel" is technically inaccurate here, since only one end is open to the air. Here and throughout we rely on vernacular usage despite the fact that "drift" or "adit" would probably be more precise.

2. Duane Smith traces the history of negative American responses to mining in *Mining America: The Industry and the Environment, 1800–1980* (Lawrence: University Press of Kansas, 1987).

3. Eric Margolis, "Mining Photographs: Unearthing the Meanings of Historical Photos," *Radical History Review* 40 (1988): 37.

4. Only coal strip mines are federally mandated to restore their ground after mining is finished. All states regulate mining within their borders, however, and environmental efforts frequently focus on making these requirements more stringent. The most common practice is for states to require companies to file a mining and reclamation plan that describes how the ground will be restored after mining is completed. Before approval and issuance of mining permits, a bond must be posted to guarantee completion of the restoration work, as well as to indemnify the state against any negative environmental consequences. Efficacy of these regulations varies widely by state, and environmental lobby groups frequently complain that the amounts of the bonds are set too low to insure environmental protection. The principal environmental problems from mining, however, occur in historical mines that were abandoned before any such state regulations were in effect.

5. Thomas Michael Power, *Lost Landscapes and Failed Economies: The Search for a Value of Place* (Washington, D.C.: Island Press, 1996), 93. See, also, Richard V. Francaviglia, *Hard Places: Reading the Landscape of America's Historic Mining Districts* (Iowa City: University of Iowa Press, 1991), 167.

6. For mining folklore, see Ronald M. James, "Knockers, Knackers, and Ghosts: Immigrant Folklore in the Western Mines," *Western Folklore* 51 (April 1992): 153–77; also, Archie Green, *Only a Miner: Studies in Recorded Coal-Mining Songs* (Urbana: University of Illinois Press, 1972, 284–92. Merle Travis's song, written in 1946, is entitled "Dark as a Dungeon."

7. The *Reno Gazette-Journal* reported on September 27, 1995 that casino spectators, failing to distinguish between performance and routine maintenance, were watching technicians perform tasks like changing light bulbs. This led to the decision to employ stunt actors dressed in period costume to perform on the mining rig ("Legacy to Add Stunt-Actor Performances on Mining Rig").

8. As philosopher David Rothenberg explains in *Hand's End: Technology and the Limits of Nature* (Berkeley: University of California Press, 1993, 42): "Language and photography prove to be distinct ways to abstract experience, each retaining some of the dynamism of the happening, but ex-

Despite hard evidence to the contrary, mining is associated in the popular imagination with the tantalizing promise of quick and miraculous wealth. This association gives it particular resonance in the gambling industry, which plays on similar desires. Here a bank of slot machines in the Silver Legacy Resort and Casino in Reno, Nevada, is capped by a symbolic ore cart.

changing another part for abstract reproducibility in order to remake the lived event into something recountable for others."

9. The literature of this field is vast. For a succinct review of the cultural landscape approach, see Joan Iverson Nassauer, "Culture and Changing Landscape Structure," *Landscape Ecology* 10 (1995), 229–37. A helpful collection of essays on vernacular landscape study is *Understanding Ordinary Landscapes,* edited by Paul Groth and Todd W. Bressi (New Haven: Yale University Press, 1997).

10. The influence of landscape stereotypes on attitudes toward scenery is discussed in Reginald G. Golledge, "Cognition of Physical and Built Environments," in Tommy Garling and Gary W. Evans, eds., *Environment, Cognition, and Action: An Integrated Approach* (New York: Oxford University Press, 1991), 35–62. For examples of mine tourism see chapters 8 and 1 on American Flat, Nevada, and the Mesabi Iron Range of Minnesota, respectively. Industrial tourism is discussed by John Sears in *Sacred Places: American Tourist Attractions in the Nineteenth Century* (New York: Oxford University Press, 1989), 182–208, and illustrated first-hand by *Picturesque America,* the two-volume tourist compilation edited by Willam G. Bryant and published in 1872 and 1874.

INTRODUCTION

1. The figure for 1999 was 47,335 pounds, according to the Mineral Information Institute of the United States Geological Survey, of which 20,871 pounds was sand, gravel, and stone. A complete breakdown can be found on the Website of the National Mining Association (http://www.nma.org), along with information about the production and use of minerals in the U.S.

2. Cedric E. Gregory, *A Concise History of Mining* (New York: Pergamon Press, 1980) is a thorough treatment of many aspects of mining and provides additional information about mining's products.

3. The following summary of the history of mining is drawn in particular from Gregory, *A Concise History of Mining*; as well as Robert B. Gordon and Patrick M. Malone, eds., *The Texture of Industry: An Archeological View of the Industrialization of North America* (New York: Oxford University Press, 1994); Robert Raymond, *Out of the Fiery Furnace: The Impact of Metals on the History of Mankind* (South Melbourne: Macmillan Company of Australia, 1984); T. A. Rickard, *A History of American Mining* (New York: McGraw-Hill, 1932); and Howard N. Sloane and Lucille L. Sloane, *A Pictorial History of American Mining* (New York: Crown Publishers, 1970).

4. As explained in Chapter 2, coal is divided into two types: the more common soft or bituminous form, and the rarer, harder anthracite. Most common U.S. coal is soft coal that is high in sulfur content and thus not desirable for most uses. With the cessation of anthracite mining, low-sulfur bituminous coal from the western U.S. is currently the most highly valued form. The significance and consequences of Darby's discovery are explored by Judith Alfrey and Catherine Clark in *The Landscape of Industry: Patterns of Change in Ironbridge Gorge* (London: Routledge, 1993).

5. For early lead mining see Rickard, *History of America Mining,* 147–78.

6. For a succinct account of hydraulic mining in California, see Raymond F. Dasman, "Environmental Changes before and after the Gold Rush," *California History* 77 (Winter 1998/99): 116–20. The aftermath can be seen in California's Malakoff Diggings State Park.

7. The 1872 Act does not cover sand and gravel except for "uncommon varieties."

8. The Secretary of the Interior is authorized to charge permit and lease fees on fossil fuel and fertilizer minerals such as coal, oil, sulfur, phosphate, and potash.

9. Rickard, *History of American Mining,* 324.

10. For these and other Comstock mining innovations, see Ronald M. James, *The Roar and the Silence: A History of Virginia City and the Comstock Lode* (Reno: University of Nevada Press, 1998), 45–60, 123–31.

11. While a full account of labor relations in the mining industry cannot be provided here, one representative incident is the Industrial Workers of the World (IWW) strike in Goldfield, Nevada, in 1906–7, a tense confrontation which ended with the arrival of federal troops and breaking of the union. See C. Elizabeth Raymond, *George Wingfield: Owner and Operator of Nevada* (Reno: University of Nevada Press, 1992), and Sally Zanjani and Guy Rocha, *Ignoble Conspiracy* (Reno: University of Nevada Press, 1986) for contrasting management and labor views of the same incidents. See, also, Rickard, *History of American Mining.*

12. Elliott West, "Golden Dreams: Colorado, California, and the Reimagining of America," *Montana* 49 (Autumn 1999): 2–11. See chapter 5 for copper mining at Bingham Canyon.

13. West, "Golden Dreams," 10.

14. See chapter 1 for an account of the Mesabi Iron Range.

15. For the environmental consequences of the original Pennsylvania oil wells, see Brian Black, "*Petrolia: A Sacrificial Landscape of American Industrialization*," *Landscape* 32 (1994): 42–48.

16. Gerald D. Nash, *The Federal Landscape: An Economic History of the Twentieth-Century West* (Tucson: University of Arizona Press, 1999), 66–67. See, also, Brian Black, *Petrolia: The Landscape of America's First Oil Boom* (Baltimore: Johns Hopkins University Press, 2000).

17. Smith, *Mining America*, 2.

18. See chapter 3 for an account of how the uranium boom played out in Texas.

19. Smith, *Mining America*, gives a full and sobering account of the environmental consequences of American mining.

20. The flotation process was invented in Australia in 1904 and the U.S. in 1905. It was employed to extract gold and copper from low-grade ores by combining them with acids, oil, or grease and crushing the mixture in a ball mill, a large hopper filled with steel balls that crushed the rock as it rotated. The resulting foam "floated" the metals up from the crushed rock (Gregory, Concise History, 140; Sloane and Sloane, Pictorial History, 33). Similarly technology contributed to the mining of bauxite, since large-scale smelting of aluminum became practical in the U.S. only after there was a source of cheap hydroelectric power in the Pacific Northwest.

21. See chapters 5 and 6 for examples of the extent of landscape transformation that results from modern open-pit mining methods.

22. The quotation is from George Dimock, *Exploiting the View: Photographs of Yosemite and Mariposa by Carleton Watkins* (North Bennington, VT: Park-McCullough House, 1984), 17.

23. Stilgoe's discussion of historical attitudes toward mining is in *Common Landscape of America, 1580 to 1845* (New Haven: Yale University Press, 1982), 265–300. See, also, Carolyn Merchant, *The Death of Nature: Women, Ecology, and the Scientific Revolution* (San Francisco: Harper & Row, 1980).

24. In *Mining America,* Smith traces growing awareness of the adverse environmental consequences of mining, as well as effects on miners.

25. Richard Francaviglia, "In Her Image: Some Reflections on Gender and Power in Mining History," *The Mining History Journal* 5 (1998): 118. William J. Mills points to analogies between mining and abortion in "Metaphorical Vision: Changes in Western Attitudes to the Environment," *Annals of the Association of American Geographers* 72 (1982): 244.

26. Robert L. Thayer, "Pragmatism in Paradise: Technology and the American Landscape," *Landscape* 30 (1990): 1–11. In *Derelict Landscapes: The Wasting of America's Built Environment,* John A. Jakle and David Wilson observe that Americans characteristically seek to avoid contact with or awareness of derelict zones (Totowa, NJ: Rowan & Littlefield, 1992). Although Jakle and Wilson do not consider mines, their model clearly helps explain general American ignorance about and avoidance of mining. See, also, Steven C. Bourassa, "A Paradigm for Landscape Aesthetics," *Environment and Behavior* 22 (November 1990): 787–812.

27. Three exceptions are Richard Francaviglia, *Hard Places*; Robert B Gordon and Patrick M Malone, eds., *The Texture of Industry: An Archaeological View of the Industrialization of North America* (New York: Oxford University Press, 1994); and John Fraser Hart, *The Rural Landscape* (Baltimore: Johns Hopkins University Press, 1998), 42–55. Works pertinent to specific minerals or locations are cited in the notes of subsequent chapters, but a good example not cited there is Larry Lankton, *Cradle to Grave: Life, Work, and Death at the Lake Superior Copper Mines* (New York: Oxford University Press, 1991).

28. Elizabeth Ann R. Bird calls for histories of this sort that help us better understand such landscapes: "We need histories of environmental problems that examine the social relations, structural conditions, cultural myths, metaphors, and ethical presuppositions that constitute the social negotiations with nature that contribute to those problems" ("The Social Construction of Nature: Theoretical Approaches to the History of Environmental Problems," *Environmental Review* 11 (1987): 262).

29. Francaviglia, *Hard Places,* 11. Francaviglia observes elsewhere in *Hard Places* that features similar to those visible in mines are admired when they are construed as "natural": "This combination—the effects of time and physical processes on the landscape—is exactly what we are supposed to appreciate when we look into the Grand Canyon" (142).

CHAPTER 1

1. Lewis Mumford, *Techniques and Civilization* (New York: Harcourt, Brace & World, 1934; reprinted 1963), 73.

2. Paul Landis, *Three Iron Mining Towns: A Study in Cultural Change* (Ann Arbor, MI: Edwards Bros., Inc., 1938), 51. Landis reports that the Range towns of Eveleth, Virginia, and Hibbing had begun to advertise the charms of the "Arrowhead District" beginning in 1926, and that they had circulated "attractive folders" that included pictures of iron mines as well as lakes, public buildings, and fish, beginning in 1930.

3. The name Mesabi has several variant spellings (Mesaba, Missabe, etc.) and is reportedly derived from an Ojibwa term meaning "Sleeping Giant." This account of the discovery and exploitation of the Mesabi Iron Range is drawn from Russell H. Bennett, *Quest for Ore* (Minneapolis: T. S. Denison & Co., 1963); E. W. Davis, *Pioneering with Taconite* (St. Paul: Minnesota Historical Society, 1964); Landis, *Three Iron Mining Towns*; Edmund J. Longyear and Walter R. Eastman, *Longyear: The Mesabi and Beyond* (Gilbert, MN: Iron Range Historical Society, 1984); and Peter F. Torreano, *Mesabi Miracle: The 100-Year History of the Pillsbury-Bennett-Longyear Association* (Hibbing, MN: Sargent Land Company, 1991). See, also, Arnold R. Alanen, "Years of Change on the Iron Range," in Clifford E. Clark, Jr., ed., *Minnesota in a Century of Change* (St. Paul: Minnesota Historical Society Press, 1989), 155–94.

4. David A. Walker, *Iron Frontier: The Discovery and Early Development of Minnesota's Three Ranges* (St. Paul: Minnesota Historical Society Press, 1979), 86–99, 118; *Iron Range Country: A Historical Travelogue of Minnesota's Iron Ranges* (Eveleth, MN: Iron Range Resources and Rehabilitation Board, 1979), 99.

5. J. H. James in *The Great Missabe Iron Range* [pamphlet, 1892], Delamare Library, University of Nevada, Reno.

6. Although the techniques used on the Mesabi had been used elsewhere in Lake Superior mines, the scale of the operation at the Mesabi dwarfed previous efforts and demonstrated the applicability to western operations (Walker, *Iron Frontier*, 132). See chapter 5 for their application at Bingham Canyon, in Utah.

7. Edmund Longyear traced the various stages of Mesabi communities from exploration camps, to drill camps, to mining camps, and, with luck, to villages or cities. He thought that the crucial shift from drill camp to "location," or mining camp, occurred when miners' wives and families arrived and occupied separate houses. Prior to that, workers lived in tents or log bunk houses (*Longyear,* 46–48). For Mesabi towns, see Arnold R. Alanen, "The 'Locations': Company Communities on Minnesota's Iron Ranges, *Minnesota History* 48 (1982): 94–107. For the cultural diversity of Eveleth, see Polly Bullard, "Iron Range Schoolmarm," *Minnesota History* 32 (1951): 193–201.

8. For the seasonal nature of Mesabi mining, see *Report of the Iron Range Historical–Cultural Survey (Oct. 1, 1978–Sep. 30, 1979),* prepared under the direction of Dr. Joseph Stipanovich, director for Iron Range Resource and Rehabilitation Board, typescript, Minnesota Historical Society, St. Paul, MN, 58–59.

9. *Iron Range Country,* 91–92.

10. W. J. T. Mitchell, "Introduction," in Mitchell, ed., *Landscape and Power* (Chicago: University of Chicago Press, 1994), 2.

11. John Caddy, *The Color of Mesabi Bones: Poems and Prose Poems* (Minneapolis: Milkweed Editions, 1989).

12. James Gray, *Pine, Stream and Prairie: Wisconsin and Minnesota in Profile* (New York: Alfred A Knopf, 1945), 78.

13. For natural ore and taconite, see Davis, *Pioneering With Taconite.*

14. Taconite was described disparagingly by retired foreman Forrest Condon during a tour of the Minnesota Taconite Company's (MinnTac) taconite processing plant in Mountain Iron, Minnesota, July 24, 1998. A pilot plant to process taconite had opened in Babbitt, MN, in 1922, but proved uneconomical while natural ore was still widely available.

15. According to David Meineke, president of Meriden Engineering in Hibbing, MN, seven mines were operating on the Mesabi in July, 1998. Together they produced more than seventy-five percent of all U.S. iron ore. For the taconite pollution, which was a result of Reserve Mining Company processing at Silver Bay, on the shores of Lake Superior, see Robert Bartlett, *The Reserve Mining Controversy* (Bloomington: Indiana University Press, 1980). U.S. Steel, which operates MinnTac, processes its taconite on the Mesabi and ships only finished pellets to be loaded on Lake Superior ore boats. For details of the Taconite Amendment, see James R. Tillis, "Tomorrow is Here! Rebirth of the Mesabi Range," (Virginia, MN: Northeastern Minnesota Development Association, 1966), 12–19.

16. *Minnesota Minerals* (St. Paul: Minnesota Department of Mines and Minerals, 1994), 5, emphasis added.

17. Doreen Massey, *Space, Place, and Gender* (Minneapolis: University

of Minnesota Press, 1994), 5. Massey points out that place is also inextricably bound up in time, so that the variant landscapes being commemorated in the Mesabi all have reference to the same place, but at many different periods. For miners' pride in the transformations they have affected in the landscape, see Kent C. Ryden, *Mapping the Invisible Landscape* (Iowa City; University of Iowa Press, 1992).

18. The description of iron ore dust is from Caddy, *Mesabi Bones*.

19. Annual Report of the Iron Range Resources and Rehabilitation Board, 1942, Ironworld Research Center.

20. Longyear and Eastman, *Longyear*, 31.

21. As geographer David Lowenthal observes of agricultural landscapes in Britain: "What lingers as scenery dies as social identity." From "European Landscape Transformations: The Rural Residue," in Paul Groth and Todd W. Bressi, eds., *Understanding Ordinary Landscapes* (New Haven: Yale University Press, 1997), 185. Information on the Hibbing neighborhood came from an interview with David Meineke, July 24, 1998.

22. Iron Mining Association of Minnesota brochure, in authors' possession. For a visual and philosophical rumination on the paradox of engineered natural landscapes, see Peter Goin, *Humanature* (Austin: University of Texas Press, 1996).

23. Aguar, Jyring and Whiteman, "Recreation Survey and Analysis, Regional Area, Mesabi & Vermilion Ranges, Minnesota," 1964, Minnesota Historical Society, 1.

24. Hull-Mahoning Mine Tour pamphlet, Hibbing Visitors' Guide, both in authors' possession. David Nye, *American Technological Sublime* (Cambridge: M.I.T. Press, 1994). For Americans, the technological sublime was also linked with nationalism, as Nye explains: "The sublime was inseparable from a peculiar double action of the imagination by which the land was appropriated as a natural symbol of the nation while, at the same time, it was being transformed into a man-made landscape" (37). James Dickinson describes "a sort of late 20th century sublime" that awes us with "the speed with which change dissolves the past and constantly reshapes the once immutable landscape around us (82)," in "Entropic Zones: Buildings and Structures of the Contemporary City," *CNS* 7 (September 1996): 81–95.

25. Authorities in Anaconda, Montana, have artfully combined reclamation and industrial tourism. They created a golf course on a Superfund site that marks the former location of a copper smelter. According to the *New York Times*, the Old Works Golf Course is a recreational reclamation project with "an industrial smelting theme that carries right down to the black slag, or smelting waste, used in the bunkers and the cranes and old heavy equipment scattered around the grounds" (6 April 1997, 20). For an intriguing exploration of the process by which locations may acquire new identities and evolve from ruins into monuments, see Dickinson, "Entropic Zones." For a British example, see Stephen Daniels, "Joseph Wright and the Spectacle of Power," in *Fields of Vision: Landscape Imagery and National Identity in England and the United States* (Princeton: Princeton University Press, 1993), 43–79.

26. Daniels, *Fields of Vision*, 8. For the history of labor strife on the Mesabi, see Arnold R. Alanen, "Early Labor Strife on Minnesota's Mining Frontier, 1882–1906," *Minnesota History* 52 (1991): 246–63; Robert M. Eleff, "The 1916 Minnesota Miners' Strike Against U.S. Steel," *Minnesota History* 51 (1988): 63–74.

CHAPTER 2

1. For the anthracite industry, see Donald L. Miller and Richard E. Sharpless, "The Ecological and Economic Impact of Anthracite Mining in Pennsylvania," in Chimyl K. Majumdar, ed., *Energy, Environment, and the Economy* (Easton: Pennsylvania Academy of Science, 1981), 169–84; and *The Kingdom of Coal: Work, Enterprise, and Ethnic Communities in the Mine Fields* (Philadelphia: University of Pennsylvania Press, 1985). An excellent overview is provided by H. Benjamin Powell, "The Pennsylvania Anthracite Industry, 1769–1976," *Pennsylvania History* 46 (1980): 3–27.

2. "Paynes Pitch," in Karen Blomain, ed., *Coalseam: Poems from the Anthracite Region* (Scranton: University of Scranton Press, 1993), 26.

3. "Slices Through Time: The Physical and Cultural Landscapes of Central and Eastern Pennsylvania," in *The Philadelphia Region: Selected Essays and Field Trip Itineraries* (Washington, D.C.: Association of American Geographers, 1979), 4.

4. [Lewis H. Miner] *The Valley of Wyoming: The Romance of Its History and Its Poetry, Compiled by a Native of the Valley* (New York: Robt. H. Johnston & Co., 1866), 16–17.

5. Peter Roberts, *Anthracite Coal Communities: A Study of the Demography, the Social, Educational and Moral Life of the Anthracite Regions* (New York: Macmillan, 1904), 6.

6. Contemporary views are reported in the newsletter of a local reclamation agency, *Earth Conservancy News* 2 (December 1995), 2.

7. Ele Bowen, "The Prose, Poetry and Scenery of the Coal Regions of Pennsylvania," *Graham's American Monthly Magazine,* 1854; transcribed as Job 54, Folder 1, of field notes for the proposed Pennsylvania Anthracite Book, which was never published (American Guide Series, Record Group #13, Pennsylvania State Archives, Harrisburg, PA).

8. William Griffiths, "Semi-Centennial Address: Some of the Beneficial Results of Judge Jesse Fell's Experiment with Wyoming Coal," *Proceedings and Collections of the Wyoming Historical and Geological Society* 10 (1908–9): 85.

9. Roberts, *Anthracite Coal Communities,* 123.

10. Richard Richardson, *Memoir of Josiah White* (Philadelphia: J. B. Lippincott & Co., 1873), 31.

11. George E. Stevenson, *Reflections of an Anthracite Engineer* (Scranton: privately printed, 1931); William J. Nicholls, *Coal Catechism* (Philadelphia: George W. Jacobs & Co., 1906). The breaker is described by Rosamond D. Rhone, "Anthracite Coal Mines and Mining," *Review of Reviews and World's Work* 26 (1902): 59.

12. Homer Greene, *The Blind Brother: A Story of the Pennsylvania Coal Mines* (New York: Thomas Y. Crowell, 1887), 35.

13. George G. Korson, *Songs and Ballads of the Anthracite Miner: A Seam of Folklore Which Once Ran Through Life in the Hard Coal Fields of Pennsylvania* (New York: Frederick H. Hitchcock, The Grafton Press, 1927), 43.

14. The distinctive whistles of the breakers were remembered by Jack Mills of Wyoming, PA, in an interview April 13, 1999.

15. Dr. Hollister, *History of Lackawanna,* 2nd ed., 1869, quoted in Stevenson, *Reflections,* 72.

16. Complaints about preference being given to mules over men were frequently heard among old miners, and were recorded by George Korson in *Minstrels of the Mine Patch: Songs and Stories of the Anthracite Industry* (Philadelphia: University of Pennsylvania Press, 1938), 103.

17. Italians and Slavs are stereotyped in Matthew Stanley Kemp, *Boss Tom: The Annals of an Anthracite Mining Village* (Akron, OH: Saalfield Publishing Co., 1904), 296, 72–73. Abysmal housing conditions that prevailed for Slavs are described in Miller and Sharpless, *Kingdom of Coal,* 176–88.

18. Production statistics are from Jacques Steinberg, "Coal Tries for a Comeback," *New York Times,* March 3, 1996, E6.

19. Lewis and Marsh, "Slices Through Time," 35.

20. John Bodnar, *Anthracite People: Families, Unions and Work, 1900–1940* (Harrisburg: Pennsylvania Historical and Museum Commission, 1983), 11. The summary of environmental consequences is from Miller and Sharpless, *Kingdom of Coal,* xx–xxi. The most notorious Pennsylvania example of environmental degradation due to coal mining is in Centralia, where an underground mine caught fire in 1962 and eventually forced the evacuation of a town. The fire continues today. Although nothing of similar magnitude has occurred in Wyoming Valley, 140 years of coal mining unquestionably altered the landscape for the worse.

21. Thomas Kielty Blomain, "Slag Valley," and Vincent D. Balitas, "Payne's Pitch"; both in Karen Blomain, ed., *Coalseam,* 28, 43.

22. "The Miner's Song," in Korson, *Songs and Ballads,* 94–95; S. R. Smith, *The Black Trail of Anthracite* (Kingston, PA: S. R. Smith, 1907), 113.

23. "A Polish Immigrant Makes Good," Interview with Simon Praszinsky, August 17, 1939, in field notes for the proposed Pennsylvania Anthracite Book (American Guide Series, Record Group #13, Pennsylvania State Archives, Harrisburg, PA).

24. George Korson noted in *Minstrels of the Mine Patch* that Slavs planted flowers even among the culm banks (127) and Peter Roberts approvingly recorded the sacrifices made by "Sclavs" for their gardens (*Anthracite Coal Communities,* 107). Frank Norris was astonished to find lawns surrounding miners' cabins when he visited Wilkes-Barre during the 1902 strike.

25. Information on coal carving in the 1930s, which was done by members of the Patience family in West Pittston, is from Folder 68, Job 54, in the field notes for the proposed Pennsylvania Anthracite Book (Pennsylvania State Archives, Harrisburg, PA).

26. M. L. Quinn, "Should All Degraded Landscapes Be Restored? A Look at the Appalachian Copper Basin," *Land Degradation & Rehabilitation* 3 (1992): 115–34. In their work on reclamation of coal lands, based on a similar British experience, I. G. Richards, J. P. Palmer, and P. A. Barratt point out that "colliery spoil heaps may also be considered local landmarks and therefore worthy of retention rather than being reshaped" (*The Reclamation of Former Coal Mines and Steelworks,* Studies in Environmental Science 56, Amsterdam: Elsevier, 1993, 147).

27. Information on Earth Conservancy comes from its newsletter, *Earth Conser-*

vancy News, and from an interview with Engineering Projects Manager Thomas Chesnick.

28. Quoted in Bonnie Adams, "Coalition may be formed to offset mine water harm," *Wilkes–Barre Times Leader,* September 6, 1999.

29. Opposition to Earth Conservancy's reclamation efforts is neither organized nor widespread, but comes in the form of individual comments or complaints from Wyoming Valley residents. As was the case in Tennessee's Copper Basin, many residents recognize the environmental desirability of Earth Conservancy's activities, even as they lament the eradication of the remaining vestiges of the anthracite landscape. A recent initiative of Earth Conservancy, which addresses these concerns, involves studying the feasibility of preserving one of the few remaining coal breakers in the state. Built in 1939 by the Glen Alden Coal Company, the Huber breaker would be converted into a community park, similar to efforts on Minnesota's Mesabi Iron Range (see chapter 1).

CHAPTER 3

1. For the early history of the industry in Texas, see D. Hoye Eargle and John L. Snider, "A Preliminary Report on the Stratigraphy of the Uranium-Bearing Rocks of the Karnes County Area, South-Central Texas," *Report of Investigations No. 30,* (Austin: Texas Bureau of Economic Geology, July 1957). Other useful Bureau of Economic Geology publications include Peter T. Flawn, "Uranium in Texas—1967"; and D. Hoye Eargle, George W. Hinds, and Alice M. D. Weeks, "Uranium Geology and Mines, South Texas," *Guidebook Number 12,* 1971. The AEC closed its Austin office in 1962, when the first boom period leveled off. Information on the prospecting pamphlet, which had more than 10,000 copies in circulation, is from Flawn, 3. We are especially indebted to Sharon Stewart of Chacon, New Mexico, and Ronald L. Parker, of College Station, Texas, for their assistance in providing references for this chapter.

2. Income estimates are from the Texas Department of Agriculture, "Agricultural and Rural Impacts of Uranium Recovery Activities in the South Texas Uranium District," *Report to the 72nd Legislature,* 1991, ii.

3. Indeed, scientific opinion varies considerably over the nature of these dangers. A 2000 General Accounting Office report on federal radiation exposure standards concluded that they "do not have a conclusive scientific basis, despite decades of research." Quoted in Gina Kolata, "For Radiation, How Much Is Too Much?" *New York Times,* November 27, 2001, D1.

4. Occasionally uranium was located on land where the State of Texas had retained mineral rights, although the surface rights were privately owned. The fractures that uranium created within the close-knit Polish and Czech community in Karnes County readily surface in conversations with area residents. At the Panna Maria Visitor's Center, directly across the road from Panna Maria Immaculate Conception Catholic Church, staffers confided in 1999 that their Polish priest had tried to keep them from selling land to Chevron in the 1970s because uranium would only cause them trouble. To their continuing regret, however, they had listened to the blandishments of "really friendly" salesmen who "put on a show." According to their accounts, the uranium company representatives staged community barbeques, showed beautiful slides of reclaimed uranium mines, and brought little presents for the children of targeted landowners. Even twenty-five years after the fact, bitterness still lingered about the outcome.

5. Eargle, et. al., *Uranium Geology and Mines,* is especially rich in detail on the first decade of uranium mining.

6. For a succinct account of recent uranium mining in Karnes County, see Railroad Commission of Texas, Surface Mining and Reclamation Division, *South Texas Uranium District Abandoned Mine Land Inventory* (1994), 4.1–4.3.

7. Estimated total Karnes County uranium ore tonnage is reported by Marc A. McConnell, et al., "Distribution of Uranium-238 in Environmental Samples from a Residential Area Impacted by Mining and Milling Activities," *Environmental Toxicology and Chemistry* 17 (November 5, 1998): 841–50. There was no requirement that tailings impounds or ponds be lined to protect the groundwater until 1982. The estimate of waste production per ton of ore originated in the 1989 Texas Senate Subcommittee on Health Services and was cited in the Texas Department of Agriculture, "Agricultural and Rural Impacts of Uranium Recovery Activities," 11.

8. We are indebted to William Chovanec and Mark Rhodes of the Surface Mining and Reclamation Division for historical photographs, background information, and an explanation of the complicated structure of mine reclamation in Texas. Mark Rhodes and Roni Anson served as excellent tour guides to Karnes County reclamation sites. The 1975 legislation is summarized in William E. Galloway, Robert J. Finley, and Christopher D. Henry, "South Texas Uranium Province—Geologic Perspective," *Guidebook No. 18* (Austin: Texas Bureau of Economic Geology, 1979), 40–41.

9. The environmental characterization of Karnes County is from *South Texas Uranium District Abandoned Mine Land Inventory*, 2.1. The remark about consuming fish was made by a Falls City resident to Ronald L. Parker, of Texas A&M University. Texas Railroad Commission authorities in charge of restoring abandoned mines report that, while landowner wishes do not determine the reclamation plan for any site, they *are* taken into consideration.

10. Information on plant restoration comes from Roni Anson, Environmental Quality Specialist for the Abandoned Mine Lands Division of the Texas Railroad Commission.

11. The amount of the property liens on reclaimed land averages $200 per acre. The figure is based on the difference between the prereclamation and post-reclamation property appraisals.

12. Texas Senate Subcommittee on Health Services, "Interim Report to the 71st Legislative Session on Regulation of Uranium Mill Tailings and Wastes With Similar Radiological Characteristics," 1991, 13. Epidemiological studies confirm that environmental contamination associated with milling sites is far greater than that associated with mining only sites (McConnell et al., "Distribution of Uranium-238," 841).

13. Information on the groundwater monitoring for the Susquehanna-Western Mill site, known as Falls City in the literature, can be found on the DOE website (*http://www.doegjpo.com/gwwp/fct/ea/ea.html*).

14. Ibid., 12.

15. *South Texas Uranium District Abandoned Mine Land Inventory*, 7.44. Recent studies by William W. Au, while acknowledging and enumerating the difficulties of such measurement, have attempted to specify the increased health risks resulting from uranium-238 exposure for residents near processing and milling sites in Karnes County. See W. W. Au et al., "Population Monitoring: Experience with Residents Exposed to Uranium Mining/ Milling Waste," *Mutation Research* 405 (September 20, 1998): 232–45. We are indebted to Dr. Au for sharing his work with us.

16. For problems with such epidemiological studies, see Au, et all., "Population Monitoring," and William W. Au et al., "Factors Contributing to Discrepancies in Population Monitoring Studies," *Mutation Research* 400 (May 25, 1998): 467–78. The former study estimates that the elevated health risk for affected Karnes County residents is roughly equivalent to that for workers in the nuclear industry (244).

17. Texas Department of Agriculture, Office of Natural Resources, "Agriculture and the Uranium Industry: A Staff Analysis," Austin, September, 1998; Andy Rivers, quoted in an exhibit by Sharon Stewart, *The Toxic Tour of Texas*, featured on the Website of the Texas Humanities Resource Center (*http://humanities-interactive.org/texas/toxic citizen_act_essay2.html*). For debates over the necessity of regulating radiation exposure, see Kolata, "For Radiation, How Much Is Too Much?

CHAPTER 4

1. For the uranium boom, see Raye C. Ringholz, *Uranium Frenzy: Boom and Bust on the Colorado Plateau* (New York: W. W. Norton, 1989). Wade V. Lewis, a trained mining engineer, tells the story of the Free Enterprise discovery, and its transformation into a "health" mine, in *Arthritis and Radioactivity* (Seattle: Peanut Butter Publishing, 1955, rev. ed. 1994). We are indebted to Barbra Erickson for this and numerous other sources related to the Montana radon health mines.

2. Information on the individual mines comes from their brochures, and from Barbra Erickson, "'. . . And the People Went to the Caves to be Healed,'" in Stephen Tchudi, ed., *Western Futures: Perspectives from the Humanities at the Millennium, Halcyon* 22 (2000): 31-52.

3. Lewis, *Arthritis and Radioactivity*, 11. Lewis's decision about the "health business" is reported in Erickson, "'And the People Went to the Caves.'"

4. Seth Tom Bailey, "True Reports on the Underground Cure for Arthritis," *True Magazine* (December 1955): 16-20, ff. Information on the requests to the Montana Bureau of Mines and Geology was provided by Robin McCullough, of that agency. Wade Lewis reports the practice as well in *Arthritis and Radioactivity*, 102.

5. The EPA's response is reported by Bailey, 18. For skepticism about EPA radon recommendations, see Philip H. Abelson, "Mineral Dusts and Radon in Uranium Mines," *Science* 254 (November 8, 1991): 777. Epidemiological studies in the U.S. have also failed to uncover statistically convincing links between the presence of radon and lung cancer. See Gina Kolata, "For Radiation, How Much Is Too Much?" *New York Times*, November 27, 2001, D1.

6. The U.S. Geological Survey Website has an excellent brief introduction to radon (http://sedwww.cr.usgs.gov:8080/radon/georadon/2.html). Information on radon concentration in the health mines comes from mea-

surements made by the Montana Department of Health in 1991, and reported in Erickson, 7.

7. Quotations in this and the following paragraph come from Dan Burckhart, "Mining For a Cure," *Billings Gazette*, January 25, 1998, 1B.

8. Unless otherwise noted, all quotations from mine visitors are from the October 1997 "Endorsements" brochure of the Free Enterprise Health Mine.

9. The sixty percent figure is reported in Bailey, "True Reports." Contemporary pain relief rates are contained in individual mine brochures. The 1996 trade association brochure lists only five of the six present health mines. Perhaps pointedly, it does not include the Lone Tree Health Mine, the property that created its space in 1988, specifically to cater to the radon-seeking visitors.

10. The current Free Enterprise Health Mine Website address is http://www.radonmine.com. Newsletter contents are from the Summer 1998 issue.

11. Visitor figures and explanations for the decline appear in the January 2000 issue of "Mine Notes," found at the Free Enterprise Website. Visitor numbers reported for the intervening years were 1,013 in 1992, 1,000 in 1993, 896 in 1994, 911 in 1995, 743 in 1996, 647 in 1997, and 512 in 1998.

12. The "healing power of radon" was promoted in the Summer 1998 newsletter.

13. Floyd Pennington, of the Arthritis Foundation, and Leonard Sagan, of the Electric Power Research Institute, are both quoted by Eric Morgenthaler in "For a Healthy Glow Some Old Folks Try a Dose of Radon," *Wall Street Journal* (October 12, 1990), A1.

CHAPTER 5

1. Thomas Michael Power, *Lost Landscapes and Failed Economies: The Search for a Value of Place* (Washington, D.C.: Island Press, 1996), 112.

2. Information on the mine comes from the Kennecott Utah Copper Company, which publishes numerous informative brochures about its operations in Bingham Canyon. Other useful sources include Leonard J. Arrington and Gary B. Hansen, *"The Richest Hole on Earth": A History of the Bingham Copper Mine*, Utah State University Monograph Series, vol. 11 (October 1963); Lynn R. Bailey, *Old Reliable: A History of Bingham Canyon, Utah* (Tucson: Westernlore Press, 1988); Jon Christensen, "Can a cop-

per firm restore a blasted ecosystem?" *High Country News* 26 (May 30, 1994), 8–12; A. B Parsons, *The Porphyry Coppers* (New York: American Institute of Mining and Metallurgical Engineers, 1933); and T. A. Rickard, *A History of American Mining* (New York: McGraw-Hill, 1932), 185–201.

3. See chapter 1 for details of mining history on the Mesabi. The innovation is noted in Arrington and Hansen: "The initiation of 'non-selective mining' at Bingham prompted the emergence of a great new and spectacular national industry, and established a pattern which came to dominate American mining" (8–9); and the connection to Mesabi is documented on pp. 53–61. The use of methods pioneered on the Mesabi is also detailed by Lewis C. Brownson, *In Partnership with Nature* (Minneapolis: Lewis C. Brownson, 1931), 22–35.

4. The Garfield smelter was operated by the American Smelting and Refining Company, controlled by the Guggenheim family. It was ASARCO's interest in the smelter that led the Guggenheims to invest in forming the controlling company at Bingham Canyon, despite their initial skepticism about the profitability of mining such low-grade ore. For details of the arrangement, see Arrington and Hansen, *Richest Hole on Earth*, 47, 76.

5. Marion Dunn, *Bingham Canyon* (Salt Lake City: Publishers Press, n.d.), 107–8.

6. Bailey, *Old Reliable*, 99.

7. Dunn, *Bingham Canyon*, 4.

8. Violet Boyce and Mabel Harmer, *Upstairs to a Mine* (Logan: Utah State University Press, 1976), 18. Russell Elliott describes a similar system of discrete residential enclaves in another Guggenheim copper facility, at McGill, Nevada, in *Growing Up in a Company Town* (Reno: Nevada Historical Society, 1990).

9. Scott Crump, *Copperton* (Salt Lake City: Publishers Press, 1978), xiii.

10. Crump, *Copperton*, 16.

11. The characteristic Bingham stench is described by Boyce and Harmer, *Upstairs to a Mine*, 78. For the sewer system, see Bailey, *Old Reliable*, 165.

12. For the notorious reluctance of mining companies to invest in local communities, see Power, *Lost Landscapes and Failed Economies*. Bisbee, Arizona has a similar history as a mining community, as chronicled in Carlos A. Schantes, ed., *Bisbee: Urban Outpost on the Frontier* (Tucson: University of Arizona Press, 1992).

13. Dunn recounts the connections between the 1959 strike and more willing sellers in *Bingham Canyon*, 141.

14. Boyce and Harmer, *Upstairs to a Mine,* 3.

15. Kathryn Jacobsen, "Interview of Alta Miller, 2/22/74 in Midvale," transcript, Utah Historical Society.

16. The commemorative poem, by Marvin J. Hamaker, was composed in the early 1960s, and is contained in an epilogue to Crump, *Copperton,* 191–92.

17. The Boyce and Harmer poem is on page 189.

18. A similar recognition that the sacrificed towns represented progress and prosperity for the mine (and, thus, its employees) was voiced in 1998 interviews by mine employees Dick Peterson and Gary Curtis. Both men were second-generation employees of Kennecott, who had grown up knowing the now-vanished landscapes of the canyon. While they recalled the eradicated locales fondly, their pride in the collective accomplishment of having built and sustained a mine that was so productive over such a long period was palpable.

19. For the recent history of ownership of the Kennecott Copper Company, see Charles K. Hyde, *Copper For America: The United States Copper Industry from Colonial Times to the 1990s* (Tucson: University of Arizona Press, 1988), 139–42. Information on remaining mine life comes from Dick Peterson, senior supervisor of Operations Training at Bingham Canyon Mine. Along with Gary Curtis, production controller of the Truck and Shovel Division, he provided the authors with invaluable background information during a tour of the Bingham Canyon facility.

20. Jon Christensen lays out the complexities of the environmental debate at Bingham Canyon, including questions of the proper scale and time frame, as well as appropriate standards for groundwater restoration, in "Can a copper firm restore a blasted ecosystem?"

21. Sierra Club activist Ivan Weber, quoted in Christensen, 12.

CHAPTER 6

1. The headline is from the *Rawhide Press-Times,* March 12, 1908. For an insightful discussion of the promoter's role in creating mines, see Lewis Atherton, "Structure and Balance in Western Mining History," *Huntington Library Quarterly* 30 (November 1966): 55–85. News of the company's plans to begin shutting down its operation at Rawhide in August of 2002 was announced in the *Reno Gazette Journal,* January 22, 2002 ("Kennecott Rawhide Mine Set to Downsize in August").

2. For figures on mining's economic impact, including Nevada, see Thomas Michael Power, *Lost Landscapes and Failed Economies: The Search for a Value of Place* (Washington, D.C.: Island Press, 1996), 98–99.

3. See Jon Christensen, "After the Gold Rush," *High Country News,* April 13, 1995, 19–20; Bill Epler, "Joint Venture Led by Kennecott Nearing Capacity," *Rocky Mountain Pay Dirt,* January 1991, 4A–7A. Figures on rock processing are from Kennecott Rawhide Mining Company.

4. Richard Francaviglia, *Hard Places: Reading the Landscape of America's Historic Mining Districts,* (Iowa City: University of Iowa Press, 1991), 173.

5. P. R. Whytock, "The Rawhide District, Nevada," *The Mining World* 31 (July 31, 1909), 12.

6. Duane Smith, *Mining America: The Industry and the Environment, 1899–1980* (Lawrence: University Press of Kansas, 1987), 31–32. Smith observes that nonminers molded the industry's perception of itself as they toured, watched, and "created the glamorous image of mining." Peter Bacon Hales explores the history of American photographic booster books in "American Views and the Romance of Modernization," in Martha Sandweiss, ed., *Photography in Nineteenth-Century America* (Fort Worth: Amon Carter Museum, New York: Harry N. Abrams, 1991), 205–57.

7. George Graham Rice, *My Adventures With Your Money* (New York, 1913; reprint Las Vegas: Nevada Publications, 1986). Tantalizingly little is known of Rice's career. According to Russell R. Elliott, Rice was born as Jacob S. Herzig in 1870 and had been imprisoned before he arrived in Goldfield. The failure of his L. M. Sullivan Trust Company in Goldfield in 1906 was in large part responsible for the bank closures associated with the Panic of 1907 there. In Rawhide he teamed with popular New York City comic actor Nat. C. Goodwin to form a stock brokerage in the latter's name. Goodwin apparently financed Rice's main publicity vehicle, the *Nevada Mining News.* After exposure as a swindler in Rawhide, Rice left the state for New York City where he founded another brokerage house that promoted Nevada stocks. He was convicted in 1910 of using the mails to defraud and was sentenced to federal prison. It was there that he wrote *My Adventures With Your Money.* See Elliott, *History of Nevada* (Reno: University of Nevada Press, 1973), 220–21; Hugh A. Shamberger, *Historic Mining Camps of Nevada: Rawhide* (Carson City: Nevada Historic Press, 1970), 38.

8. The story of the boulder was repeated endlessly in accounts of Rawhide, always as a story overheard or reported by others. See *1908–1909 Raw-*

hide Fallon and Vicinity City Business Mining Directory (Reno: P&C Nevada Directory Co.), at the Nevada Historical Society; Emmett L. Arnold, *Gold Camp Drifter 1906–1910* (Reno: University of Nevada Press, 1973), 97–99; Nanelia S. Doughty, "Jim Moffatt's Recollections of Rawhide," *Nevadan,* March 19, 1972, 28–29; C. B. Glasscock, *Gold in Them Hills: The Story of the West's Last Wild Mining Days* (Indianapolis: Bobbs-Merrill Co., 1932), 287–89. Rice, *My Adventures,* 230.

9. Reginald Meaker, *Nevada Desert Sheepman* (Western Printing & Publishing, 1981), 70–71. For Rickard, see, also, Glasscock, *op. cit.*; Shamberger, *Rawhide,* 31–34.

10. Glyn's visit is described at length in Shamberger, *Rawhide,* 33–35. The contemporary witness was Jim Moffat, as quoted by Doughty, *op.cit.*

11. Elinor Glyn, *Elizabeth Visits America* (London: Duckworth & Co., 1909), 213; Rice, *My Adventures,* 235. Rice's comment was reported in a 1920s reminiscence by Rawhide resident Joe McDonald, printed in Shamberger, *Rawhide,* 34.

12. *My Adventures,* 260.

13. The song can be located in the Special Collections Department of the Getchell Library, University of Nevada, Reno. The poem is in the collections of the Nevada Historical Society, Reno. According to Shamberger, Knickerbocker's oration was the reason that Rawhide "has never been forgotten," (*Rawhide,* 2). The funeral, and the absence of note-takers, is reported on p. 27. Emmett Arnold reports the Rickard connection in *Gold Camp Drifter,* 121, along with the fact that Knickerbocker was imported from Los Angeles for the occasion.

14. The use of photography as a promotional tool for nonmining western landscapes is discussed by Peter B. Hales in *William Henry Jackson and the Transformation of American Landscape* (Philadelphia: Temple University Press, 1988) and Anne Farrar Hyde, *An American Vision: Far Western Landscape and National Culture, 1820–1920* (New York: New York University Press, 1990). For mining photography see Joel Snyder, "Territorial Photography," in W. J. T. Mitchell, ed., *Landscape and Power* (Chicago: University of Chicago Press, 1994), 175–201. See Francaviglia, "Victorian Bonanzas: Lessons from the Cultural Landscape of Western Hard Rock Mining Towns," *Journal of the West* 35 (January 1994): 53–63, for the importance of the built environment in advertising a mining town's prosperity and stability.

15. F. W. Clark, introduction, N. E. Johnson, *Souvenir Views of Raw-*hide (Los Angeles: F. W. Clark, 1908); Arley Barthlow Show, "The Truth About Rawhide," *Death Valley Magazine* (May 1908), 88; *1908–1909 Rawhide Fallon Directory, op. cit.,* 5.

16. The technological sublime is discussed in chapter 5. See, also, David Nye, *American Technological Sublime* (Cambridge: MIT Press, 1994), 37. He describes it as "a peculiar double action of the imagination by which the land was appropriated as a natural symbol of the nation while, at the same time, it was being transformed into a man-made landscape."

17. *Mining and Scientific Press,* March 28, 1908, 424.

18. *Rawhide Rustler,* February 29, 1908.

19. "Notes on Rawhide Nevada," *Mining and Scientific Press,* March 18, 1908, 424.

20. Ibid.; *Goldfield Review,* February 8, 1908; Fred S. Cook, *Historic Legends of Mineral County* (Pahrump, NV: The Printery, n.d.), 21.

21. For the later years of Rawhide, see Shamberger, *Rawhide* and Sally Zanjani, *A Mine of Her Own* (Lincoln: University of Nebraska Press, 1997) 284–300. According to resident Russ Tyler, in Charles O. Ryan, *Nine Miles from Dead Horse Wells* (New York: Exposition Press, 1959), many of the buildings in Rawhide were moved to Yerington. Both Ryan and Shamberger have the story of the beer being used in the fire.

22. *Nevada State Journal,* June 4, 1950.

23. Francaviglia, *Hard Places,* 167.

24. *Reno Evening Gazette,* September 4, 1941.

25. In this regard the carefully cultivated and mysteriously enduring public image of Rawhide defies the melancholy effects that Patricia Nelson Limerick finds in another failed Nevada mining town of roughly the same vintage. See "Haunted by Rhyolite: Learning from the Landscape of Failure," with photographs by Mark Klett, in Leonard Engel, ed. *The Big Empty: Essays on the Land as Narrative* (Albuquerque: University of New Mexico Press, 1994) 27–47.

26. Quoted in Epler, "Joint Venture," 7A.

27. Archaeological Research Services, Inc., "Historic Context for the Mining District of Rawhide, Mineral County, Nevada," prepared for Kennecott Rawhide Mining Company, February 26, 1993, 34.

1. Because scale is such an important aspect of mining landscapes, claims about ordinal ranking of mines are ubiquitous in the literature. These rankings are, of course, historically and geographically contingent. They are also unsubstantiated. Eagle Mountain is classified as the nation's fourth-largest open-pit mine by Dennis McDougal in "Eagle Mtn., Calif.": Company Town," *Palm Springs Life* (October 1975): 108. Its ranking among iron ore mines is discussed on the Website of the Eagle Mountain High School Class of 1972 (http://ajourneypast.com/eaglemountainhigh.html). Unless otherwise noted, quotations from Eagle Mountain residents are from this source (EMHS Website).

2. Information on the history of Eagle Mountain is scattered in the geological literature. This account is drawn from Ronald Dean Miller, *Mines of the High Desert* (Glendale, CA: La Siesta Press, revised ed., 1968), 54–65; Robert L. Dubois and Richard W. Brummett, "Geology of the Eagle Mountain Mine Area," in John D. Ridge, ed., *Ore Deposits of the United States, 1933–1967*, vol. 2 (NY: American Institute of Mining, Metallurgical, and Petroleum Engineers, 1968), 1593–1606; Report XX of the State Mineralogist (Sacramento: California State Printing Office, 1924), 190–96; and "The Phase Out," 1983 *Talon* [Eagle Mountain High School Yearbook], 1–27. The latter volume was provided to us courtesy of Chester and Sharon Brenneise, former residents and teachers at Eagle Mountain High School. We are indebted to them for these and other sources on the community of Eagle Mountain.

3. Dubois and Brummet, "Geology of the Eagle Mountain Mine Area," 1595; California Division of Mines, *Mineral Commodities of California,* Bulletin 176 (1957), 250–52.

4. California Division of Mines, *Mineral Commodities of California,* Bulletin 156 (1950), 315–18. Kaiser originally purchased the townsite with the provision that the land would revert to the federal government in the event it was no longer actively occupied.

5. See chapter 1 for details on the processing of lower-grade iron ore into taconite pellets for use in blast furnaces. The process was invented in Minnesota for use on the Mesabi Iron Range.

6. Information on the townsite comes from *A History of Eagle Mountain, California, A Saga of a Desert Community (1947–1983)*, a typescript manuscript provided to us by Chester and Sharon Brenneise. Internal evidence suggests that the opening segment on community facilities and house types was produced between 1962 and 1965 by the Kaiser Steel Corporation. The quotation is from page 2.

7. Ibid.

8. Moore's comments were found on the Website of the Eagle Mountain Refugees (*http://www.wombat.ffni.com/~mymail/scrapbook/scrap. html*), which is no longer in existence. It was consulted in 2000, and copies are in the author's possession.

9. Single workers were interviewed by McDougal, "Eagle Mtn.," 109. The quotation is from the EMHS Website. In the 1970s Kaiser built another community about ten miles from Eagle Mountain. Named Lake Tamarisk, it was built around a golf course and intended to attract professionals and supervisory personnel from Eagle Mountain. There the company sold the homes rather than renting them. At the time some suspected that Kaiser was trying to close the townsite, either to mine underneath it or just to rid itself of the expenses of maintenance.

10. Mine Manager John Englund is quoted in "The Phase Out," EMHS *Talon*, 4.

11. The comment about roots is from the biographical entry of Doug Nelson, on the Eagle Mountain Refugee Website. Subsequent comments in the paragraphs that follow are from the same source.

12. In the late 1990s Kaiser Ventures owned seventy-four percent of MRC. The company was formed in 1982 for the specific purpose of reclaiming the Eagle Mountain site. Information on the landfill proposal is drawn from newspaper accounts and from the 1997 Environmental Impact Statement and Report on the Eagle Mountain Landfill and Recycling Center Project, prepared by CH2MHill. The economic forecast comes from John E. Husing, "Eagle Mountain Landfill & Recycling Center: Economic Impact on Coachella Valley, Riverside County & Inland Empire," January 10, 1997. Both of these documents are in author's possession.

13. Details of the plan, including the language about restoration, are found in MRC, "Report on Eagle Mountain: The Eagle Mountain Landfill and Recycling Center," July 12, 1997.

14. A good overview of the controversy is provided by Elizabeth Manning "Park May Get Trashy Neighbor," *High Country News,* September 29, 1997, 4. See, also, Gordy Slack, "Wasting the Desert," *Pacific Discovery* 47 (Fall 1994), 6–7.

15. Details of the National Park Service agreement are contained in "MRC, Park Agree on New Landfill," *Riverside Desert Sun,* December 21, 1996.

16. Both quotations are from "Dump Plans Shock Residents," *Reno Gazette Journal,* August 28, 1997. Claims about the landfill's rank in size echo the rhetoric about the relative size of open-pit mines, although the connotations of size for the former are negative. Articles describe MRC's landfill variously: "the world's largest," or "one of the world's largest," or "could be the world's largest." In fact it wouldn't be the world's largest for a considerable period of time.

17. "Controversial Eagle Mountain Refuse Dump Gets Final Approval," *Reno Gazette Journal,* December 17, 1999; Lukas Velush, "Final Landfill Permit Anticipated Today," *The Desert Sun,* December 15, 1999. Concerns about groundwater pollution raised by adjacent property owners such as the Charpieds obviously stem from different concerns. Judge McConnell's rulings, however, spoke primarily to the conservation and wilderness preservation concerns raised by the National Parks and Conservation Association.

18. All spelling and punctuation are from the original postings. Quotations are from Tom Cox and Sherry Watson.

CHAPTER 8

1. Mrs. Frank Leslie, *California: A Pleasure Trip from Gotham to the Golden Gate* (New York: G. W. Carleton Co., 1877), 278–79. We are indebted to Jen Huntley-Smith for calling our attention to these and other descriptions of the Comstock Lode in the nineteenth century.

2. Grace Greenwood, *New Life in New Lands: Notes of Travel* (New York: J. B. Ford and Co., 1873), 179.

3. Richard V. Francaviglia, *Hard Places: Reading the Landscape of America's Historic Mining Districts* (Iowa City: university of Iowa Press, 1991), 11. For a folklorist's efforts to explore such meanings, see Kent C. Ryden, *Mapping the Invisible Landscape: Folklore, Writing, and the Sense of Place* (Iowa City: University of Iowa Press, 1993).

4. For information on American Flat in the nineteenth century, see Mary B. Ansari, *Mines and Mills of the Comstock region, Western Nevada* (Reno: Camp Nevada Monograph #8, 1989), 53–55; Italo Gavazzi, "American Flat, Stepchild of the Comstock Lode, Part I," *Nevada Historical Society Quarterly,* 41 (Summer 1998), 92–101.

5. Albert D. Richardson, *Our New States and Territories* (New York: Beadle & Co., 1866), 44; Robert E. Kendall, "American Flat, Stepchild of the Comstock Lode, Part II," *Nevada Historical Society Quarterly,* 41 (Summer 1998), 102–14.

6. *Nevada State Journal,* July 27, 1969; George J. Young, "The New Treatment Plant of the United Comstock Mine," *Engineering and Mining Journal-Press* 114 (November 11, 1922), 846–53; Kendall, "Stepchild of the Comstock, part II," 105–8. The Comstock Merger Mines Co. purchased the assets of the United Comstock in December of 1924.

7. Information on the third mining phase at American Flat can be found in Ansari, *Mines and Mills of the Comstock Region,* 54.

8. According to Robin Holabird, deputy director of the Motion Picture Division of the Nevada Commission on Economic Development, the films were *Far from Home,* starring Drew Barrymore, and *Apex,* a science fiction movie.

9. We are indebted to the Carson City District Office of the BLM for copies of draft versions of planning documents and interpretive pamphlets for the American Flat Mill Site, from which this and subsequent BLM quotations are drawn. A similar variance between official and popular conceptions of a former mining site is traced by Erika Doss in "Sculpture from Strip Mines," in *Spirit Poles and Flying Pigs: Public Art and Cultural Democracy in American Communities* (Washington, D.C.: Smithsonian Institution Press, 1995), 112–55. In that case, the conflict was between proponents of an environmental art installation and dirt-bikers who had used the site as an off-road motorcycle course.

10. Richard F. Moreno, "The Nevada Traveler," *Lahontan Valley News,* April 29, 1966, 4.

11. For the amusement park see *Reno Gazette Journal,* April 19, 1995, C1.

CODA

1. The survey recording the low 1997 ranking of the mining industry is reported by Saleem H. Ali, "Environmental Resistance and Aboriginal Development: A Comparative Study of Mining Ventures and Public Conflicts in the United States and Canada," unpublished Ph.D. dissertation, Massachusetts Institute of Technology, 2001. We are indebted to Dirk van Zyl, of the University of Nevada, Reno, for bringing this resource to our attention.

2. The Bettmann Archive's new home is described in "From Scruffy Quarters to Limestone Labyrinth," *New York Times*, April 15, 2001, 18.

3. Francaviglia's *Hard Places* is unusual in its careful attention to the historical and cultural contexts of American mining, beyond its environmental consequences. His book is an invaluable compendium of the physical elements of the mining landscape.

4. Thomas C. Hunt, a reclamation ecologist, in personal communications with the authors, 2001-2002.

ACKNOWLEDGMENTS

We gratefully acknowledge the many individuals and institutions who aided us in understanding the range of issues embedded in *Changing Mines in America*. Their ideas and their assistance have helped educate us about the complexities and the fascination of both modern and historical mining:

Dennis Albrecht; Bill and Pat Alverson; Patricia Lewis and Burdette Anderson; Roni Anson; Amon Carter Museum of Art; Christina Barnet; Kim Biulio; Charlotte Borgeson; Chester and Sharon Brenneise; Dean Burton; Llee Chapman; Thomas Chesnick; William Chovanec; Louis Cononelos; Ellie and Tom Crosby; Deborah J. Cruze; Gary Curtis; Stephen Davis; Donald M. Deines; Patrick Earing; Patti and Steve Fickle; Dana and Kari Goin; Rich Hendel; Fran Hull; Ken Hunter; Joshua Tree National Park; Kaiser Eagle Mountain, Inc.; Kennecott Rawhide Mining Company; Kennecott Utah Copper Corporation; Dennis M. Kerstiens; John Livermore; Scott Lupo; Susan Lynn; Jesse Malone Jr.; David G. Meinke; Jack Mills; Erik Oberg; Denise Oliver; Helen O'Neil; Paul Page; Jim Pagliarini; Ronald L. Parker; Dick Petersen; Helen Plummer; Jan Roberts; Mark Rhodes; Chris Robison; John Rohrbach; Lara Schott; Sharon Stewart; Tim Terrell; Candice Towell; U.S. Bureau of Land Management; U.S. Department of the Interior; Dirk van Zyl; Denis Wood; and Joe Zarki.

The Charles Redd Center for Western Studies awarded us the John Topham and Susan Redd Butler Faculty Research Award. This award provided invaluable assistance during a critical phase of the project. The Nevada Humanities Committee funded the Mesabi Iron Range photographic section, as well as awarding partial subvention support for this book's publication. The Graduate School at the University of Nevada, Reno, provided partial funding for color reproductions. The Public Resource Foundation of Reno, Nevada, provided funds to assist in the research and publication of this book. The Barrick Goldstrike Mines, Inc., near Carlin, Nevada, recognized the importance of funding publi-

cations that offer unique points of view about this important industry. The Eagle Mountain Mine photographic section was completed during an artist-in-residency appointment at Joshua Tree National park. Paul F. Starrs composed the map. Other funds were kindly provided by Edda Morrison, friend and patron of the arts. Since this project was conducted in part during Peter's term as Foundation Professor at the University of Nevada, Reno, he would like to express special thanks to the University of Nevada, Reno, Foundation.

Earlier versions of some chapters appeared in the following publications: "Physical; Graffiti: Mining Legacies at American Flat," in Stephen Tchudi, ed., *Western Technological Landscapes* (Reno: University of Nevada Press, 1998), 133–49; "Recycled Landscapes: Mining's Legacies in the Mesabi Iron Range," in David Nye, ed., *Landscape and Technology* (Amherst: University of Massachusetts Press, 1999), 267–83; "Radon Health Mines," *Doubletake* (Spring 1999), 40–45; "Redeeming a Postmining Landscape," *Journal of Architectural Education* 54 (February 2001), 195–97; "Living in Anthracite: Mining Landscape and Sense of Place in Wyoming Valley, Pennsylvania," *Public Historian* 23 (Spring 2001), 29–45. In each case we are grateful for the insight of editors, anonymous reviewers, and readers; and for permission to reuse material.

Three individuals involved in this project deserve special thanks. Thomas C. Hunt, an ecologist and landscape architect who is director of the department of reclamation, environment, and conservation and head of the Pioneer Farm at the University of Wisconsin, Platteville, provided valuable technical expertise and assistance and saved us from numerous errors. Those that remain, it goes without saying, are solely our responsibility, despite his best efforts. J. Dee Kille, of the University of Nevada, Reno, proffered not just research assistance but genuine scholarly insight. Without her indefatigable efforts the chapter on Eagle Mountain would not have been possible. And, finally, we owe a debt to George F. Thompson, president and publisher of the Center for American Places. His determination and unyielding confidence in this work were essential to the development and publication of *Changing Mines in America.*

ABOUT THE AUTHORS

Peter Goin is Foundation Professor of Art in photography and video at the University of Nevada, Reno. He is the author of *Tracing the Line: A Photographic Survey of the Mexican-American Border* (limited edition artist book, 1987), *Nuclear Landscapes* (Johns Hopkins University Press, 1991), *Stopping Time: A Rephotographic Survey of Lake Tahoe* with essays by C. Elizabeth Raymond and Robert E. Blesse (University of New Mexico Press, 1992), and *Humanature* (University of Texas Press, 1996). He has also served as editor of *Arid Waters: Photographs From the Water in the West Project* (University of Nevada Press, 1992) and as co-author of the *Atlas of the New West: Portrait of a Changing Region* (Norton, 1997), a collaborative effort with members of the Center of the American West at the University of Colorado at Boulder. His most recent book, co-authored with another photographer and a creative writer, is *A Doubtful River*, a project that examines the complex watershed of the first federal irrigation dam, the Newlands Project. His photographs have been exhibited in more than fifty museums nationally and internationally, he is the recipient of two National Endowment for the Arts Fellowships, and his video work has earned him an EMMY nomination. In the year 2000, he received the *Governor's Millennium Award for Excellence in the Arts*. He lives with his family in Reno, Nevada.

C. Elizabeth Raymond is professor of history at the University of Nevada, Reno. She is author, co-author, and co-editor, respectively, of *George Wingfield: Owner and Operator of Nevada* (University of Nevada Press, 1992), *Stopping Time: A Rephotographic Survey of Lake Tahoe* (University of New Mexico Press, 1992), *and Comstock Women: The Making of a Mining Community* (University of Nevada Press, 1997). She has published widely on topics in cultural landscape history, including Midwestern regional identity, and a sense of place in the Great Basin, and she been active in the public humanities as member of the Nevada State Humanities Committee and as project director for the *Nevada Online Encyclopedia*.

The Center For American Places is a tax-exempt 501 (c)(3) nonprofit organization, founded in 1990, whose educational mission is to enhance the pulic's understanding of, and appreciation for, the natural and built environment. It is guided by the belief that books provide an indispensible foundation for comprehending—and caring for—the places where we live, work, and explore. Books live. Books endure. Books make a difference. Books are gifts to civilization.

With offices in New Mexico and Virginia, Center editors bring to publication 20-25 books per year under the Center's own imprint or in association with publishing partners. The Center is also engaged in numberous other educational programs that emphasize the interpretation of *place* through art, literature, scholarship, exhibitions, lectures, curriculum development, and field research. The Center's Cotton Mather Library in Arthur, Nebraska, its Martha A. Strawn Photographic Library in Davidson, North Carolina, and a 10-acre reserve along the Santa Fe River in Florida are available as retreats upon request. The Center strives every day to make a difference through books, research, and education. For more information, please send inquiries to P.O. Box 23225, Santa Fe, NM 87502, U.S.A. or visit the Center's Web site (*www.americanplaces.org*).

About the Book: The text for *Changing Mines in America* was set in Minion and Franklin Gothic. The paper is acid-free Hannoart gloss text, 100# weight. The four-color separations were produced in Hong Kong, and the book was printed in Canada.

FOR THE CENTER For American Places:

George F. Thompson,
 president and publisher
Randall B. Jones,
 associate editorial director
Denis Wood, manuscript editor
Carrie Nelson House,
 designer and typesetter
David Skolkin, production advisor
 and jacket designer
Dave Keck, of Global Ink, Inc.
 production coordinator